The Santa Cruz Beach Boardwalk

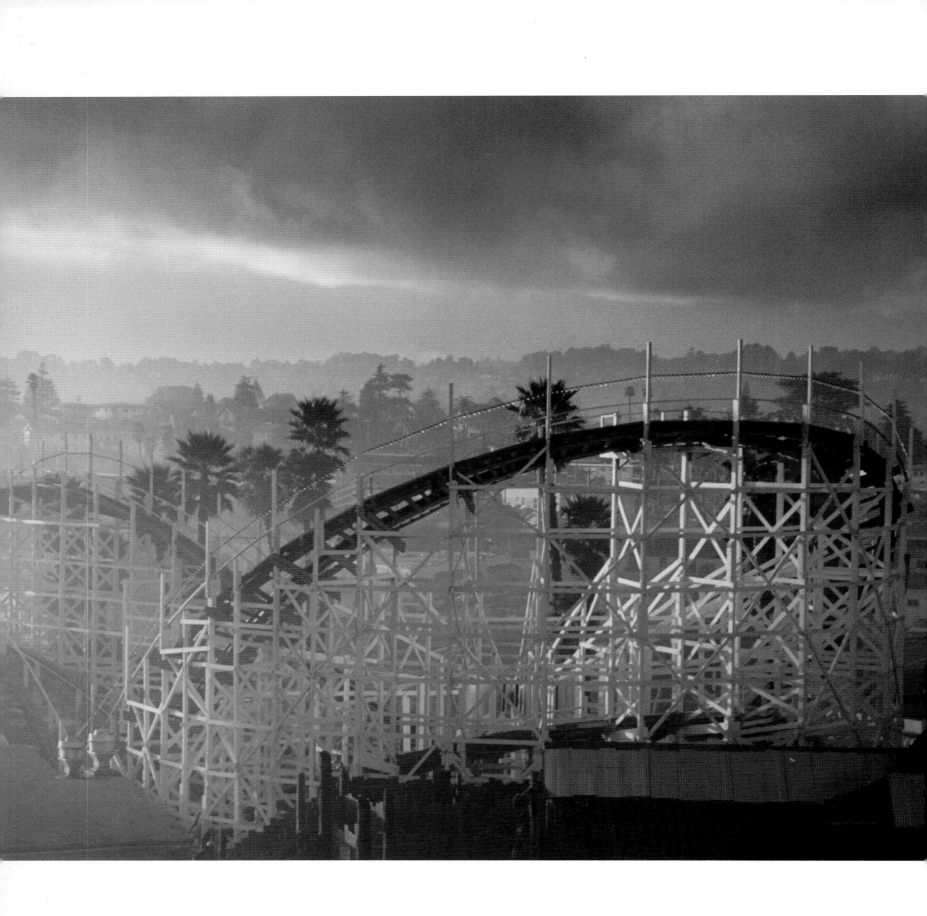

The Santa Cruz Beach Boardwalk

A CENTURY BY THE SEA

THE SANTA CRUZ SEASIDE COMPANY

TEN SPEED PRESS
Berkeley | Toronto

DEDICATION

To all Boardwalk employees and concessionaires, past and present. Your energy, dedication, and creativity have given this grand place its heart and soul.

Ten Speed Press
P.O. Box 7123
Berkeley, California 94707
www.tenspeed.com

Distributed in Australia by Simon and Schuster Australia, in Canada by Ten Speed Press Canada, in New Zealand by Southern Publishers Group, in South Africa by Real Books, and in the United Kingdom and Europe by Publishers Group UK.

Cover and text design by Toni Tajima
Frontispiece photo by Annie Colbeck

This publication is a companion to the exhibition "Santa Cruz Beach Boardwalk" shown at the Museum of Art & History at the McPherson Center in Santa Cruz, California, in 2007.

Library of Congress Cataloging-in-Publication Data
Santa Cruz Seaside Company.
 The Santa Cruz Beach Boardwalk : a century by the sea / the Santa Cruz Seaside Company.
 p. cm.
 Includes index.
 ISBN-13: 978-1-58008-814-5
 ISBN-10: 1-58008-814-7
 ISBN-13: 978-1-58008-815-2
 ISBN-10: 1-58008-815-5
 1. Amusement parks—California—Santa Cruz—History. 2. Beaches—California—Santa Cruz—History. 3. Santa Cruz (Calif.)—History. 4. Santa Cruz (Calif.)—Pictorial works. I. Title.
 GV1853.3.C22S26 2007
 791.06'879471—dc22 2006029805

Printed in China
First printing, 2007

1 2 3 4 5 6 7 8 9 10 — 11 10 09 08 07

FRONT COVER IMAGES: Santa Cruz Casino and Natatorium, circa 1907; the Wild Mouse ride, 1971; and Santa Cruz Beach Boardwalk, circa 2000 (photo courtesy of Shmuel Thaler). BACK COVER IMAGES: The Looff Carousel, 1965; the Giant Dipper, 1980; and the Santa Cruz beachfront, circa 1911. FRONT FLAP: The Cocoanut Grove, 1947. BACK FLAP: The 1941 Santa Cruz Surfing Club.

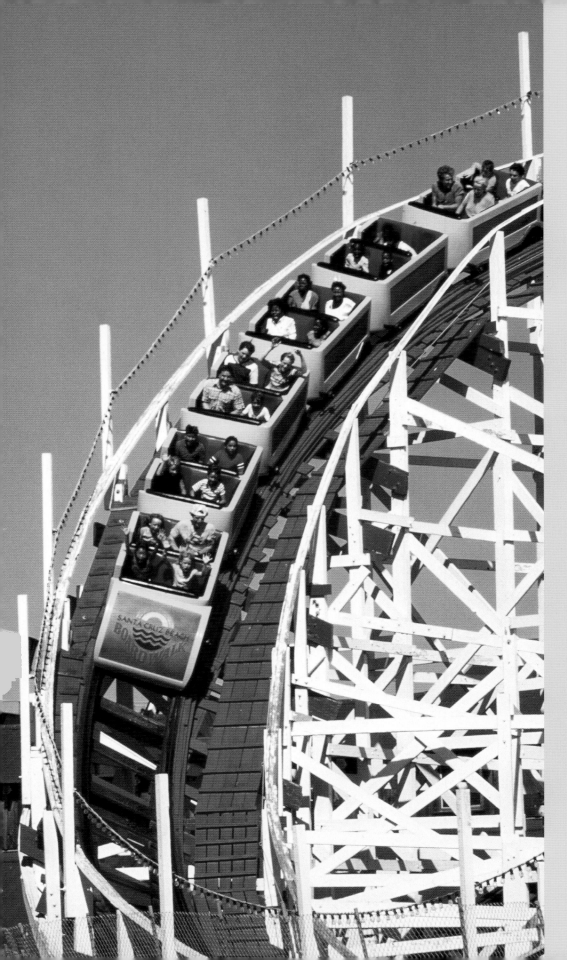

CONTENTS

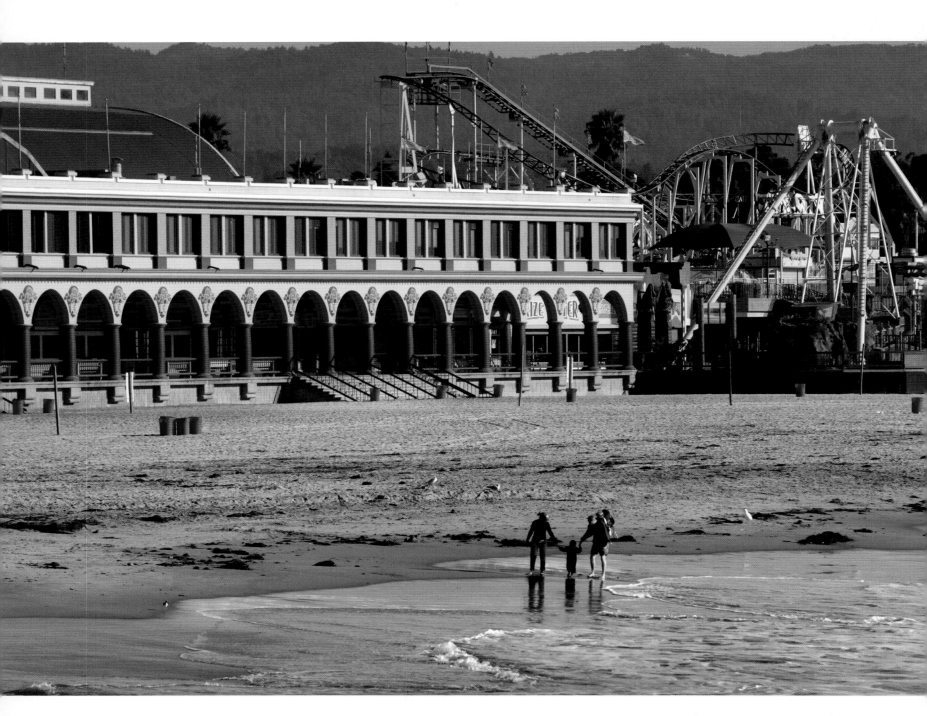

Early morning at the Boardwalk, circa 2000. (Photo courtesy of Shmuel Thaler)

ACKNOWLEDGMENTS

The Santa Cruz Seaside Company gratefully acknowledges the following people who made this book possible. The Centennial Book Team devoted countless hours to bring this project to completion: Bonnie Minford helped bring Boardwalk history to life, working tirelessly to track down fascinating stories, facts, and photographs in company archives; editing copy; and speaking for the people in the old photographs. Marq Lipton provided the leadership and support that kept us on track to get the job done, rolling up his sleeves when necessary, and reminding us to enjoy the ride. Ted Whiting III graciously shared his extensive knowledge of the Boardwalk and his own family's history, providing invaluable counsel for the project.

We owe a lot to Kimberly MacLoud, whose artistic sense and genuine love of the Boardwalk reminded us all that this story is about more than mere facts; and to Amy Sibiga, whose background in publishing and appreciation of Boardwalk history helped bring initial structure and direction to the enormous task.

We thank the following individuals at the Santa Cruz Boardwalk for their help: Carl Arnett, Shanan Behm, Janet Blaser, Charles Canfield, Tish Denevan, Brigid Fuller, Candice Gollwitzer, Annalisa Griffis, Carl Henn, Katie Hintz, Jill James, Kathie Keeley, Sam King, Dianna Ligon, Rachel Lotto, Amy Penfield, Karley Pope, Kris Reyes, Ingelise Rowe, Kevin Samson, Donaven Staab, Sandi Jo Stoltenkamp, and Sondra Woods.

We thank Gay Machado for copywriting and editing; and Rick Cloger, Bonnie Hurd, and Ann Parker for editing.

We also owe thanks to a great many people in the Santa Cruz community for their assistance and support: Sandy Cherk, Annie Colbeck, Dan Coyro, Richard Davis, Dan Dawson, Ross Eric Gibson, Ed Hutton, Glenn LaFrank, Bill Lovejoy, Mike Miller, Dana Morgan, Ted Orland, Randy and Michele Santee, Shmuel Thaler, Loyd Van Zante, and Gail Vivere.

For their cooperation and important resources, we also thank the Santa Cruz Museum of Art and History; Special Collections at the University of California, Santa Cruz; the Santa Cruz Public Library; and the Santa Cruz Sentinel.

For their treasured family stories and photos, we thank: Susan DeSousa, Lou Haber, Mel Haber, Betty Lewis, Mary Lee Lincoln (Lidderdale), Kathie Lorence, Natalie Marshall, Juliana Martinez, Marilyn Matthews (Moore), Don Passerino, Mary Pedri, Claire Press, Gary Roberts, Jim Ryan, Pat Schultz, Gloria Scurfield, Robert "Big Boy" Stagnaro, Dick Trimingham, Jean Trimingham, Harold "Gus" Van Gorder, Rae Whiterose, Ted Whiting Jr., and many others.

We also appreciate the efforts of the Ten Speed Press team, many with their own Boardwalk memories: project editor Brie Mazurek, editor Julie Bennett, special projects director Dennis Hayes, and publisher Phil Wood.

And finally, thanks to the Board of Directors of the Santa Cruz Seaside Company who supported this important project from the beginning: Charles Canfield, Dr. Robert Millslagle, Bud Rice, Dr. Jeffrey Rice, and Jim Van Houten.

FOREWORD

John Poimiroo, founder and principal of Poimiroo & Partners

IT'S SAID THAT YOU CAN'T GO HOME AGAIN, that time changes all places as well as your memories of them. One place, however, never seems to change for me: the Santa Cruz Beach Boardwalk.

This classic oceanside amusement park remains today much as it was when my family vacationed there in the 1950s. Every summer we would stay at a tiny motel off of Riverside Avenue that offered "TV and heated swimming pool," though I can't remember ever using the pool. We had the beach, after all. Each day we would parade there—burdened with umbrellas, towels, beach balls, buckets, and suntan lotions—to spend lazy days building sand castles and catching sand crabs.

After a few hours at the beach, we would beg our parents to take us to the Boardwalk, with its enticing refreshments and amusements. They didn't take much convincing. The seaside park was a sensory show for the whole family. People in street clothes promenaded beside those of us in beachwear and smelling of suntan oil. On weekends, the Sun Tan Special train arrived carrying loads of sunbathers. The olive-brown coaches waited until afternoon, when the black engine would bellow notice of returning to the peninsula with its cargo of tired but happy revelers. I longed to ride the train, although I knew we were truly the lucky ones because we had another whole week to enjoy the Boardwalk.

During the second week of our visit, Grandpa would treat us to various Boardwalk thrills, including the Wild Mouse. To the uninitiated, this metal maze of a ride looked like a junior roller coaster, but any similarity ended there. Its tiny two-passenger cars, riding the thinnest of rails, made impossible turns and convinced us at every bend that we might go soaring off into space.

Another highlight every summer was riding the Giant Dipper roller coaster. It started with a heart-pounding plunge into a pitch-black tunnel, followed by the menacing clickety-clack of cars inching up that first big hill. Nearing the top, you could look out at sailboats bobbing on Monterey Bay for a moment of calm. Then the coaster cars leaped down a near-vertical first drop, leaving your heart in midair. Screams erupted and brave hands formerly held high suddenly clenched handrails while the cars plummeted, rose, and banked, levitating you off the seat. There was nothing like the Giant Dipper. For three minutes you became Chuck Yeager, breaking the sound barrier.

The Boardwalk was filled with such innocent diversions. You could pretend to be a famous jockey riding Seabiscuit at the Balloon Race, win prize tickets by rolling Skee Balls up polished wooden ramps, or enjoy the wildly disorienting amusements of the Fun House. The Plunge saltwater pool echoed with the shouts and splashes of divers and nonswimmers alike, and the Casino's games

tested your strength, read your fortune, and assessed your personality. We bought fresh fish from Stagnaro Brothers on the nearby pier and saltwater taffy from Marini's at the Boardwalk—and you still can today. Some of my most memorable recollections are of riding the carousel, sitting astride those magical wooden horses as they circled and soared to the band organ music. We would grab a metal ring and toss it at the target, hearing the distinctive sounds of hitting—or missing—the bull's-eye.

Although a hundred years have passed since the Santa Cruz Beach Boardwalk was established, the same simple joys that entertained a previous five generations are now captivating a sixth. This beach boardwalk is the last of California's original oceanside amusement parks and remains one of the best. It has inspired songs, films, fashions, and

trends, rewarding all who visit with fond memories of simpler times.

Whoever said you can't go home again obviously never spent a summer vacation at the Boardwalk.

The impressions made during John Poimiroo's childhood vacations at the Santa Cruz Beach Boardwalk contributed to a lifetime of work in travel and tourism—including serving as the director of California State Tourism and as a travel editor of California *magazine. He has also held various communications positions at Yosemite National Park, Roaring Camp Railroads, Marriott's Great America, and Squaw Valley USA. John owns and operates Poimiroo & Partners, a travel and tour communications consultancy in California.*

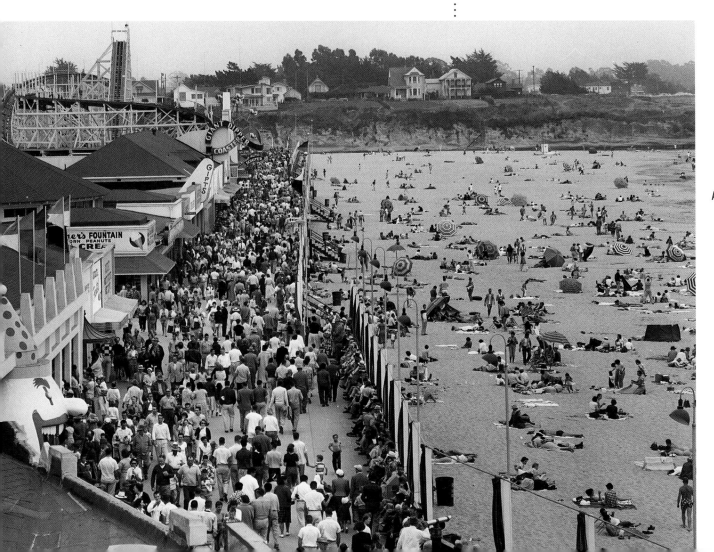

Along the Boardwalk, 1954.

INTRODUCTION

Charles Canfield, president of the Santa Cruz Seaside Company

MILLIONS OF PEOPLE feel like they grew up at the Santa Cruz Beach Boardwalk, but I actually did. My early memories are centered around this unique place, even before my father, Laurence Canfield, became president of the Boardwalk's board of directors. That was in 1952, when I was twelve years old, and I later followed in his footsteps.

Most of my life has been spent at the Boardwalk. As a child, I remember coming to the Boardwalk with my parents and sister to watch the annual Fourth of July fireworks. And in my youth, I spent countless days swimming and surfing at nearby Cowell Beach, coming to the Boardwalk for french fries and sodas.

At sixteen, I got a job running rides in Kiddie Land, a part of the park with attractions for the Boardwalk's youngest visitors. Some of those rides are still here today—and the kids seem to enjoy them as much now as they did back then. When I turned eighteen, I tried working in a lumberyard, but it was heavy work stacking lumber all day and not nearly as much fun as the Boardwalk. Soon I found myself working at the park again. After graduating from college, I joined the U.S. Navy and spent the early sixties on a ship traveling around the world. I returned to the Boardwalk after that—and haven't left since. I suspect that my reasons for returning are similar to the ones that draw our visitors back year after year, generation after generation. It seems as if no matter where you go, anywhere in the world, there isn't anything quite like the wonderful old Santa Cruz Beach Boardwalk.

What better way to honor the centennial anniversary of such a special place than to gather images and words to record its past hundred years? This book has been a labor of love, much like my entire career at the Boardwalk. My hope is that the stories and photographs throughout this book will bring to life the rich history and wonderful nostalgia that define this park and make it so special.

That history began a hundred years ago, when a man named Fred Swanton pursued his extraordinary dream to build "the Coney Island of the West" right here on the Santa Cruz shoreline. Barely two years after the massive construction was finished, sadly, his creation disappeared amid fire and smoke. Within a matter of months, however, Swanton rebuilt his dream—and it has been going strong ever since.

I remember when I returned to the Boardwalk after serving in the navy, my father (who was president of the company at the time) took me on a tour of similar seaside amusement parks throughout the state and country. We talked to other park owners about the many challenges they faced, their successes and failures. My father realized that in order for our own park to remain viable, we had to plan well into the future and think carefully about the Boardwalk's long-term evolution. His vision kept this

place going through times when park after park was closed to make room for much more lucrative operations, such as beachfront condominiums. At one time, seaside amusement parks dotted the entire California coast. These days, except for small attractions in San Diego and Santa Monica, the Santa Cruz Beach Boardwalk is all that's left of what historians call "the Golden Age of Amusement Parks."

Today I work closely with my own son, Tom, who has followed the family tradition by building a career at the Boardwalk. Much like my father and I, Tom and I work side by side in planning for the future but we are careful not to forget about the past. My family is living proof that the Boardwalk has a tendency to grab hold of people's hearts and never let go. Generations of families from throughout California and beyond have returned year after year to relive old memories and create new ones with the people they love. For a hundred years, they have come seeking escape from the routine of daily life. Here they can embrace that sense of escape—amid the sights, sounds, rides, and experiences found only along the beach in Santa Cruz.

Perhaps this fascination is the Boardwalk's singular contribution to American culture. Few places today are as they were a hundred years ago; I'm honored to be a part of something that so eloquently blends the past and the present. It is impossible to know what lies ahead for the Boardwalk over the next hundred years. But if the history of this treasure by the sea tells us anything, our Boardwalk will persevere.

This book is a tribute to a very special place, the Santa Cruz Beach Boardwalk. Throughout the twentieth century, it has provided millions of memories to those who find themselves drawn here. I have no doubt that it will provide millions more.

Charles Canfield is president of the Santa Cruz Seaside Company, owner-operator of the Santa Cruz Beach Boardwalk. Charles got his start on the Boardwalk at the age of sixteen working as a ride operator. Charles's father Laurence joined the company's board of directors in 1928 and was named president in 1952. After managing game concessions at the park, Charles became vice president of the company in 1969. He worked closely with his father on new developments and, after Laurence's passing, took the helm in 1984. Today, Charles works closely with his own son, Tom, who serves as the Boardwalk's vice president of operations.

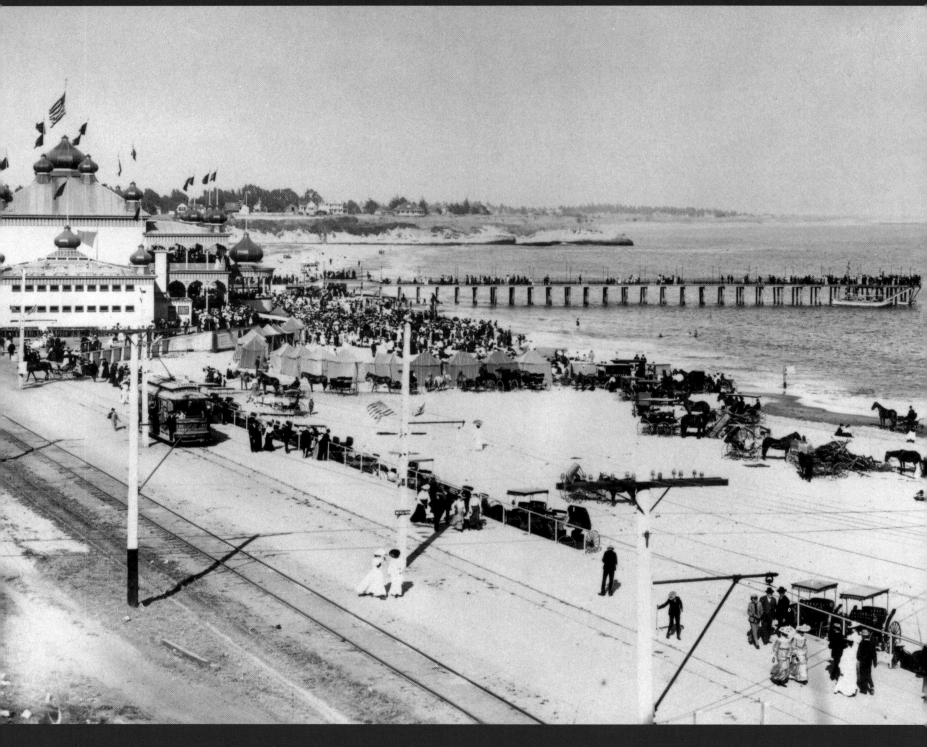

Horse-drawn carriages park on the beach as an electric streetcar leaves Neptune Casino, 1904.

Never a Dull Moment

IT WAS A NEW ERA in entertainment, a time when Americans were becoming more prosperous and less dependent on constant work for survival. And Santa Cruz, California, was the perfect spot for fun and frivolity. The natural beauty and temperate climate of Santa Cruz drew tourists from California's hot inland valleys and large cities—as they still do today. But back in 1866, when the first public bathhouse was built on Santa Cruz Beach and rail transportation was just getting in gear, visitors flocked to the town—where they often remained for several weeks at a time—to enjoy hotels, restaurants, cultural performances, band concerts, picnics, and Victorian-clothed bathing.

Americans were beginning to realize that recreation was a good thing and recreational swimming could be an enjoyable pastime. In 1870, public swimming was still considered novel, and "surf bathing" was attempted by only the most adventurous. Yet by the 1890s, partly because of Santa Cruz's magnificent, serene, and safe beaches, open-water swimming became all the rage. A September 6, 1866, article in San Francisco's *Daily Alta California* noted that Santa Cruz, though a small coastal town, actually had all the features of a first-class resort and "will soon be considered and adjudged by all the pleasure-seekers of this land as the *ne plus ultra* resort area of the Western Coast. The climate is mild and perfectly delicious."

By 1887, the Southern Pacific Railroad offered several round-trips a week to Santa Cruz, and a company travel folder encouraged tourists to travel to the town not only to enjoy the ideal weather, but also to breathe air "full of ozone." Around the same time, *Sunset* magazine described the beaches as being "free from undertow . . . [and] obnoxious fish." In 1905, *Sunset* claimed that Santa Cruz offered "more free entertainment than any other resort on the Pacific Coast," declaring there was "never a dull moment" at the beach.

TO PUT THINGS IN PERSPECTIVE

Here's what was happening:

1865 The Civil War ends.

1869 The Transcontinental Railroad is completed.

1875 The baseball glove comes to baseball.

1879 Thomas Edison invents the lightbulb.

1890 Americans become stuck on saltwater taffy.

1894 The Great Fire destroys portions of downtown Santa Cruz.

1900 Cotton candy debuts at the Ringling Bros. circus.

1903 The Wright brothers make their first flight.

1906 San Francisco experiences a devastating earthquake.

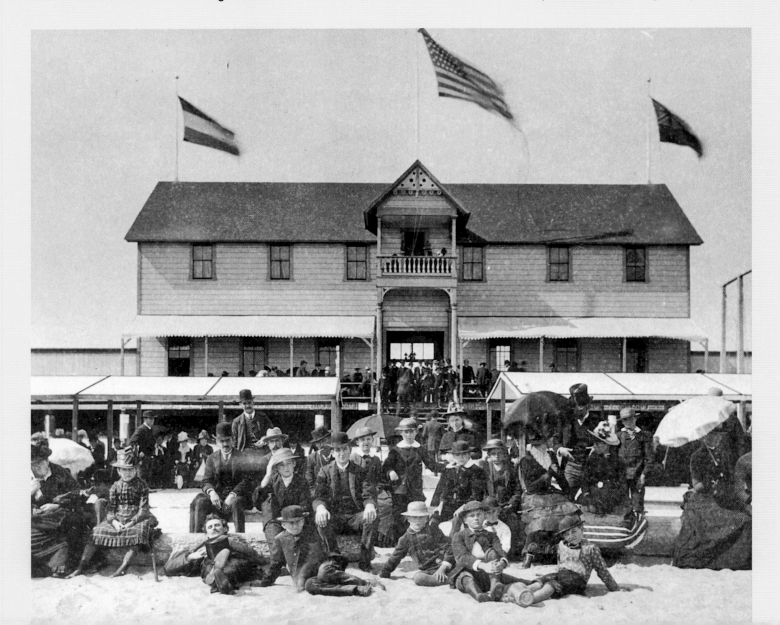

THE ERA OF THE SANTA CRUZ WATERFRONT BATHHOUSES

John Leibbrandt's portable bath sheds and Elizabeth Liddell's Long Branch Bath House ushered in the public bathhouse industry on Santa Cruz Beach in 1866. These were California's first beach bathhouses, where folks could safeguard their modesty by stepping into a private room to change into their bathing clothes. The advent of indoor running water quickly boosted the popularity of the public bathhouse. Liddell's Bath House, which featured more than a hundred dressing rooms, was modeled after a commercial bathing resort in New Jersey. Leibbrandt's little portable bath sheds stood on skids so his horses could pull them into position near the surf at daybreak and pull them back at dusk. Leibbrandt's bathhouse, built in 1872, changed its name to the Dolphin Bath House in 1884.

The Neptune Bath House was dedicated on June 10, 1884, celebrated with bonfires on the sand and a grand ball. Just down the beach, at Leibbrandt's Bath House, diners enjoyed a supper of sandwiches, ice cream, cake, and coffee while an especially handsome cake was auctioned off and Old Neptune himself arrived at the beach by barge. Built by Captain C. F. Miller, the Neptune Bath House drew patrons with its popular Saturday night mussel bakes and water shows. On more than one memorable occasion, the underwater artist Mademoiselle La Selle sewed, ate, and wrote while submerged in a water-filled glass tank, staying beneath the surface for two minutes and forty-five seconds.

The era of the Santa Cruz waterfront bathhouse reached its zenith in 1893, when John Leibbrandt, brothers Ralph Miller and A. E. Miller, and financier A. P. Hotaling joined forces to create "a bathing plunge" that they said would be the finest in the state. The Miller-Leibbrandt Plunge was a well-appointed two-story structure that included two hundred dressing rooms, a glass-enclosed observatory, a café with ornate fixtures and fireplaces, and a billiard parlor and card room. The setting was decorated lavishly with palms and other plants, and the pool was heated to a comfortable eighty-three degrees. Best of all, the Plunge featured springboards all around the perimeter, and from the ceiling hung a flying trapeze.

In 1889, there was no Beach Street, so most beachgoers strolled along a boardwalk that ran next to tracks for the railroad and horse-drawn streetcar. A circular awning covered the first merry-go-round at the beach—the Steam Flying Horses. The revolving platform of this ride was powered by a steam engine, and track wheels gave the horses a rocking motion. A banjo-strumming musician, wearing a silk hat given to him by the mayor, provided the music. The steam boiler propelling the merry-go-round stood at its center, and when the wind blew in the wrong direction, the riders got a face full of smoke and cinders from the boiler.

OPPOSITE: Beachgoers enjoy the dedication of the Neptune Bath House, held on June 10, 1884.

Beachfront Santa Cruz, 1889. The steam-powered merry-go-round is at the upper left. Passengers wait for horse-drawn streetcars.

From left, behind the beachgoers, are the Sea Beach Hotel and the Neptune Baths on the Santa Cruz beachfront in 1903.

GRAND ARMY of the REPUBLIC

BENEFIT

Of W. H. L. Wallace Post.

A Camp Fire

—AND—

GRAND BALL!

—AT THE—

BATH HOUSES

On Santa Cruz Beach,

Tuesday Eve'ng, June 16,

Delightful Entertainment of Artistic Novelties!

BEAUTIFUL TABLEAUX ON THE WATERS!

Poseidon and Amphritile, attended by a numerous retinue of Tritons, Niads, Nereides, and other inferior deities, have promised positively to come forth from their palaces and caves in the vasty deep, freely to mingle with mortal man on that occasion. Come dance and dine with them.

Dedication of Liebbrand's Bath House,

THE DOLPHIN.

Gallery of Portraits and Original Designs from Life, EN TABLEAUX, Superb Scenic Effects.

PENELOPE ! PENELOPE !

Costly Presentations !

A handsome Silver Jewel Box to the most charming young lady.
A nobby Gold-headed Cane to the most popular young man.

COME TO THE GUESSING MATCH.

A Fine Silk Hat will be awarded to the prince of guessers.

MUSIC BY HASTINGS' BAND.

Admission 50cts. Supper Free.

NO FREE LIST.

By Order of the Committee,

J. B. PEAKES, Chairman.

LEFT: An 1885 advertisement in the *Santa Cruz Surf* newspaper invites readers to a "Camp Fire and Grand Ball" at the Santa Cruz bathhouses.

BELOW: An advertisement in the August 1879 *Santa Cruz Sentinel* extols the many virtues of Leibbrandt's Bath House.

Russian, Turkish & Medicated
B A T H S !

ARE NOW OPEN AT LEIBBRANDT'S BATH HOUSE, on the BEACH. These Baths have been enlarged and thoroughly renovated for this season. They possess advantages over any other, being the only ones in the world that have FRESH AND SALT WATER AND ELECTRICITY introduced in them, and are also the only ones where the proprietor attends to his patrons in person, thereby insuring safety and strict attention. Open every day from 8 A. M. to 6 P. M.

BATHS.......................................$1 00.

N. B.—All forms of Disease treated skillfully. DR. D. SULLIVAN,
je14-3t Proprietor.

—What has become of Dr. Sullivan, the Turkish bath man? He owes a bill at this office, and although our collector can not find him we hope he has not jumped the town, and will not do so till he at least tells us of his inability to pay the bill.

BELOW: Sixty-four new "bath rooms" at the Dolphin Bath House are announced in this 1887 *Santa Cruz Surf* newspaper.

DOLPHIN BATH HOUSE

SANTA CRUZ BEACH.

Having pleased the public for over fifteen years, the

LEIBBRANDT BROS.

Take pleasure in informing their patrons and all who desire to bathe comfortably that they have made important additions to their already commodious Bathing Establishment.

SIXTY-FOUR NEW BATH ROOMS.

☞ Hot and cold salt water baths at all hours. Ladies' apartments entirely separate from the gents', both in general bathing rooms and Hot Baths.
New rafts with latest improvements in the way of slides, spring boards, floats, &c.

Experienced Swimming Teachers in Attendance.

To the right of the Neptune Baths is the Miller-Leibbrandt Plunge and its water tank. This photograph was taken from a permanent stand flanked by large rafts equipped with slides and other forms of water amusements.

THE VENETIAN WATER CARNIVALS

To celebrate and publicize Santa Cruz's recovery from the Great Fire of 1894, the philanthropist and water-lover James Philip Smith created a lagoon on the lower San Lorenzo River in 1895 and sponsored the first annual Venetian Water Carnival. The weeklong event featured water sports, masked balls, and fireworks. Its highlight was a colorful aquatic parade of gondolas and floats decorated with flowers and flags. Electric lights were strung across the river, which was partially dammed to create a lagoon for the event. Each year a beauty queen was crowned to preside over the elaborate water fair. Aided by local financiers and astute businessmen, and promoted by the Southern Pacific Railroad, the carnival attracted national attention. In 1912, Fred W. Swanton, the builder of the Santa Cruz Beach Casino, sponsored the most lavish of all the water carnivals.

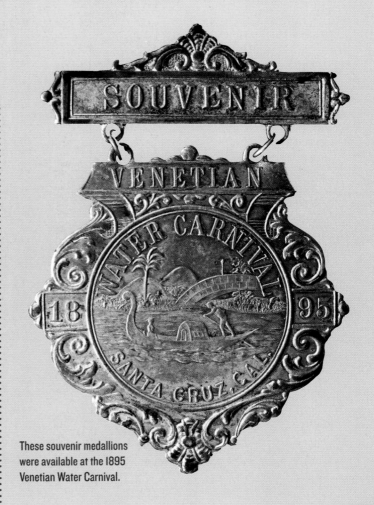

These souvenir medallions were available at the 1895 Venetian Water Carnival.

During Venetian Water Carnival week in 1896, sailors and visitors ferried to and from the USS *Philadelphia* anchored in the bay.

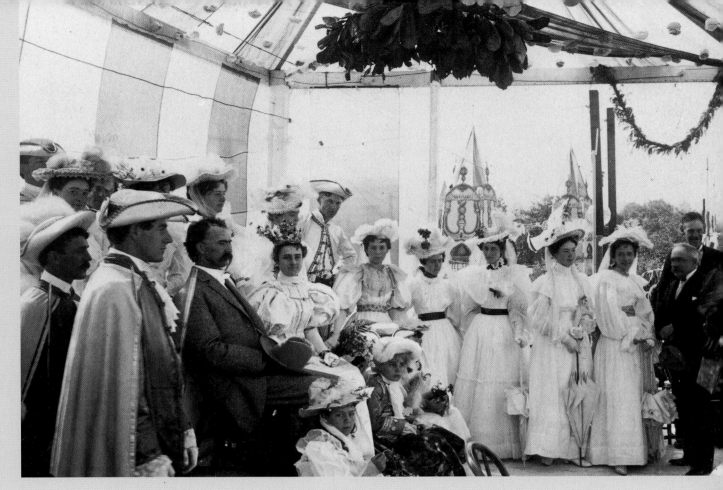

Lieutenant Governor W. T. Jeter, the mayor of Santa Cruz from 1892 to 1894 (in the dark coat), and Queen Josephine Turcott (wearing her crown) are flanked by gondoliers and court ladies in the Governor's Stand on the bank of the San Lorenzo River, 1896.

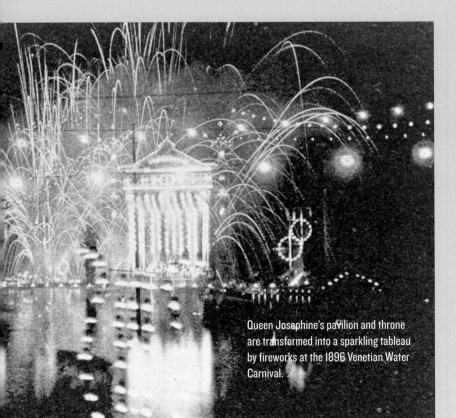

Queen Josephine's pavilion and throne are transformed into a sparkling tableau by fireworks at the 1896 Venetian Water Carnival.

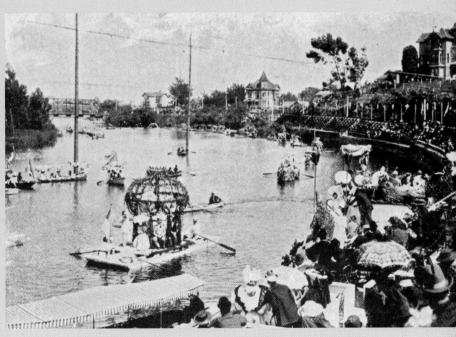

A parade of boats decorated for the 1895 Venetian Water Carnival floats past spectators sitting in bleachers at a bend in the San Lorenzo River, just above the Riverside Bridge.

Young surf bathers pose on the Santa Cruz main beach, 1906.

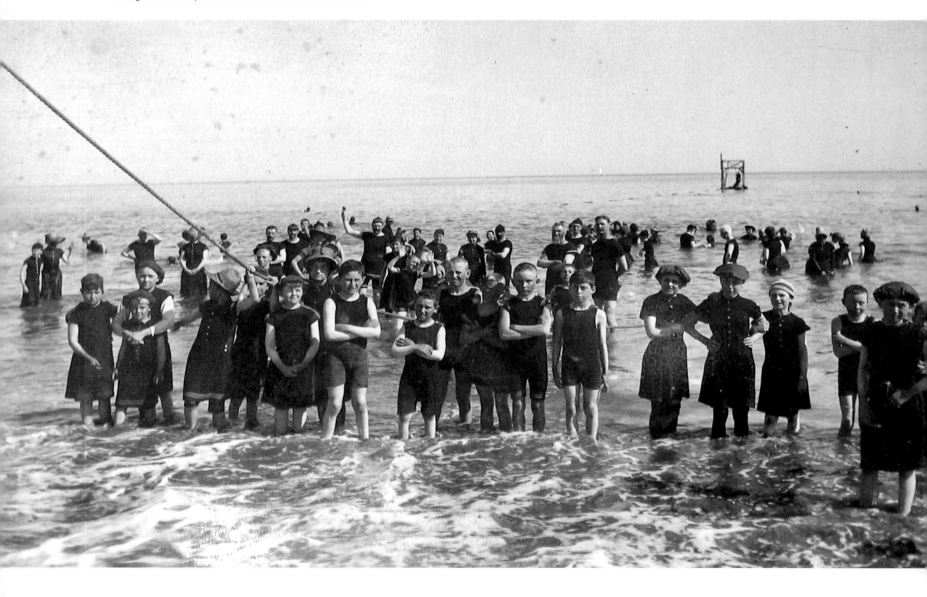

TAKING THE WATERS

By the early 1900s, the popularity of beaches and bath-houses was driven by the belief that "taking the waters" was good for one's health—which may have been true in *most* cases. But Americans quickly found that swimming was not without risk.

Newspapers hyped reports of drownings in recreational settings, particularly in storm surf and rip currents. In response, beach resorts began to hire especially good swimmers to stand "guard." In Santa Cruz, it wasn't long before brothers Ralph and A. E. Miller started advertising a teaching staff, called the "Professors of Aquatic Natation," and promoting swim teams for the Neptune Baths. One of their instructors, Arthur "Red" Wallace, became popularly known as the "human fish" for his great speed in the water. Admirers traveled from as far away as San Francisco and San Jose to see him perform.

FUN FACTS

- In 1827, the first swimming school in America opened in Massachusetts. Many of the female students had weights sewn into the hems of their bathing skirts to keep them from rising in the water and exposing their legs.

- In 1887, the first municipal swimming pool opened, in Brookline, Massachusetts.

- In 1904, England's Royal Navy rejected the "Seaman's Friend," a life belt invented by W. H. Mallison, because the belts took up too much room and they did not want sailors to know how to swim should they decide to desert.

In the 1880s, Arthur "Red" Wallace (aka the "human fish") was the first man in history to swim a hundred yards in under a minute.

SEASIDE BATHING AND FASHION

Turn-of-the-twentieth-century American society believed that the human body should remain covered in public, even at the beach. Popular swimming costumes for men were large neck-to-knee garments, heavy and highly impractical when wet. Women's suits included bloomers and black stockings—not exactly ideal in hot weather. Bathers were seen only on their way to and from the water, or in the ocean, because a city ordinance prohibited sitting on the beach in public view in bathing attire. "Clothed" couples lounged on the beach—women were properly dressed, and men wore hats and coats.

SURF BATHING.

NEW BATHING SUITS FOR LADIES and gents, 15c; children's suits, 10c and 5c; 5c for use of dressing room if you have your own suit. Bathing place opposite second rope.

je21-tf MRS. B. LEIBBRANDT.

Dolphin and Neptune BATH HOUSES.

ON THE BEACH

PLUNGE BATHS NOW OPEN

New Bathing Suits.
New Dressing Rooms.
Careful Attendants.

Massage Treatment.

Hot Salt Water Baths at All Hours
je12-tf

LEFT: Plunge baths, massage treatments, and new dressing rooms—the Dolphin and Neptune Bath Houses had it all, as advertised in the *Santa Cruz Sentinel*, 1900.

FOR WINTER WEAR

THIS STYLE!

Is extremely popular on the beach during this month, but for regular wear, one of

SKINNER'S SPRING SUITS

Would be about the proper caper.

Butterfield, Effey & Ready

82 Pacific Avenue.

LEFT: An advertisement in the *Santa Cruz Sentinel* illustrates a popular suit style for men, 1886.

SEASIDE STORE.

Bathing Suits!

Ladies' Flannel Bathing Suits
Ladies' Alpaca Bathing Suits
Knit Bathing Suits for Boys and Men

FOR MAKING BATHING SUITS.

Black Cotton Duck
Black Alpaca
Ladies' Cloths in all colors
Blue Flannels in cheap and medium grades
Trimming Braids in great variety

Samuel Leask,

96 and 100 Pacific Avenue SANTA CRUZ.

Opposite Court-House.

The Seaside Store, carrying a variety of suits and other accessories, advertised in the *Santa Cruz Sentinel*, 1900.

BATHING SUITS
—AND—
BATHING ACCESSORIES

There is as much difference between the right kind of Bathing Suits and the other kind as in any other kind of wear.

If you want the correct thing that is safe, sure and stylish, and that won't cause you a heartache when you get to the beach, come here for it.

A. C. SNYDER, 120 Pacific Av., Santa Cruz

A woman's suit and other bathing accessories are advertised in the *Santa Cruz Sentinel*, 1900.

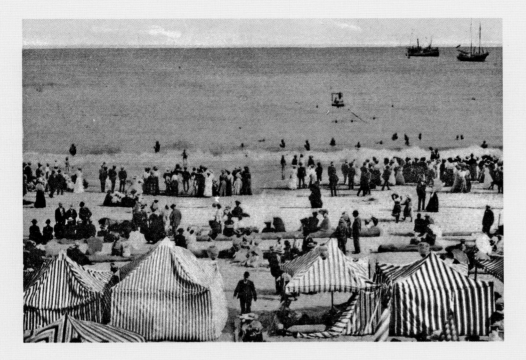

Lounging couples covered the beach in the summer of 1904. In order to relax in the shade, many people put up private tents.

An unusual sight in 1893, an adventurous woman swims far from the Santa Cruz shore.

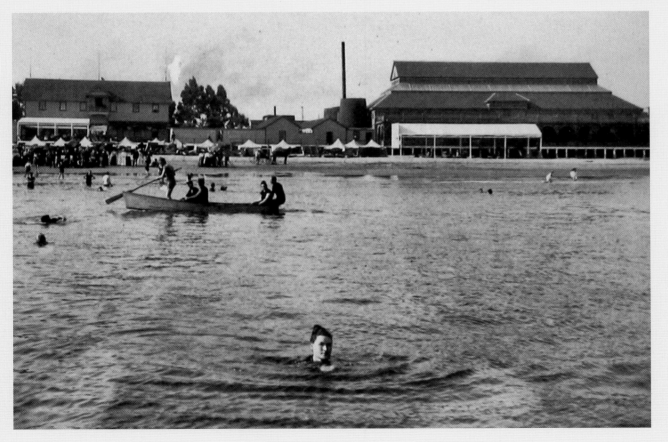

THE REMARKABLE
FRED SWANTON

No history of the Boardwalk, or of Santa Cruz itself, would be complete without an overview of the life and times of promoter extraordinaire Fred W. Swanton.

In 1866, when his family arrived in Santa Cruz, four-year-old Swanton was greatly affected by his first glimpse of this inviting land by the sea. At eighteen, he took his first adult job, and by twenty-one, Swanton had developed an all-consuming passion for promoting new ideas. In the early 1880s, he became fascinated with Alexander Graham Bell's discoveries and spent eighteen months trying to bring telephone service to several small California towns. The endeavor did not prosper. Unshaken by his lack of success, Swanton joined his father in building the Swanton House, the first three-story hotel in Santa Cruz. The building was destroyed in 1887 by a fire.

One year later, Swanton became lead agent for the Clingham Gas Machine, which was supposed to generate power from gasoline fumes; the machine was unsuccessful. Shortly thereafter, he tried his hand at show business at the Santa Cruz Opera House, bringing in professional acts from major theatrical circuits. Following this, Swanton sold and erected billboards in downtown Santa Cruz. At Beach and Cliff Streets, he put in a baseball diamond that he named Dolphin Athletic Park, which had seating for a thousand fans. By 1899, Swanton had brought several teams to the Dolphin Athletic Park, and he played a key role in making the teams part of the state league. Alas, the park was not profitable.

Swanton next opened the Palace of Pharmacy, where he sold drugs, toiletries, and fancy articles and operated a "swell" soda fountain. That lasted until he was hauled into court and fined for selling liquor without a license—even though he was quick to explain that the whiskey was sold for medicinal purposes only.

In the 1890s, fired with enthusiasm and eager for a new adventure, Swanton sold the pharmacy and began promoting California's first incandescent-lighting plant. He also got involved in bringing the electric railway to Santa Cruz and forming the Santa Cruz Swimming Baths Company—a company that never got off the ground. Swanton was also a financial backer for the Big Creek Power Company.

In the spring of 1903, Swanton set out in his old auto-mobile to invite eight Sacramento and San Joaquin Valley cities to compete in the Santa Cruz Seashore Concert Tournament. In late May, he headed up the New Santa Cruz, an organization promising subscribers "Eighty Consecutive Days and Nights of Entertainment" that would feature military and civilian bands on the beach and up-town. Swanton raised more than $2,000 in one hour. The season's total was $9,000. Also in 1903, Swanton formed the Santa Cruz Beach Cottage and Tent City Corporation and, for a building site, he acquired the Miller-Leibbrandt Plunge and bathhouse properties.

An ad in a San Francisco publication at the turn of the twentieth century trumpeted: "All Hail! Swanton Rex! Fred Swanton's first campaign for Santa Cruz was carried out in 1903. The results were marvelous. That year the railroads carried 25,230 more passengers than in 1902. The value of real estate on Pacific Avenue, the main street of Santa Cruz, has in the last five years doubled and tripled in price per front foot. Santa Cruz—Swanta Cruz—all the same."

In 1904, Swanton's promotional fervor brought even more tourists to the Santa Cruz beach and town. In fact, he convinced the Southern Pacific Railroad to lend him an entire train for an annual booster event that would attract people from around the state and beyond. Calling the runs "boomer trains," Swanton filled them with local business-men, merchants, a baseball team, and brass bands and toured the state distributing pamphlets and souvenirs. His goal was to make Santa Cruz "California's most popular playground."

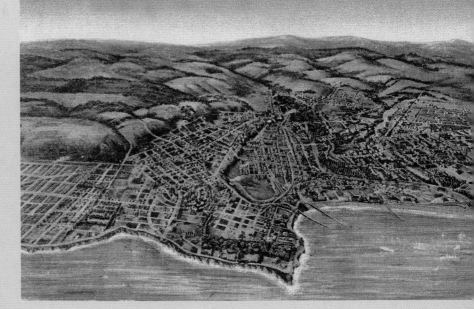

Postcard depicting a bird's-eye view of Santa Cruz, 1907.

The promoter extraordinaire, Frederick Wilder Swanton, in 1905.

FRED W.
SWANTON
"A CITY BUILDER"

SOLICITS YOUR SUPPORT FOR

MAYOR

CITY OF SANTA CRUZ MAY 3, 1927

Swanton was elected mayor of Santa Cruz in 1927.

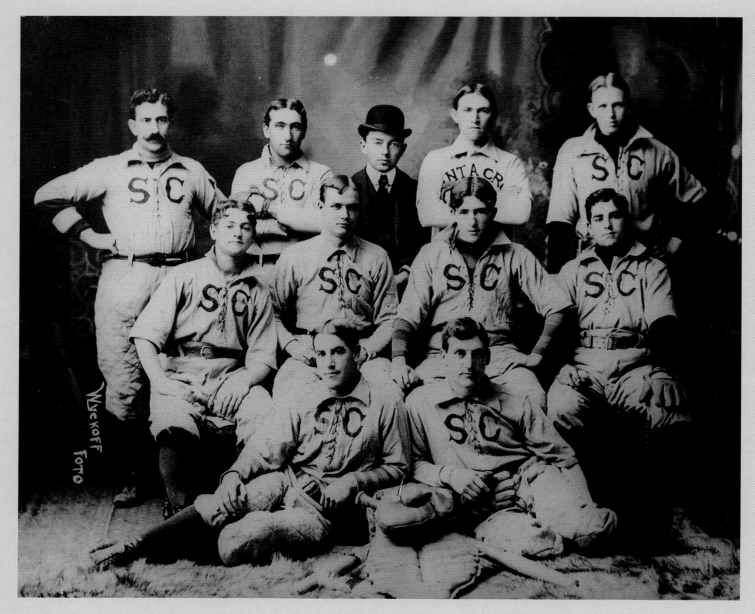

A Santa Cruz baseball team, circa 1899.

A 1906 advertisement from the *Santa Cruz Surf* announces "Baseball at the Beach."

OPENING OF DOLPHIN PARK!

Sunday, November 7th.

Santa Cruz vs. Santa Clara.

Game Called at 2 P. M. Band in Attendance.

ADMISSION, 25 CENTS.

ABOVE LEFT: This certificate represented shares in the Santa Cruz Beach Company, formed in 1906, of which Swanton was a founder.

ABOVE RIGHT: A November 1897 advertisement in the *Santa Cruz Surf* newspaper celebrates the opening of Dolphin Park.

RIGHT: In 1903, Swanton met and entertained President Theodore Roosevelt at a Big Trees park barbecue. When a reporter from the *Santa Cruz Sentinel* asked the president if everything was to his satisfaction, Roosevelt smiled and replied, "Dee-lightful!"

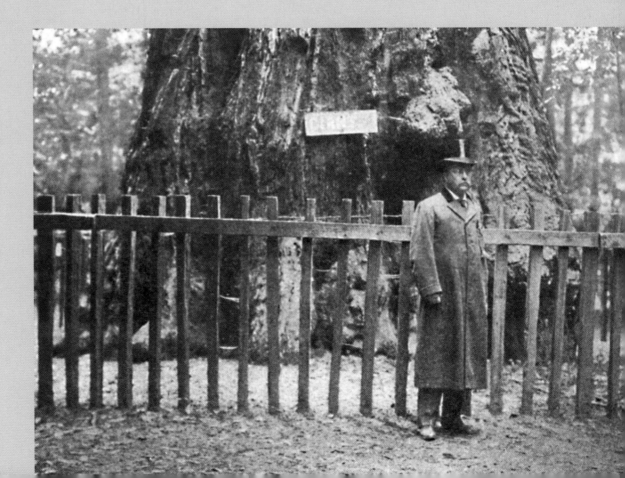

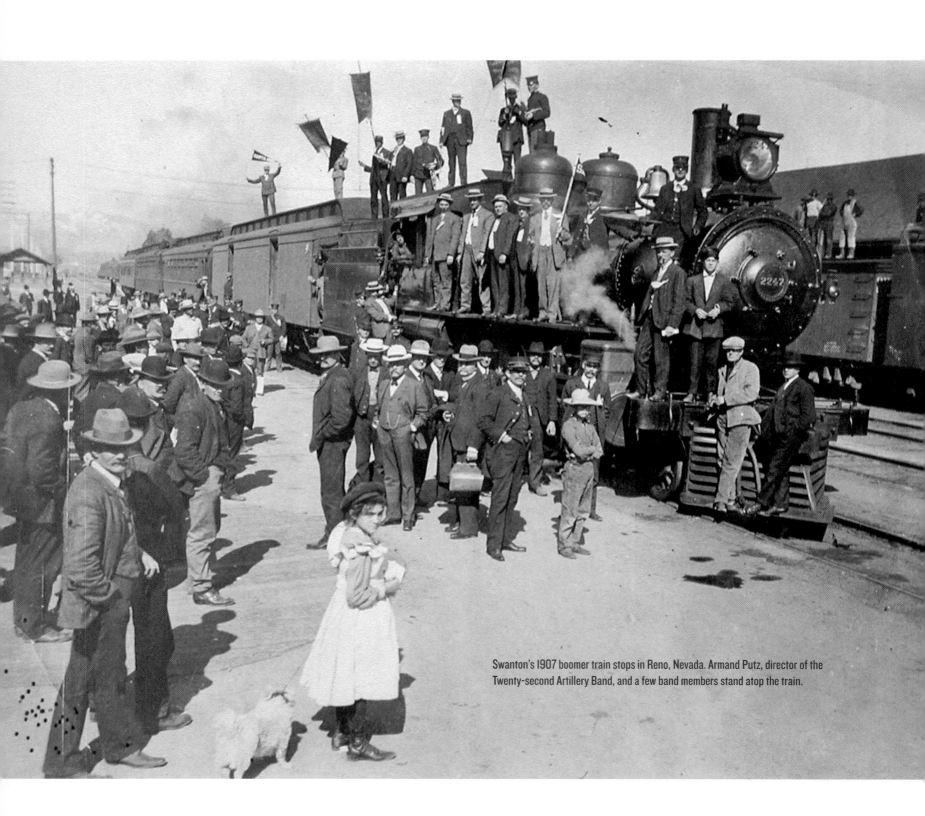

Swanton's 1907 boomer train stops in Reno, Nevada. Armand Putz, director of the Twenty-second Artillery Band, and a few band members stand atop the train.

BOOMERS BOOST SANTA CRUZ

Boomer train excursions were an annual event from 1904 to 1912, with the exception of 1910, when labor union problems stopped them in their tracks. Chairman Fred Swanton made good use of this elaborate advertising scheme. Trains traveled throughout Bay Area counties, the Sacramento and San Joaquin valleys, and as far east as Reno, Nevada. One of the onboard bands would parade down the main street, serenading the local mayor, and saluting the newspaper. Swanton would issue an enthusiastic invitation to all to join the fashionable fun-and-sun-seekers in Santa Cruz.

The boomer trains sometimes stopped at as many as three towns a day, and Swanton arranged for entertaining events at each stop. The 1911 train carried forty musicians—in addition to the Royal Hungarian Orchestra. Thirty-five thousand red parasols were distributed to onlookers, and twenty-five thousand free thirty-two-page booklets advertised the virtues of Santa Cruz, with flatter-ing photographs and lavish language. And at night—what else?—fireworks.

A thirty-foot banner, five silk flags, and eighty pennants declaring "Never a Dull Moment" flew above the marching bands, publicizing the pleasures of life at the beach. Ten thousand whistles imprinted with the snappy slogan "Blow into Santa Cruz" were distributed to children. Swanton's events were so momentous that school was often let out for the train's arrival.

One year, the Southern Pacific Railroad supplied a five-coach train that Swanton loaded with two brass bands, a number of Santa Cruz's civic leaders, advertising men, and enough souvenirs, streamers, and pamphlets to capture the attention of townspeople elsewhere in the state, to entice them to "the Vacationer's Paradise." A 1908 boomer train carried the Sand Crabs, a local Santa Cruz baseball team, along with the Beach Band and the Third Artillery Band. Swanton's booster trains were the perfect attraction for a nation fascinated with parades and public promenading.

SWANTON DRAWS CELEBRITIES

As promoter, investor, officer of the company, major beach attractions operator, and five-term mayor of Santa Cruz, Swanton welcomed the great and famous to town and to his home.

Captain Roald Amundsen, Norwegian polar explorer

Susan B. Anthony, women's rights champion

Andrew Carnegie, "the Steel King"

William F. "Buffalo Bill" Cody, world renowned showman

James J. Corbett, heavyweight champion

Brett Harte, nineteenth-century literary giant

William Randolph Hearst, newspaper magnate

Kalakaua I, King of Hawaii

Ignacy Jan Paderewski, world renowned pianist

Mary Pickford, motion picture star

President Theodore Roosevelt

John Philip Sousa, bandmaster and composer

William K. Vanderbilt, railroad magnate

Boomer train ribbons like this one from 1906 were created by the Santa Cruz Entertainment Committee.

COTTAGE AND TENT CITIES AT THE BEACH

The railroads brought tourists, but what the community wanted most was for vacationers to come and *stay*. In 1903, Fred Swanton came up with the idea of building a cottage and tent city at the beach. With the cooperation and support of the Southern Pacific Railroad, by March of that year, 111 men were working on Tent City. The tents were wood frame at the base, with three-foot wainscoting, and canvas above, which was painted with multicolored stripes. When viewed from the Santa Cruz hills, the tents produced a lively rainbow effect. By June, Tent City was in operation, and its 220 tents had the luxury of electric lights. Occupancy was on the rise.

Cottage City began to replace the tents with 150 new bungalows in 1907. Each cottage had one to four rooms and was built at an average cost of $100. A single room built on an old Tent City platform cost $65. The city of little cottages could accommodate seven hundred vacationers. From the *Santa Cruz Surf* newspaper, April 30, 1907: "The Tent City of last year is the Cottage City of this, solid and roofed buildings of small dimensions taking the place of tents. These cottages are varied in outline and painted in different colors giving a very picturesque effect to the 'city.'"

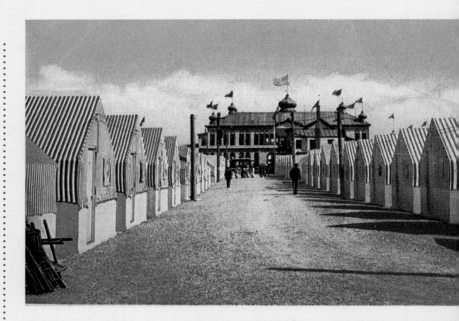

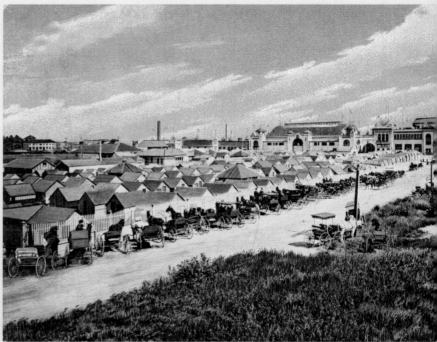

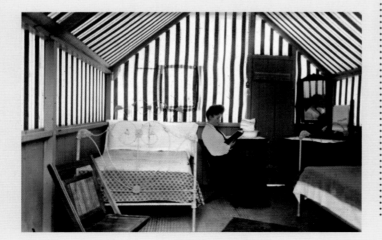

TOP : By June 1903, Tent City was in operation, despite its lack of landscaping.

ABOVE: In 1907, visitors arrived at Cottage City by horse-drawn carriages.

LEFT: An interior view of a funished tent, circa 1904.

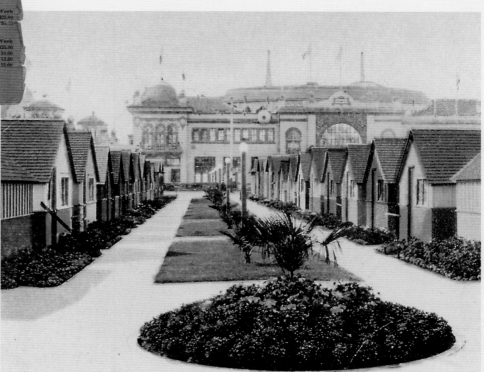

COTTAGE CITY

SANTA CRUZ, CALIF.

Located directly across Esplanade from Beach and Casino Boardwalk, adjacent to Casa del Rey Hotel.

ONE ROOM COTTAGE	Day	Week
One person	$1.00	$ 5.00
Two persons	1.50	7.50
Three persons	2.00	10.00
Four persons	2.50	12.50

TWO ROOM COTTAGE	Day	Week
Four persons	$3.00	$15.00

FOUR ROOM COTTAGE	Day	Week
Four persons	$5.00	$25.00
Six persons (or more)	7.00	35.00

HOUSEKEEPING COTTAGES	Day	Week
One person	$1.50	$25.00
Two persons	2.00	10.00
Three persons	2.50	12.50
Four persons	3.00	15.00

For further information address:
SANTA CRUZ SEASIDE COMPANY

TOP: A young Skip Littlefield (in short pants) stands in front of the Cottage City office in 1912. Littlefield went on to promote the beach and Boardwalk for more than fifty years.

ABOVE: Cottage City rental rate card, date unknown.

RIGHT: By 1912, Cottage City had such amenities as a sidewalk, grass, and palm trees.

THE FIRST CASINO:
THE MAGNIFICENT NEPTUNE

It was June 1904 and Santa Cruz Beach was alive with a blare of music, a blaze of rockets, and the boom of bursting bombs in a brilliant fireworks display. It was the grand opening of Fred Swanton's Neptune Casino—a Moorish-style wonder and a wedding cake of a building.

Under nineteen onion-shaped domes, and through an array of intricately embellished arches, the lavish Victorian interior accommodated concessions, a ballroom, and a theater. The Miller-Leibbrandt Plunge stood just to the east. Fluttering flags filled the sky during daylight hours, and at night two thousand incandescent lights created a vision of dazzling electrical splendor.

The upper floor of the Casino featured a first-class restaurant and grill, whose chef hailed from the renowned San Francisco Palace Hotel. Within weeks of the opening, the Neptune Casino was fairly bustling with a Druid convention. Tent City and the nearby Sea Beach Hotel were packed. Swanton's dream of building an Atlantic City on the Pacific Coast now seemed increasingly possible, as he proclaimed Santa Cruz "The Queen of Summer Resorts!"

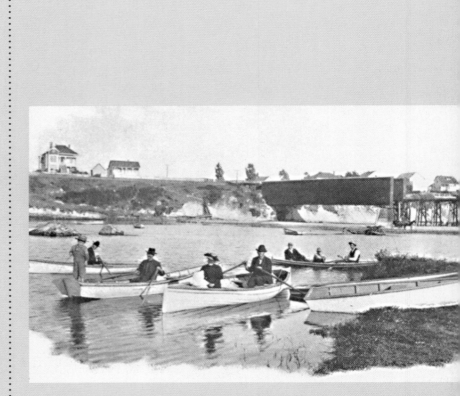

Vacationers enjoy boating on the San Lorenzo River.

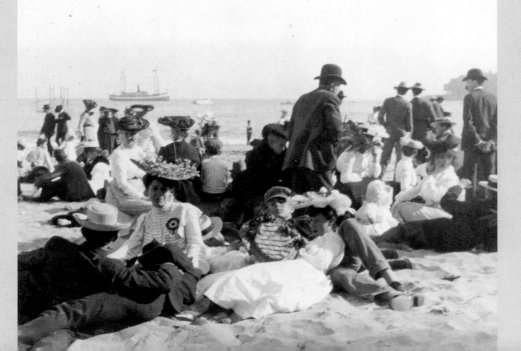

In the era of the Neptune Casino, lounging on the beach was a full-dress affair, 1904.

The Neptune Casino incorporated Moorish-style design elements taken from the Alhambra Palace in Spain. On the beach, awnings provided shaded areas for the public's comfort. A fish pond concession (at right) offered additional amusement. On the far left, up on a hill, is the Sea Beach Hotel, 1904.

A WORLD OF PLEASURES

It wasn't long before the spectacular Neptune Casino attracted visitors from around the globe. With them came interest from varied and unusual concessionaires, like William Lemos, an early Santa Cruz commercial artist who opened a studio at the Casino. The Hanly Baths, a Santa Cruz institution known to footloose and fancy-free vacationers for massage and podiatry services, became the first certified first-aid headquarters on the beachfront. The baths featured fresh and saltwater Turkish baths, electric tubs, electric vibrations, and medical gymnastics, which were exercises claimed to promote health or cure disease. In addition, a physician specializing in plastic surgery and skin diseases was always in attendance.

Businesswoman Mary Jane Hanly endeared herself to three generations of beach and Plunge lifeguards who went to the woman they called the "Mother of the Boardwalk" with their troubles after instances of drowning. She would patiently listen and offer understanding. In 1910, Hanly established an eight-room sanitarium on a bluff overlooking the bay, and in 1924, she endowed a new hospital at the same location. Many new births to Santa Cruz familes occurred in Hanly Hospital, and some of these children became the next generation to work at the Boardwalk.

On the Fourth of July in 1904, Southern Pacific trains brought more than eighteen thousand celebrants to the new Casino. The day began with a balloon ascension, followed by a sack race, a pie-eating contest (boys only), a cracker-eating contest (girls only), a nail-driving contest (gents only), a sawing contest (ladies only), a tug-of-war, and a catch-the-duck race.

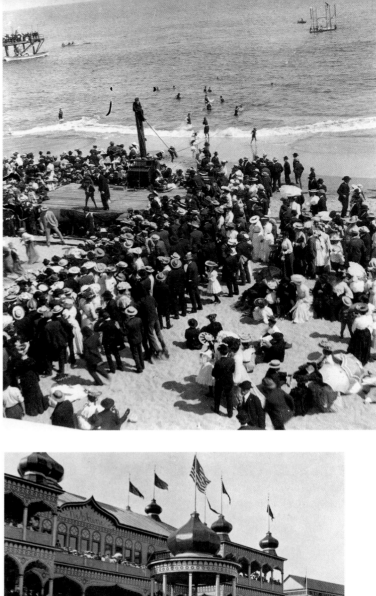

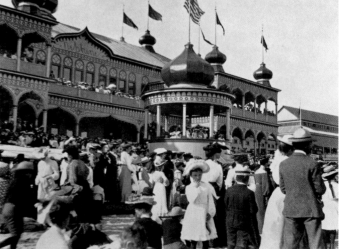

TOP: A 1904 summer crowd watches a sack race on the Casino beach. Other entertainment included swimming with a sturdy safety line that ran out to a raft.

ABOVE: The ladies of the Omega Nu sorority (seated in the bandstand) and the crowd watch the finish of a sack race, 1904.

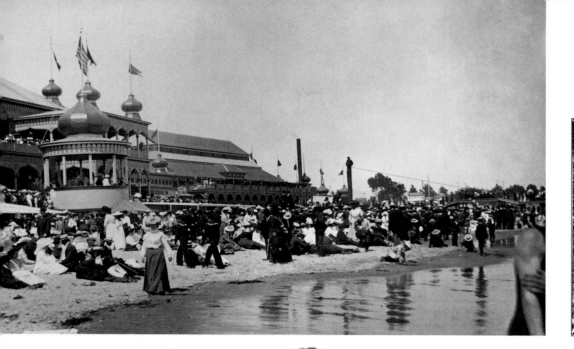

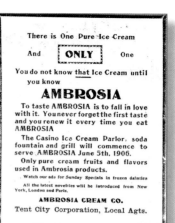

There is One Pure Ice Cream

And **ONLY** One

You do not know that Ice Cream until you know

AMBROSIA

To taste AMBROSIA is to fall in love with it. You never forget the first taste and you renew it every time you eat AMBROSIA

The Casino Ice Cream Parlor, soda fountain and grill will commence to serve AMBROSIA June 5th, 1906.

Only pure cream fruits and flavors used in Ambrosia products.

Watch our ads for Sunday Specials in frozen dainties

All the latest novelties will be introduced from New York, London and Paris.

AMBROSIA CREAM CO.

Tent City Corporation, Local Agts.

ABOVE: A section of the wide steps on the beach side of the Neptune Casino led down into the onion-domed band-stand. When not in use for concerts, the bandstand was an excellent spot from which to watch happy social activities on the beach. Streetcars and horse-drawn conveyances deposited friends, neighbors, and vacationers; small tents gave shelter from the sun and a place to visit; and inside the Casino, there was a restaurant and concessions for entertainment and souvenirs.

RIGHT: On opening night of the new roller rink at the beach, in 1906, famous Canadian speed skater Harley Davidson gave an electrifying performance of fancy skating. The high point was a sensational leap over five chairs.

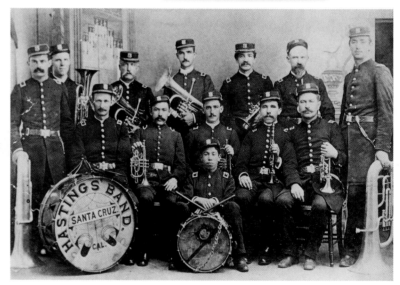

TOP: An advertisement entices beachgoers to visit the Casino Ice Cream Parlor, 1906. The parlor burned down eighteen days after the grand introduction of ambrosia ice cream. It was opened again a few days later, in a building that escaped the devastating fire.

ABOVE: Professor George Hastings (seated far right with his E-flat cornet) and band (wearing Civil War–style band uniforms) played Santa Cruz beach concerts and dances for more than a decade. As a boy, he had been a cornet player with the Montgomery Queen Circus when it first came to town in 1872. Hastings liked Santa Cruz so much, he returned several years later and founded the Hastings Band. The large drum shown in this 1886 photograph (bottom left) is now in the Santa Cruz Seaside Company archives.

23

FIRE STRIKES

Disaster struck in the early morning hours of June 22, 1906, at the beginning of the summer season. A towering fire of unknown origin raged through the Santa Cruz Beach area. Dawn revealed the extent of the terrible damage. In the smoking ruins were the remains of the lavish Neptune Casino as well as the Miller–Leibbrandt Plunge, the Dabelich food center, and the Tent City Restaurant. Only two years had passed since the elaborate opening. And now . . . rubble.

Even before the smoke cleared, Fred Swanton called a meeting of the board of directors of the Santa Cruz Beach Cottage and Tent City Corporation. The board decided to pay as many debts as possible, form a new company, and make plans for rebuilding immediately after the summer season. Financial backers for the newly formed Santa Cruz Beach Company included John Martin and Eugene de Sabla, San Francisco capitalists who were committed to Santa Cruz. Martin was named president of the new company, and Swanton was named director general.

The unstoppable Swanton took action to erect temporary structures near the remaining convention hall, skating rink, and Pleasure Pier. Three days after the fire, work started on the floor for a temporary pavilion to replace the destroyed Neptune Casino. The pavilion, a huge tent soon dubbed the Canvas Casino, had space for concessions, dances, concerts, and even the state's 1906 Republican Convention. Also quickly constructed were a temporary plunge open to the sky and a bandstand near the Pleasure Pier.

"Never a dull moment" had never been such an appropriate theme. The disastrous fire failed to keep the throngs from their beloved beach. Happy crowds came trooping to their favorite spots as regularly as ever—despite the temporary inconveniences and crowding. The appeal of amusements by the sea continued to draw folks from Santa Cruz and elsewhere who loved a beach holiday. They came to enjoy themselves, as they continue to do today.

OPPOSITE: The 1906 fire destroyed the Casino, its restaurant, and the Plunge.

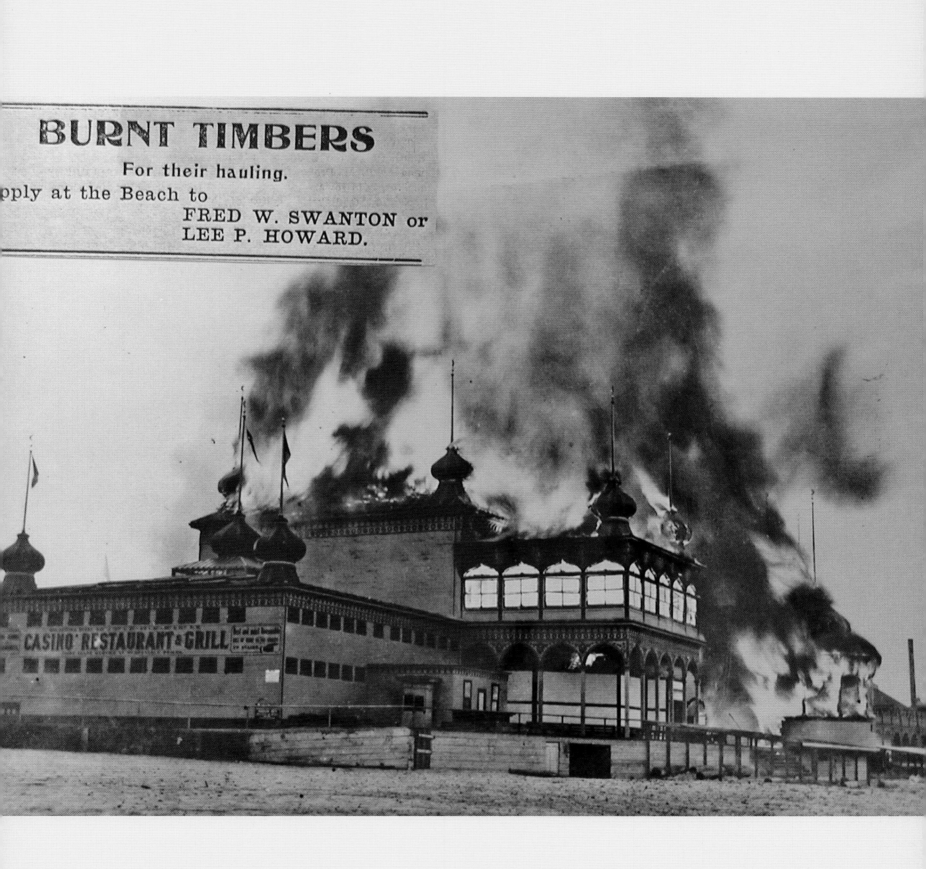

BURNT TIMBERS

For their hauling.

pply at the Beach to

FRED W. SWANTON or
LEE P. HOWARD.

CASINO RESTAURANT & GRILL

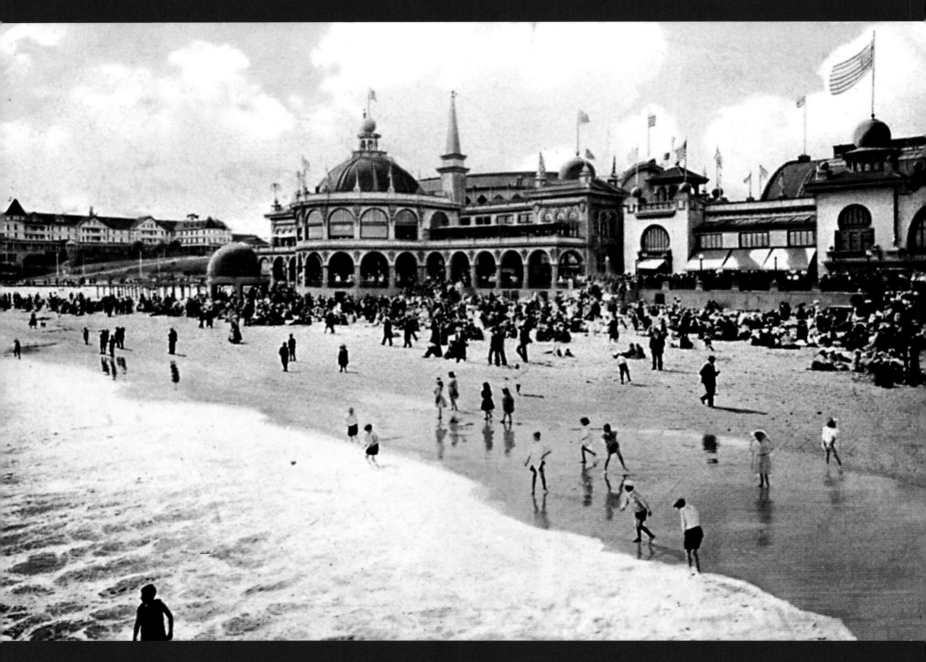

This postcard depicts the Natatorium, the Casino, and the Sea Beach Hotel along the Santa Cruz waterfront, circa 1908.

The Second Casino & the Birth of the Boardwalk

NOT EVEN A DISASTROUS FIRE could defeat Fred W. Swanton's dream. By 1907, Swanton was the director general of the newly formed Santa Cruz Beach Company, and he was forging ahead with the construction of a new casino as well as a concrete tank for a natatorium. Immediately after the fire, Swanton began advertising as if his revitalized tourist destination already existed. He produced red parasols, brochures, and postcards that residents were encouraged to send to friends and relatives. His advertisements featured renderings of the future Casino, and it looked even grander than the original. As construction progressed, fire prevention understandably was a high priority. Swanton went to enormous expense to install two thousand sprinkler heads and, for the new ballroom stage, an asbestos curtain.

The second floor of the Casino was dominated by a combination theater and ballroom, with twelve private boxes near the stage and dressing rooms for entertainers. Sometimes referred to as the Casino Theater, it was also used to host conventions. It could easily hold twenty-five hundred guests. On opening night, it glowed in tones of buff and crimson, making a lush background for the ladies' gorgeous gowns. In the impressive rotunda, there was the Casino Grill restaurant, which had a complete butcher shop in its kitchen. On the north side was a dining room for employees and band members. Imported Haviland china had been purchased for banquets seating up to 250 persons.

Bordering the Casino Grill was a series of private dining rooms, each distinctively decorated according to a theme: Arts and Crafts, Japanese, German, English, or Dutch Delft. In 1904, while vacationing in Waikiki, Swanton had envisioned the counterpart of a Waikiki hotel on Santa Cruz Beach and the Royal Hawaiian Orchestra playing in his new Casino as Hawaiian beach boys like Duke Kahanamoku performed aquatic feats in the new Plunge. On the Casino's opening night, the Royal Hawaiian Sextette was on hand to serenade guests.

Another of Swanton's trips, this one to San Francisco, had prompted the installation of two electric cash registers for the new Casino. Swanton also installed two thousand switches, which controlled a total of twenty thousand incandescent lights. Separated from the ballroom, a replica of New York's famous Waldorf-Astoria bar formed a forty-by-sixty-foot parallelogram of highly polished, Honduras mahogany, with a serving frontage of eighty-four feet. Inside the main floor entrance, to the right, were quarters for a hairdresser and manicurist, and to the left, a reception room for conventions. There was a penny arcade and an ice cream parlor with a tiled floor and opalescent glass

lamps. There were also booths for Western Union and postal wires.

The hand-painted walls and ceilings elicited oohs and aahs as guests entered the ladies' reception parlor and lavatory. From the esplanade entry, two grand stairways led upward. One took guests to the theater and grill rooms, the other to the office of Director General Swanton, whose ideas would continue to affect the seaside town of Santa Cruz for decades.

Here's what was happening:

1907	Color photography is invented. Henry Ford creates the first Model T.
1910	The concept of the weekend is established in the United States.
1912	The *Titanic* sinks. Arizona and New Mexico become U.S. states. Women's swimming and diving competitions are added to the Olympics.
1914	World War I begins. Keystone Studios makes its first movie with Charlie Chaplin, *Making a Living.* The Panama Canal opens.

The Canvas Casino and the temporary plunge baths opened about two weeks after the June 22, 1906, fire. Bathers used rows of small tents for dressing rooms.

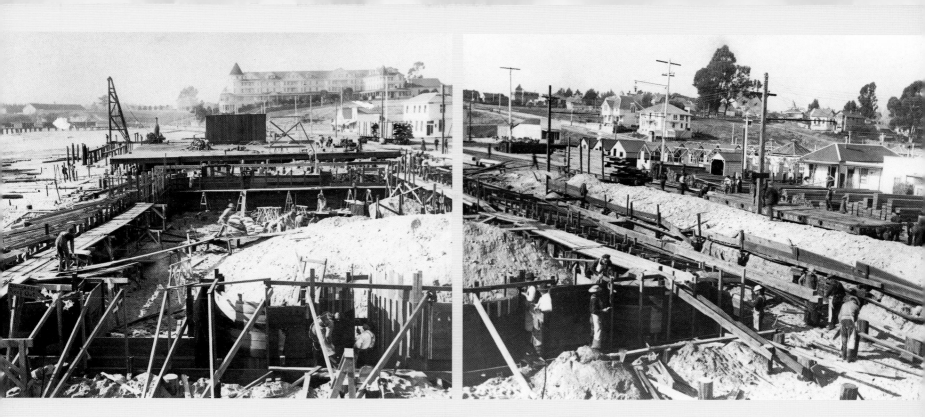

Cement forms are readied for the Natatorium, 1907. The Casino's deck is visible in the background.

CONSTRUCTION BEGINS

William H. Weeks, a local architect known throughout California, was hired to draw plans for the elaborate new Casino and Natatorium. Most important to Weeks throughout his building career were libraries and schools; he was known as the top architect of the Carnegie library buildings in California when that fortune was financing library construction throughout the country.

Although building plans were submitted to twenty-eight different contractors, few bids for the new Casino were received. With unpredictable weather, the shortages of building materials following the devastating San Francisco earthquake in 1906, a fluctuating stock market, and the Beach Company's June deadline, most firms were reluctant to undertake such a project. But Swanton was determined to complete his elaborate structure for the 1907

summer season, so he and the Beach Company acted as their own contractors. They hired day laborers for the job, and construction began on October 30, 1906.

More than five hundred laborers worked daily at the construction site, providing a boost for the employment rate in Santa Cruz County. Undoubtedly, those numbers were needed, as construction required the installation of 450 outside windows and doors, an elaborate sprinkler system, a 245-foot casino floor, balconies, arches, domes, and much more—in a little more than seven months.

The 1907 Natatorium's arched roof soared above the water's surface. The main pool, measuring 144 feet by 64 feet, featured a 40-foot slide with a thirty-degree angle. A smaller interior pool was intended for women, children, and nonswimmers. The arches and the second-floor spectator gallery were brightly lit with eight hundred electric lights. Gaslights were installed on the girders in case of power outages.

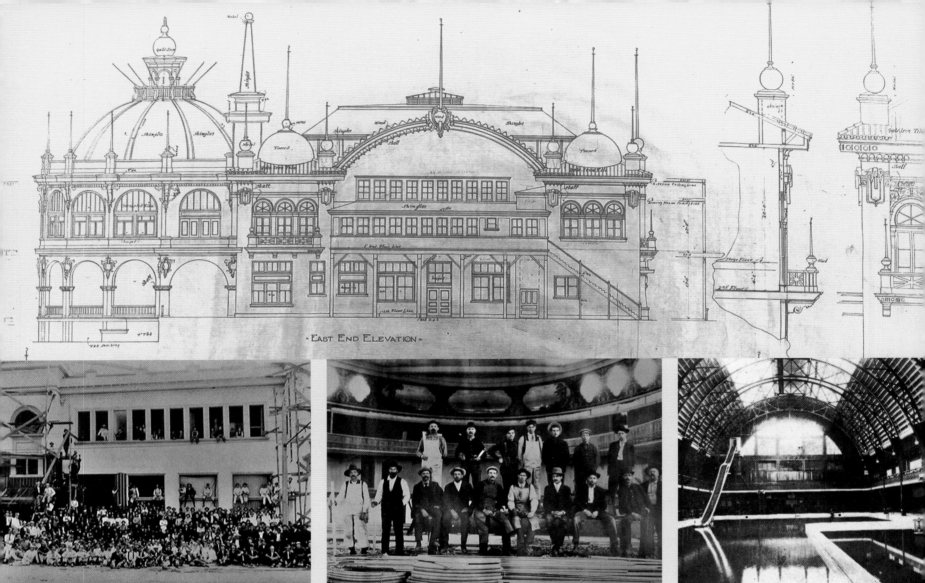

- EAST END ELEVATION -

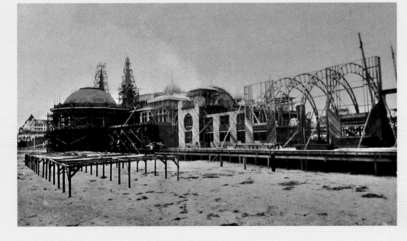

ABOVE: The Casino construction crew, also known as Swanton's Five-Hundred-Man Army, spring 1907. Journeymen carpenters wore white shirts to show their status.

Artisans and finish carpenters pose in the Casino's ballroom, May 1, 1907. The detailed flooring was composed of 1 by 2¼-inch maple strips.

The newly constructed Natatorium had slides for both pools and gaslights on the girders, 1907.

LEFT AND BELOW: With the new Casino dome in place, its silhouette is echoed by the repeated arches of the Natatorium, March 1907.

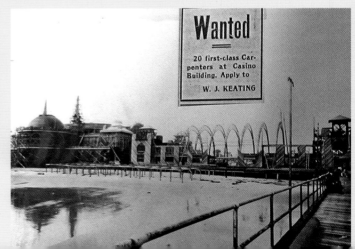

Wanted

20 first-class Carpenters at Casino Building. Apply to
W. J. KEATING

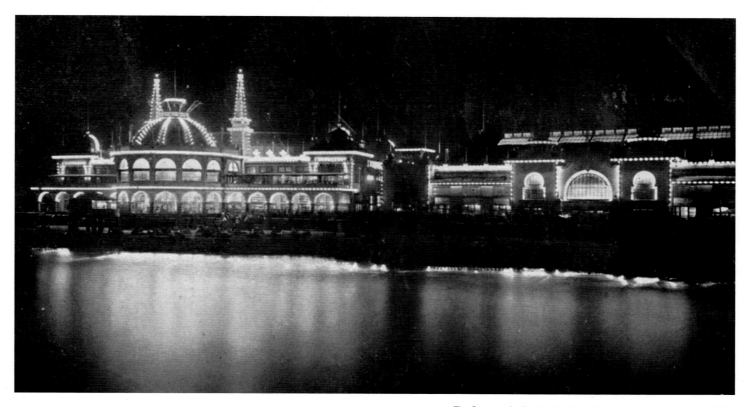

The Casino is bathed in the glow of thousands of electric lights, 1908.

THE GRAND OPENING

"The whole is bespatted with domes and minarets and pinnacles, towers and spires and flagstaffs, hung with flags, banners and pennants, until by count their number is 154."

—*Santa Cruz Shoreline,* 1907

It was June 15, 1907, and it was opening night—an unforgettable evening, according to a report by the *Santa Cruz Sentinel* the next day: "Thousands of people were on hand to marvel at the mighty structures illuminated by countless lights and fireworks. With the cream of society of the Golden West . . . the citizens of the city . . . were never in a more hopeful or jubilant mood than when on this memorable occasion they beheld the dreams of Director-General Fred Swanton. . . . Tears were seen creeping unconsciously in the eyes of many people, so overjoyed were they at real-izing what a great step Santa Cruz had just taken . . . from yesterday into today."

Everyone who was anyone attended the gala grand opening and inaugural ball. On this glorious night, the who's who list included such names as James Duval Phelan, the mayor of San Francisco; Louis Sloss, a prominent San Francisco merchant; the soon-to-be-senator Samuel M. Shortridge; and San Francisco tycoons A. P. Hotaling, Darius Ogden Mills, James C. Flood, and James G. Fair. When all was said and done, more than twelve hundred people had come to celebrate, and the congratulatory messages poured in, including wires from the governors of three western states and a telegram from President Theodore Roosevelt himself.

The new pride of the Pacific Coast boasted one of the biggest and most ornate indoor, heated saltwater pools ever to grace the shoreline. A larger-than-life statue of King Neptune stood on a Natatorium balcony. Nonswimmers could watch the splashing and merriment from the galleries.

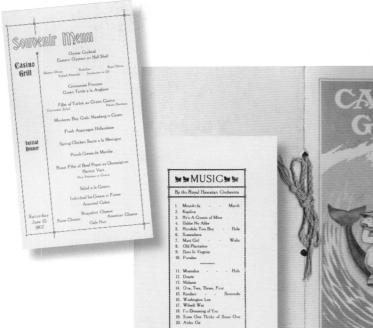

Souvenir Menu

Casino Grill

Oyster Cocktail
Eastern Oysters on Half Shell

Queen Olives Radishes Ripe Olives
Salted Almonds Anchovies in Oil

Consomme Princess
Green Turtle a la Anglaise

Fillet of Turbot au Gratin Casino
Cucumber Salad Potato Duchess

Monterey Bay Crab, Newberg in Cases

Fresh Asparagus Hollandaise

Initial Dinner

Spring Chicken Saute a la Meringue

Punch Creme de Menthe

Roast Fillet of Beef Pique au Champignon
Haricot Vert
New Potatoes in Cream

Salad a la Casino

Individual Ice Cream in Forms
Assorted Cakes

Saturday
June 15
1907

Swiss Cheese Roquefort Cheese American Cheese
Cafe Noir

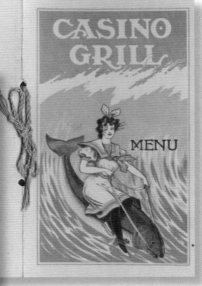

MUSIC

By the Royal Hawaiian Orchestra

1. Moanikeala - - March
2. Kapilina
3. He's A Cousin of Mine
4. Ualan No Alike
5. Honolulu Tom Boy - Hula
6. Somewhere
7. Maui Girl - Waltz
8. Old Plantation
9. Barn In Virginia
10. Paoakea

11. Moanalua - - Hula
12. Drarie
13. Malanai
14. One, Two, Three, Four
15. Kaiulani - - Serenade
16. Washington Lee
17. Wiliwili Wai
18. I'm Dreaming of You
19. Some One Thinks of Some One
20. Aloha Oe

CASINO GRILL

MENU

Ball and Dinner

On the Anniversary of the Burning
of the First Casino

Saturday Night, June 22, '07

Dinner $1.50 per plate
Admission to Ball 50 Cents

ABOVE: The Casino Grill served an anniverasy dinner one week after the Casino reopening.

LEFT: In 1907, the Casino Grill offered this souvenir menu to the grand opening attendees. The feast was prepared by chef Phil Jungman, fresh from San Francisco's Cliff House but also well-known for his stints at the Del Monte Club in Monterey, the University Club in Chicago, and the millionaires' Alto Club in Salt Lake City.

BELOW: This 1911 panorama shows the rebuilt Santa Cruz beachfront. The photograph was originally used on a four-panel chromocard.

Sea Beach Hotel Bandstand Casino rotunda Natatorium

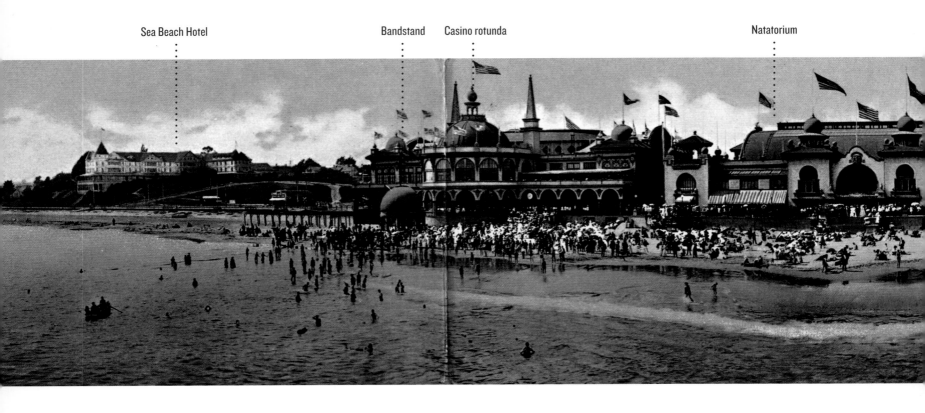

The Casino's grand ballroom featured a bandstand, balcony seating, and twelve private boxes.

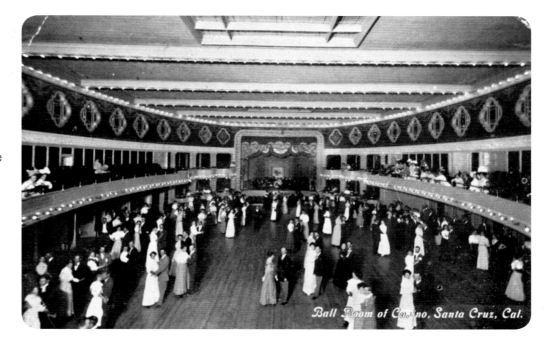

Ball Room of Casino, Santa Cruz, Cal.

BELOW: Some beach buildings escaped the 1906 fire, but others shown in this panorama were built between 1906 and 1911.

Japanese parasols for sale or rent

The Aquarium

Dance hall and skating rink

Dairy Kitchen

Bowling alley

L. A. Thompson Scenic Railway

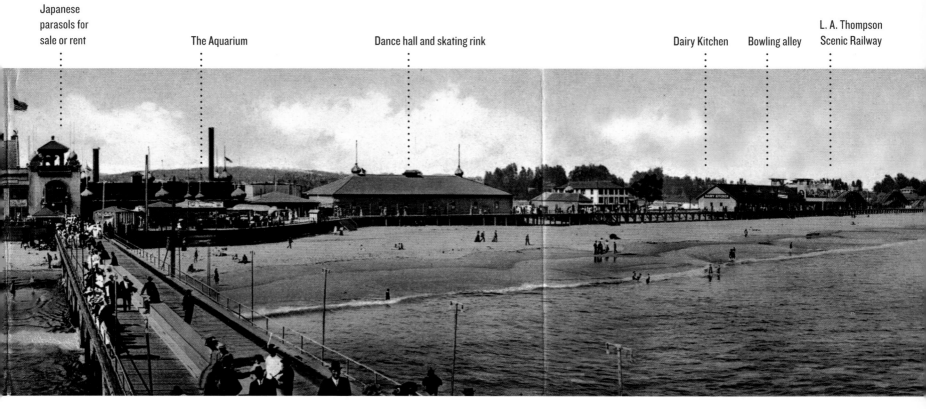

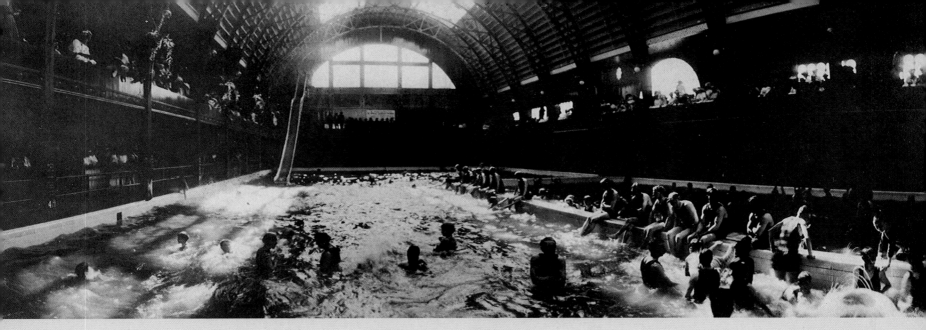

Spectators in the gallery watch the noisy hijinks in the eighty-three-degree saltwater below, 1907.

THE PHENOMENON OF THE NATATORIUM

It was big with an ornate exterior. It was a heated, indoor, saltwater phenomenon, and it fascinated swimmers and nonswimmers alike. With a decorative interior designed by John McLaren, a landscape designer associated with the famous Golden Gate Park in San Francisco, the new Natatorium (or the Plunge, as it was also called) was a spectacle unto itself.

But Fred Swanton also brought in aquatic attractions to guarantee crowds. One such example was Arthur Cavill, a man whose family was credited with originating the Australian crawl stroke. Another was Hawaii's legendary Duke Kahanamoku, the Olympic hero heralded as the greatest swimmer of all time. The crowds in 1913 were enthralled by Duke's aquatic prowess and his proclamation that the Plunge was his favorite pool.

Over its lifespan, more than seven million people frolicked in the Plunge. Some twenty-five hundred people could use the lockers and dressing rooms at one time, and thousands of towels and suits were on hand for rental. The pool's two tanks, with a combined capacity of 408,000 gal-

lons, were replenished daily with water from the famously chilly Pacific Ocean, which was heated from a breathtaking fifty degrees to a comfortable average temperature of eighty-three degrees. The ocean water, said to have healing properties, was pumped in to refill the tanks. In 1943, the local naval convalescent hospital at the Casa del Rey Hotel used the Plunge for patient therapy.

Generations of Plunge visitors from Santa Cruz and elsewhere fondly recall the Natatorium and its outstanding events. The nationally famous Plunge Water Carnival posted a sign saying "standing room only" every time the show opened. The Red Cross Learn to Swim programs were held at the Plunge starting in early 1941. Many Santa Cruzans can probably boast that they learned to swim there.

Changing times, waning attendance, and aging equipment precipitated the closing of the Plunge in 1962. Today the building holds the Neptune's Kingdom entertainment center with a miniature golf course.

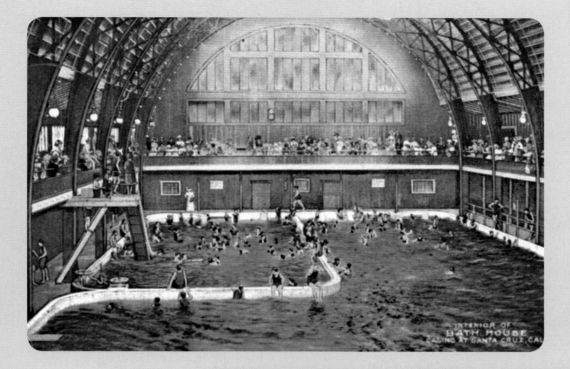

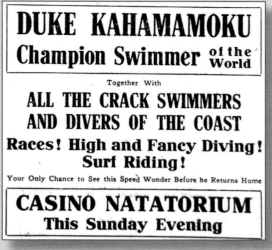

DUKE KAHAMAMOKU
Champion Swimmer of the World

Together With

ALL THE CRACK SWIMMERS
AND DIVERS OF THE COAST
Races! High and Fancy Diving!
Surf Riding!

Your Only Chance to See this Speed Wonder Before he Returns Home

CASINO NATATORIUM
This Sunday Evening

ABOVE LEFT: This 1907 postcard features the Natatorium's expansive interior.

ABOVE RIGHT: After Hawaiian Duke Kahanamoku's 1913 exhibition, bodysurfing and surfboarding became increasingly popular at Santa Cruz beaches.

RIGHT: A small interior tank was available for women and children, its depth ranging from two feet to five and a half feet, with a ten-foot slide.

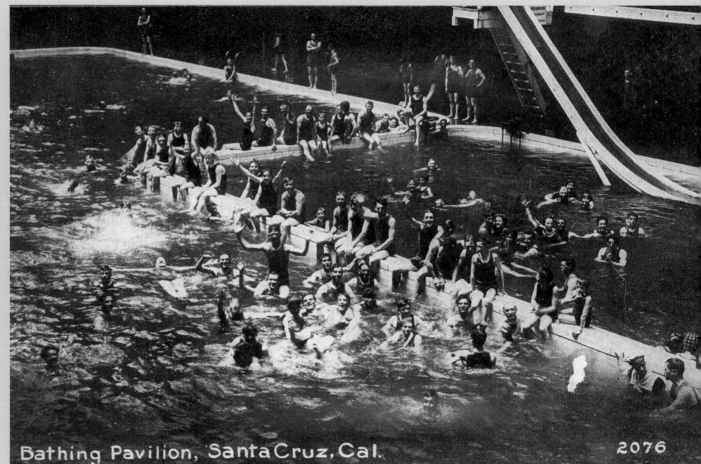

Bathing Pavilion, Santa Cruz, Cal. 2076

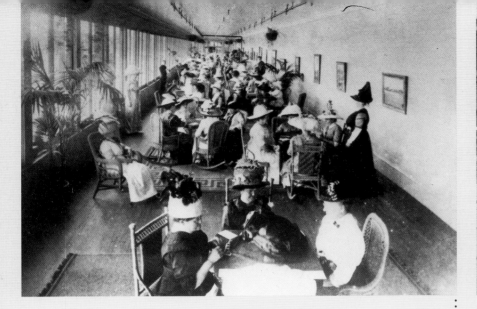

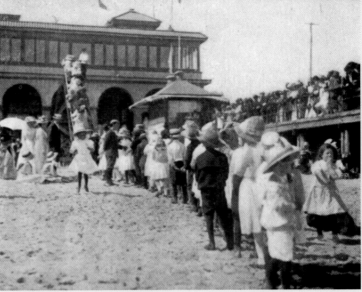

DREAMY DAYS ON THE SANDS

A typical summer experience in Santa Cruz was perfect for "dreamy days on the sands, launch rides on the beautiful bay, or a spin to the big ship *Balboa*." The Palm Court sunroom was a popular meeting place for ladies of the day. Ample hats seemed a required accessory, and the room itself was outfitted with wicker tables and chairs and potted palms. The long sun porch extended the full length of the adjoining natatorium, allowing plenty of visiting space.

Another important part of a day at the beach was the Pleasure Pier, built in 1904. It offered a place to stroll or greet passersby from metal settees installed along the railings. A large pipe ran down the center of the pier carrying ocean water to the indoor saltwater swimming pool, and pleasure seekers could take rides on Faraola Brothers launches. In 1925, summer rides were given on John Faraola's two speedboats, the *Spendthrift* and the *Vagabond*. A year later, William Johnson offered speedboat rides at the pier, and the Malio Stagnaro family did the same from 1931 to the early 1960s. Sadly, when the Plunge closed in 1962, the Pleasure Pier was dismantled.

Although Santa Cruz was the site of California's first Temperance Society chapter, founded in 1848, locally brewed beer proved popular. Even the Casino opened a saloon in 1910, which went out of business with the onset of prohibition in 1917.

On Sunday, August 12, 1907, the Santa Cruz Beach Company's glistening white pleasure ship, the *Balboa*, anchored a thousand feet offshore as launches ferried visitors back and forth for ten cents a ride. The three-masted, 207-foot beauty was built in Maine in 1874 and had been newly reconditioned. The motto of the *Balboa* was, "Everything to please—nothing to offend." In the center of the upper deck a canvas canopy covered the dining room and grill. Private eating quarters were at the stern and a buffet was laid toward the bow. The second deck held the *Balboa*'s 180 by 40-foot ballroom. The *Sinaloa*, a 70-foot, twin-screw gasoline launch was said to be the largest gas launch on the coast. It made daily two-hour runs to Monterey, returning to the dock at the Pleasure Pier early each evening.

In 1908, Teddy Roosevelt's Great White Fleet, with fifty ships and more than fourteen thousand men, could be seen from the Casino, anchored in the bay. Led by "Fighting Bob" Evans, a relative of Boardwalk founder Fred Swanton, the fleet became the first armada to circumnavigate the globe. From Lighthouse Point to Twin Lakes, twenty-five thousand spectators lined the coast. In town, on Pacific Avenue, a thousand schoolchildren carrying huge bouquets of flowers paraded for the occasion. Two days later, the excited children were welcomed as guests aboard ships of the fleet.

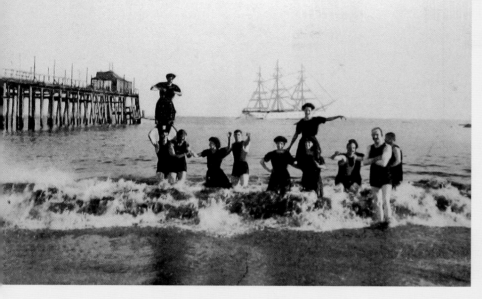

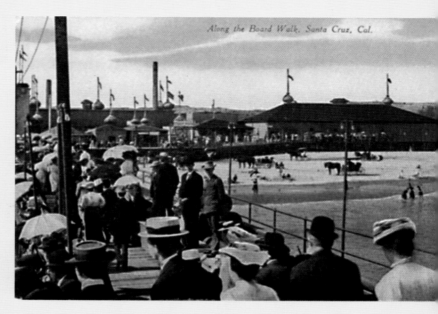

With the pleasure ship *Balboa* in the background, Norris and Rowe Circus performers pose in the Santa Cruz surf, 1907.

An essential part of the Boardwalk experience, the Pleasure Pier was built in 1904.

RIGHT: The local Santa Cruz Brewing Company brewed a popular Santa Cruz lager.

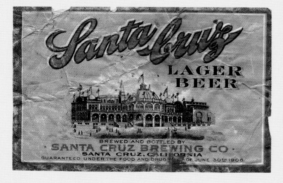

BELOW: Roosevelt's Great White Fleet is seen in the bay opposite the Casino, 1908.

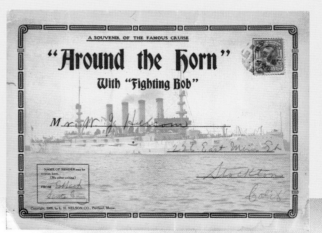

ABOVE: "Around the Horn" souvenir mailing cards were sent from Santa Cruz to friends and relatives who were not lucky enough to see the Great White Fleet in person.

SUITS THEM JUST FINE: BATHING APPAREL

Photographs of bathing beauties are an important part of any beach's history. Casino photographer and concessionaire William Scherer captured the latest in swimwear styles in 1907. The innovative sweater manufacturer Jantzen started with a wool sweater cuff in 1913 and developed the first elasticized swimsuit.

RIGHT: This bathing beauty may be displaying a racy look by wearing lacy stockings rather than solid woolen ones, 1907.

BELOW LEFT: Bathing "costumes" seems an appropriate term for these outfits, since few people could really swim well in them, 1907.

BELOW RIGHT: The reverse of this 1907 print reads: "Daring photograph by noted Santa Cruz photographer William Scherer."

MUSIC AT THE BEACH

There were few locales in 1912 whose appeal could compete with the sounds and activities on Santa Cruz beach. The Boardwalk was open all day and into the evening hours, and arriving crowds were greeted by rousing tunes from brass bands. Lighter popular songs might be played for those who chose to dance, and a wide variety of music entertained those seated before the big sound shell of the bandstand.

A typical Sunday afternoon concert might include "The Postillion," a waltz from the *William Tell Overture*; the Sousa march "El Capitan"; a selection from the *Wall Street Girl*, a popular musical at the time; and a Civil War song or a selection from Verdi's *La Traviata*. Even the Casino Grill offered live classical selections while guests enjoyed traditional dining fare.

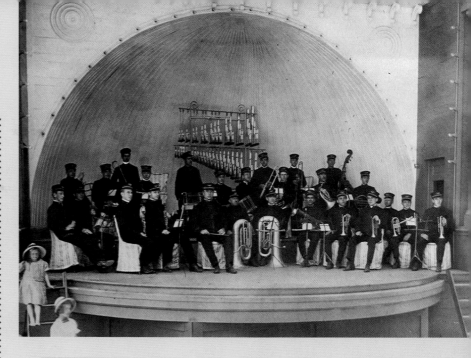

ABOVE: The Lou Williams Santa Cruz Beach Band may have been about to play the rag novelty "Never a Dull Moment," written by Henry Welch and dedicated to Santa Cruz Beach in 1912.

LEFT: This August 23, 1912, article in the *Santa Cruz Surf* described a Casino floor manager being arrested for ordering the band to play a rag.

CRUZ, CALIFORNIA, FRIDAY EVENING, AUGUST

ARRESTED FOR RAGGING

Rudy Casper Will Stand Trial Before a Jury

The first arrest under the antiragging ordinance was made at half past 12 yesterday morning at the Casino, when Rudy Caspers of San Jose, the floor manager, was taken in charge by Chief of Police Jones.

Caspers ordered a rag to be played by the band, and a number of couples were on the floor going through the mazes of the forbidden dance.

Some one stood below and notified Chief of Police Jones, who appeared, but just as Caspers was making his escape through the grill and archway. He was taken in charge and deposited $10 bail.

Today the charge was preferred against him.

This morning Caspers plead not guilty before Judge Stanley, and demanded a jury trial. The case was set for next Wednesday.

It is understood that Caspers, for the offense, has been released from his position with the Beach Company.

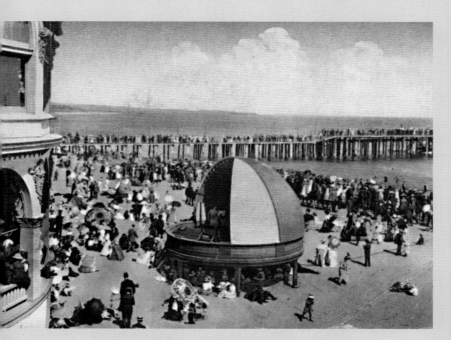

The crowd enjoys a band concert on the beach, circa 1910.

This bandstand photograph shows the railroad wharf in the background, 1911.

THE FIRST THRILL RIDE: THE L. A. THOMPSON SCENIC RAILWAY

Ladies tucked their skirts tightly around their ankles, and gentlemen firmly pulled their top hats down, anticipating the ride ahead on the nation's longest roller coaster. The beach's first thrill ride, a roller coaster known as the L. A. Thompson Scenic Railway, opened on July 1, 1908. The four-minute trip covered 1,050 feet of straight wooden track, plus the curves. Presenting this amusement ride was a sizable feat for Fred Swanton, costing a cool $35,000 to construct.

Since the speed limit on Santa Cruz city streets at that time was ten miles an hour, it was no doubt a thrill to go hurtling down the Scenic Railway's slopes at a reckless twenty-five miles per hour! In 1910, Buffalo Bill Cody's Wild West Circus rented the entire Leibbrandt tract of land for a late September show. Dozens of spectators climbed to the highest point on the Scenic Railway to watch the show. A few years later a daring young Laurence Canfield, future president of the Santa Cruz Seaside Company, and his cohorts rode their bicycles on the Scenic Railway.

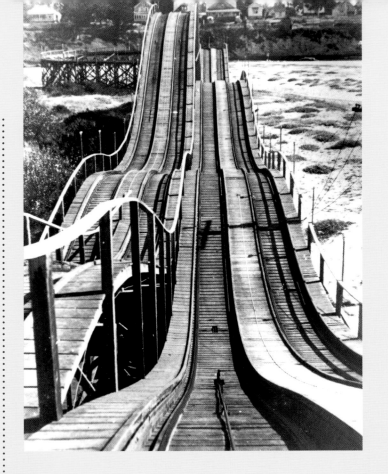

ABOVE RIGHT: Looking down the "drop" of the L. A. Thompson Scenic Railway, 1908.

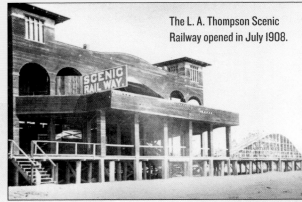

The L. A. Thompson Scenic Railway opened in July 1908.

An early type of roller coaster, the 1908 Scenic Railway was located at the present-day site of the Giant Dipper.

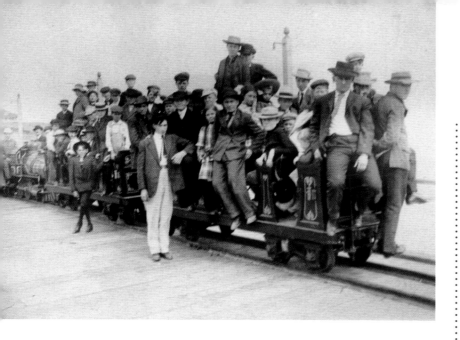

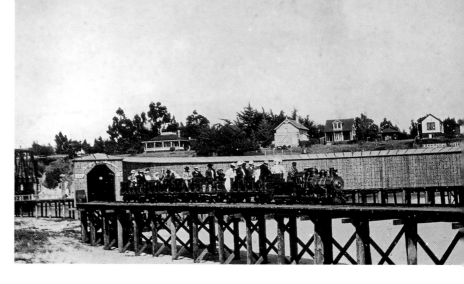

ALL ABOARD FOR FUN

For yet another Boardwalk attraction, Fred Swanton brought in a scaled-down steam train in 1907. The Ocean Shore Jr. Railroad could carry one hundred passengers, and the engine was so powerful, the train was used by logging and mining companies in the off-season. It's operation required a licensed engineer and fireman. The train followed a track that ran from the Pleasure Pier to the river, chugged through a tunnel turnabout, and returned to the pier. This small railroad was in operation until about 1915.

A second train, the Sun Tan Jr., operated by concessionaire Stanley E. Kohl from 1928 to 1933, was taken over by the Seaside Company, which continued its operation for about two more years. A third train, the City of Santa Cruz, a streamliner built by the Standard Welding Company of Santa Cruz, ran along the Boardwalk from about 1938 until the beginning of World War II. The train was losing money, however, and the track was taken out to make room for a series of stairways that offered beachgoers easier access to the coast.

A postcard of Fred Swanton's miniature steam train, originally called the Ocean Shore Jr. Railroad, records a July 2, 1907, special run. Most passengers were Southern Pacific VIPs. Swanton is fifth from the left.

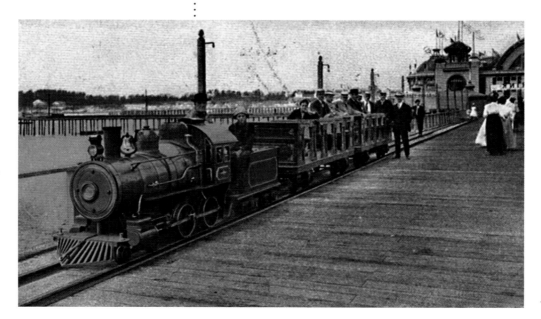

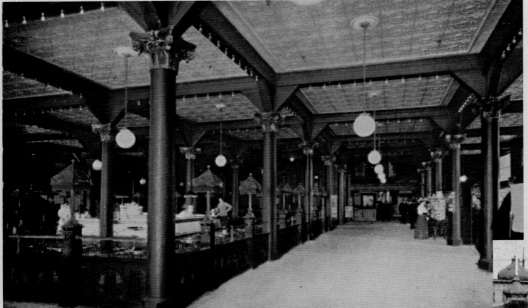

LEFT: On the left in this 1907 image of the Casino ground floor is the ice cream fountain, with its opalescent glass lamps and a tile floor that can still be seen in the arcade a hundred years later. On the right, a woman browses postcards at the Curio Store.

BELOW: A beachfront photography studio, 1912.

A WEALTH OF CASINO AND BEACH CONCESSIONS

By June 22, 1907, the Santa Cruz Beach Company accounts listed dozens of shops and concessions:

- a skating rink, an aquarium, and a merry-go-round
- a photograph gallery and a miniature railroad
- a haberdashery, a china hall, and jewelry and curio stores
- a newsstand and a cigar stand
- an ice cream parlor; candy, peanut, and popcorn stands; and a dry goods booth
- a penny arcade, a shooting gallery, and a fortune-teller's booth
- a Japanese bowling alley, archery, and a box ball court
- a laundry and a garage

- a massage parlor; a manicure and hairdressing shop; and a barbershop, which boasted "an automatic gas water heater and equipment equal to the best metropolitan establishments."

Then there were the convention hall, theater, restaurant, saltwater tub baths and plunge baths, Cottage City, the ship *Balboa*, and the launches. The Casino housed a Western Union office, ukulele store, branch of the public library, saloon, outdoor bandstand, the Sperry Flour demonstrator (who offered freshly baked scones), a gated soda fountain, and 150 oak-cased arcade machines. Perhaps most exciting was the Human Roulette Wheel, operated by A. E. Hawes. The wheel worked by manpower and centrifugal force, sending passengers whirling and sprawling from the center to the outer edge.

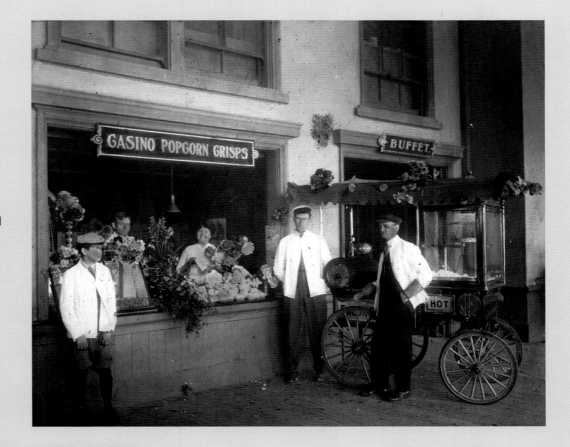

E. J. Mann's peanut and popcorn stand had a prime location in front of the Natatorium, circa 1908.

Painted backgrounds such as this one provided plenty of photo opportunities for Boardwalk visitors, 1912.

Goats, ponies, and even sheep were frequently used as photo props along the Boardwalk, 1911.

THE LOOFF CAROUSEL: A MARVELOUS MERRY-GO-ROUND

Whirligigs, roundabouts, carousels. Call them what you will, Americans were enchanted with the colorful carved horses, unforgettable calliope music, and brass ring tossing offered by early twentieth-century merry-go-rounds. In 1911, Charles I. D. Looff installed a dazzling new merry-go-round at the beach with polished brass, scores of mirrors, and elaborate decorative carvings. A well-known manufacturer of carousels, Looff had placed his first merry-go-round at Coney Island Amusement Park in New York in 1880. Today, the almost century-old carousel at the Santa Cruz Beach Boardwalk is still in operation gracing its original 1911 location.

A golden-age carousel, the merry-go-round features seventy-three hand-carved horses, each identifiable as a Looff original, and includes six attractive closed-mouth steeds, an uncommon style. Two chariots ensured that ladies of the early 1900s could observe modesty and safety by not having to ride sidesaddle or sit astride the horses. The seventy-one "jumpers" move up and down, while the remaining two are stationary "standers."

The Boardwalk's merry-go-round is also notable in that it's a "pure" carousel, meaning that all the horses were produced by the original company. It's one of only a handful in existence featuring a ring machine. For every 6.5 people who ride it today, 1 person walks off with a ring—that means seventy thousand rings must be purchased every year to replace them. The rings are taken home as souvenirs, and filching a ring is nothing new. A photograph from 1911 clearly shows a sign pleading, "Please do not take rings!" In the 1970s the rings were briefly discontinued at the carousel, but only very briefly, as ridership plummeted by about 75 percent.

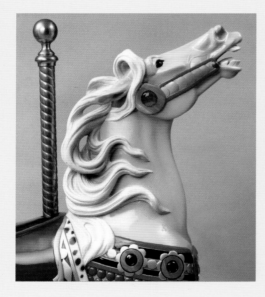

From 1911 to 2007, each original carousel horse has traveled a distance equivalent to circling the globe twelve times.

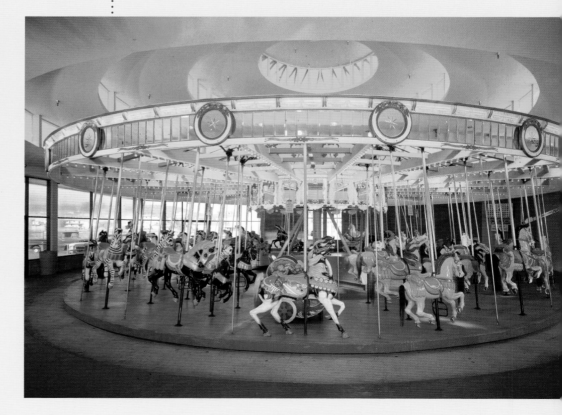

Dear Sirs:

I have to apologize for a momentary lapse of conscience. My husband and I went to the Boardwalk to celebrate our 45th Anniversary. I wanted to ride the carousel. I took one of the rings as a souvenir but it has bothered me ever since. I've taught my children not to do things like this and I would have been disappointed in them if they had done this. Please forgive me.

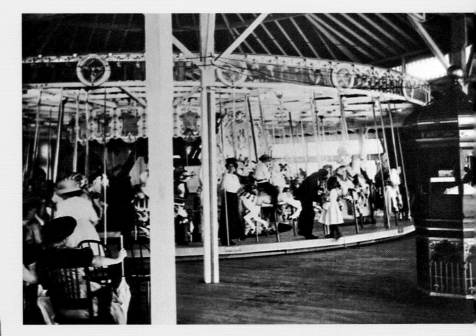

LEFT: An anonymous note, sent to Boardwalk management in the 1990s, reveals that taking a merry-go-round ring as a souvenir can lead to years of guilt.

ABOVE: In 1911, a hundred rocking chairs (far left) were placed in the carousel building, so that mothers could rest and enjoy the music as their children galloped the horses.

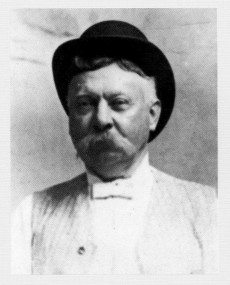

ABOVE: When European furniture carver Charles Looff immigrated to the United States, he was asked for his middle name. Having none, he was told he had to have a middle name for the purposes of "ID," so he made the letters part of his name on the spot. Photo circa 1910.

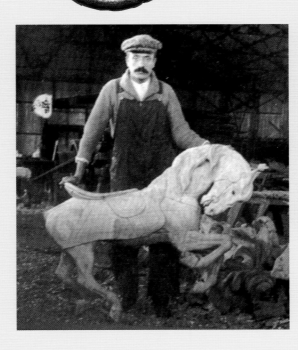

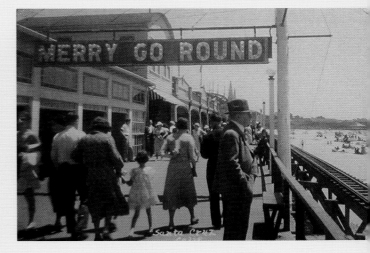

ABOVE: The Boardwalk carousel drew many admirers, 1930.

LEFT: A craftsman shows the dedication to detail necessary for the creation, maintenance, and repair of the magnificent carousel horses, 1915.

THE CASA DEL REY HOTEL IN 1911

By September 1910, when it was becoming obvious that the Beach Company's revenues were not meeting expectations, Fred Swanton announced that part of the fault lay in the "appalling lack of hotel accommodations. Santa Cruz's three leading hotels do not have the capacity of more than 500 people. [Something must be done, as] the Potter Hotel at Santa Barbara handles 700 visitors. The Del Monte Hotel across the bay can cater to 1,000."

On October 24, 1910, it became official: the San Francisco firm of Rickon and Ehrhart, general contractors, was awarded the bid to build a three-hundred-room hotel across from the Casino on Beach Street. It had a rumored budget of half a million dollars and an unbelievable six-month deadline for completion. Four days later, teams of horses began pulling down the 225 Cottage City structures; ten days later, all the cottages had been demolished and the new hotel site was ready for construction.

Later that year, according to an article in the *Santa Cruz Surf*, "Enough bonds have been subscribed to guarantee erection of the buildings. . . . S.F. capitalists are enthusiastic over the new venture." With funds secured from banks,

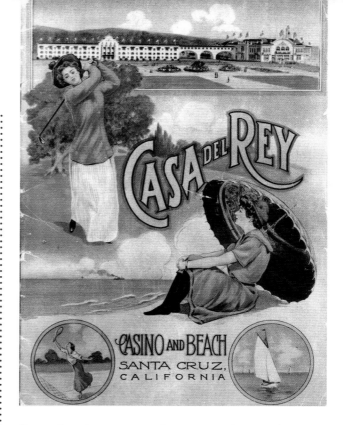

RIGHT: This 1911–12 booklet, copublished by the Santa Cruz Beach Company and the Southern Pacific Railroad Company, sings the praises of Santa Cruz and its attractions with words in verse accompanying each photograph.

BELOW: This custom fob and Casa del Rey room key were found before the 1989 demolition of the grand old hotel.

Santa Cruz investors, and Swanton's financial angels, the grand hotel would be built. Eugene de Sabla, a major investor, named it "Casa del Rey"—House of the King.

January 1911 brought a formal announcement in the news media accompanied by an artist's rendering of the hotel showing a bridge spanning Beach Street. With the six-month completion date not far off, additional workers were hired, including forty plasterers, twelve lathers, ten painters, forty carpenters, sixteen cement workers, and twenty-five laborers. Hotel rooms were completed at the astonishing rate of twenty-five a day.

The eagerly awaited Casa del Rey Hotel was scheduled to open on June 3, 1911. As the *Santa Cruz Surf*'s lead article that day stated: "No longer a dream, no longer a scheme, no longer an expectation, but a real live hotel."

On Saturday, June 3, 1911, the Casa del Rey Hotel opened. Dining room rates were $2.50 a plate. Table service was ready for eight hundred guests, and Santa Cruz's mayor, George W. Stone, was the first to sign the guest book. A special streetcar connected all trains from the depot to the hotel, and a steady stream of motorcars rolled toward the Casa del Rey. By 6 P.M., people had to be turned

An artist's rendering of the Casa del Rey was used on a 1910–11 promotional postcard for the Southern Pacific Railroad Company. Wide avenues, palm-studded gardens, and two biplanes complete the idealized vision.

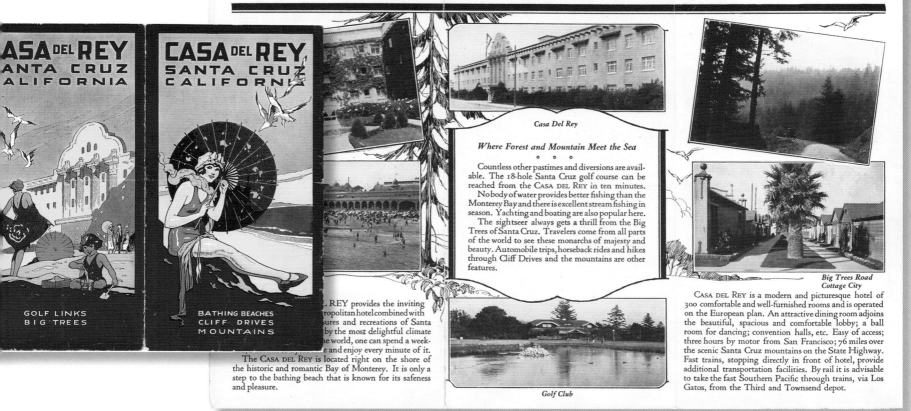

IDEAL FOR A VISIT, OR YOUR HOME BOTH WINTER AND SUMMER

CASA DEL REY
SANTA CRUZ
CALIFORNIA

GOLF LINKS
BIG TREES

CASA DEL REY
SANTA CRUZ
CALIFORNIA

BATHING BEACHES
CLIFF DRIVES
MOUNTAINS

Casa Del Rey

Where Forest and Mountain Meet the Sea

• • •

Countless other pastimes and diversions are available. The 18-hole Santa Cruz golf course can be reached from the CASA DEL REY in ten minutes.

Nobody of water provides better fishing than the Monterey Bay and there is excellent stream fishing in season. Yachting and boating are also popular here.

The sightseer always gets a thrill from the Big Trees of Santa Cruz. Travelers come from all parts of the world to see these monarchs of majesty and beauty. Automobile trips, horseback rides and hikes through Cliff Drives and the mountains are other features.

... REY provides the inviting ...ropolitan hotel combined with ...sures and recreations of Santa ... by the most delightful climate ... e world, one can spend a week- ... e and enjoy every minute of it.

The CASA DEL REY is located right on the shore of the historic and romantic Bay of Monterey. It is only a step to the bathing beach that is known for its safeness and pleasure.

*Big Trees Road
Cottage City*

CASA DEL REY is a modern and picturesque hotel of 300 comfortable and well-furnished rooms and is operated on the European plan. An attractive dining room adjoins the beautiful, spacious and comfortable lobby; a ball room for dancing; convention halls, etc. Easy of access; three hours by motor from San Francisco; 76 miles over the scenic Santa Cruz mountains on the State Highway. Fast trains, stopping directly in front of hotel, provide additional transportation facilities. By rail it is advisable to take the fast Southern Pacific through trains, via Los Gatos, from the Third and Townsend depot.

Golf Club

A 1920s brochure displays the many year-round activities available while staying at the Casa del Rey.

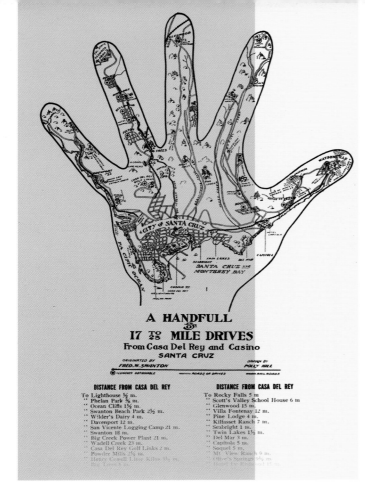

ABOVE: Produced by Swanton, a promotional booklet was published in 1911–12 by the Santa Cruz Beach Hotel Company, the Santa Cruz Beach Company, and the Southern Pacific Railroad. The outspread hand map showed Santa Cruz and the surrounding communities, calculating the distance for each point of interest from the Casa del Rey.

away. Many industry and business leaders were among the first guests, including sugar baron John D. Spreckles Jr.; *San Francisco Chronicle* publisher M. H. de Young; and John Martin and Eugene de Sabla, the future founders of the Pacific Gas and Electric Company.

In the coming years, famous visitors to the hotel would include the actors Mary Pickford, Cary Grant, Douglas Fairbanks, and Fred MacMurray; the director Cecil B. De-Mille; and the author and screenwriter Jeanie MacPherson. The comedian Bert Tracy made a movie at the Casa del Rey titled *His Weak End.* Many Miss California contestants were housed there, beginning with the 1924 pageant. Will Rogers, the treasured American humorist, and the actor Harold Lloyd, best known for his high-action comedies of the 1920s, also stayed at the hotel while attending a dog show in the Casino, in which Lloyd had entered three of his Great Danes.

The Casa del Rey Hotel stood proudly through two world wars, depressions, and many changes of management and ownership. The structure was demolished after it was irreparably damaged in the 1989 Loma Prieta earthquake.

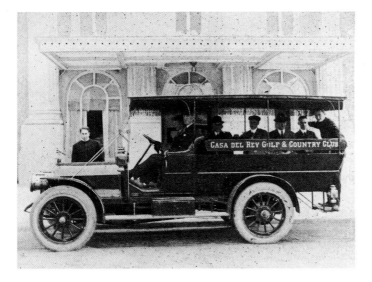

ABOVE: Through French doors, the Garden Room at the Casa del Rey opened onto two interior courts. Steps led down to Italian gardens designed by John McLaren of San Francisco's Golden Gate Park.

LEFT: Visitors to the Casa del Rey arrive in a bus that provided transportation from the hotel to the golf links, 1912.

THE CASA DEL RAY GOLF AND COUNTRY CLUB

Wasting no time, Fred Swanton next announced that the Casa del Rey must have a country club, golf course, and clubhouse. The *Santa Cruz Sentinel* ran the following exclusive: "The golf course will have 18 holes of play—one of the largest on the coast. Rincon Spring, with its 150,000 daily gallons of water, will be piped throughout the links, making it perpetually green. An automobile branch road . . . will run . . . to the clubhouse. Views from this location will afford vision to all 18 holes, as well as Santa Cruz, the bay and the San Lorenzo Mountains."

The Casa del Rey Golf and Country Club, which closed in 1935, was located a few miles northeast of the Board-walk. Now called Pogonip, the property is owned by the city of Santa Cruz.

In 1911, gentlemen golfers wore vests or sweaters and knickerbockers, while ladies wore toe-length skirts and fashionable hats.

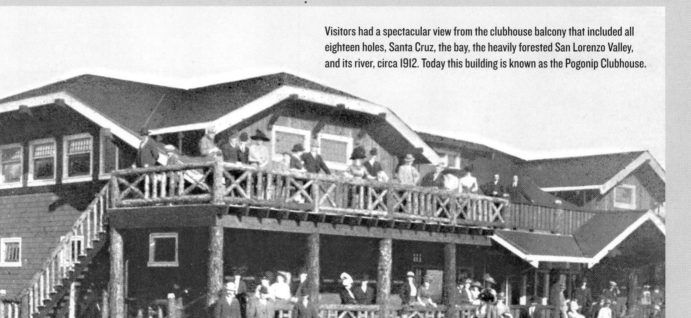

Visitors had a spectacular view from the clubhouse balcony that included all eighteen holes, Santa Cruz, the bay, the heavily forested San Lorenzo Valley, and its river, circa 1912. Today this building is known as the Pogonip Clubhouse.

THE ARCADE MACHINES: LOVE, STRENGTH, AND FORTUNE

Today's Casino arcade occupies the same site as the penny arcade that opened with the second Casino in 1907. Louis Sallee, the first signed concessionaire, made a handsome $12,000 investment in machines featuring palmistry, astrology, horoscopes, the latest musical hits, mechanical singing birds, moving-picture machines, an automatic rifle and pistol range, nickel slot machines, and more. For only a penny, the arcade was a great place to indulge your curiosity, to show off for your girl, or to bring to light a forecast of what your future might hold. A description, and even a picture, of a future wife or husband and children could be had for a penny. Who could resist? The prediction might answer an inner desire, or its foolishness might offer a chance to laugh and show what a good sport you were. Many antique arcade machines can be found around the Boardwalk today.

Moving-Picture Viewers

In the late 1800s, American Mutoscope and Biograph Co. of New York began producing a coin-operated movie viewer. The metal pre-1910 version was called a clamshell Mutoscope because of the large clamshell cast into the side of the machine; it displayed moving pictures while the viewer turned a crank. At the arcade's tempting Mutoscope, everyone from boys in knickers to matrons who had to hold onto their hat brims when peering through the viewer wanted a peek at something perhaps they shouldn't see. From their pulpits local ministers denounced the Photographic Bathing Girl Picture Machine.

Some fifteen hundred cards with photographs, displayed in rapid sequence, produced a flickering, live-action, motion picture. Subjects were Westerns like *Shooting Up the Town* or sports reels, comedy acts, and burlesque pieces. Some moving-picture machines sported such spicy titles as *The Ole Swimming Hole*, *Fan Dance*, and *The Nudist Colony*, but they rarely lived up to viewers' expectations. A fellow could hardly refuse the temptation to put a

FAR LEFT: The picture on the 1905 Ole Swimming Hole coin-operated movie viewer suggested a treat for the eyes that would not be delivered, but arcade visitors looked—just to be sure.

LEFT: The popular Mutoscope displayed moving pictures while the viewer turned a crank.

RIGHT: This moving picture machine tells a story of a crooked cop getting what he deserves.

nickel in the slot and turn the crank to see moving pictures with such titillating titles as *The Law Cheats Too* ≈ or ≈ *He Thought It Was Maid to Order . . . But Got Flatfoot Stew.* Due to the Mutoscope's lasting popularity, reproduction reels like a Charlie Chaplin cop movie are still being made and can be used in the original picture viewers.

Strength-Testers

Gents who fancied themselves he-men, or wanted to be, answered the call to prove it with machines that exhorted: "Squeeze the Handles to Test Your Grip," or "Lift the Handles and I'll Tell Your Strength," and even "It's Up to You: Test Your Lungs, Try Physical Culture" or, "For Chest Expansion, Practice Deep Breathing. Without Good Wind You Cannot Have Staying Power."

The strength-tester known as the Mickey Finn Tug-of-War was a combination grip and pull machine. If you pulled the tug-of-war rope to 750 pounds, a bell rang and a red devil popped into the window above Mickey Finn's head. Installation directions cautioned that the machine should be carefully screwed down, into a joist if possible, because of the terrible tugs it had to endure.

The High Ball Lung Tester was said to appeal to the sporting class. The ball in the upper section of the cabinet rose and fell, indicating pressure. One bulb in the circle of nine incandescent bulbs above would light at each additional fifty pounds blown in, and the bell rang when five hundred pounds was reached. The Exhibit Supply Company, who evidently expected this machine to be popular, promised a large money box and a nonclogging coin chute.

Called the Owl Lifter because of the casting of an owl's head above the dial, this penny strength-tester offered "practical physical culture" and invited users to test their grip and lifting power. Attempts were rated around the dial as "only the strong deserve the fair," "not quite good enough," "it won't be long now," and "fascinate the fair sex—a fine physique does it."

TOP LEFT: The strength-tester Mickey Finn Tug-of-War (an arcade machine made from 1904 until 1913) was a combination grip and pull machine.

TOP RIGHT: The High Ball Lung Tester appealed to "the sporting class."

BOTTOM: The penny strength-tester known as the Owl Lifter invited players to test their grip and lifting power.

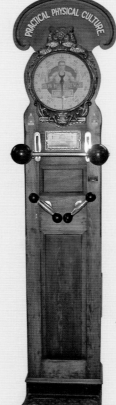

51

Fortunes: Love and Health

Originally produced from 1897 to 1904, the feline fortune-teller Puss in Boots would tell a customer their future for one cent. Puss in Boots would grant a card with personal details about your future mate. Cupid's Mailbox, a machine from 1904, taught arcade-goers how to signal their feelings to someone with eye flirtation: "Winking the right eye means 'I love you.' Winking the left eye means 'I hate you.' Winking both eyes means 'Yes.' Winking both eyes at once means 'You are being watched.' Winking the right eye twice means 'Sorry, I'm engaged.'"

At the genteel Lady Perfume Sprayer, made in 1905, a young lady could receive some assistance before socializing: "To perfume your handkerchief etc. Hold same over spray of lilacs in hand of figurine and drop one cent in slot of purse." Then, equipped with an enticing fragrance, she was ready for being sociable in the arcade.

The 1904 machine known as the Doctor claimed to work on one's health. The Doctor was said to "put new life in you." Its sign assured passersby: "Vibration is the law of life. This humming wonder will make you feel free as a daisy. Drop coin in the slot, and put the rubber to any part of the body, or to the face. This doctor charges one cent only. Other doctors charge two to five dollars for vibration. Do not fail to take this treatment daily."

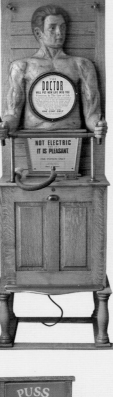

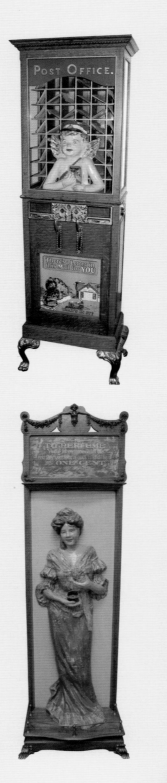

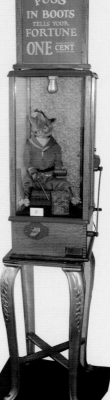

TOP LEFT: Cupid's Mailbox helped customer's negotiate their love life's most pressing questions.

TOP RIGHT: The machine known as the Doctor worked on the modern "science" of vibration.

BOTTOM LEFT: The Lady Perfume Sprayer of 1905 was popular with the arcade's young ladies.

BOTTOM RIGHT: For a penny, the Puss in Boots fortune-teller would reveal details about one's future mate.

DENIZENS OF THE DEEP

Some of the fish in Santa Cruz's waters were the biggest that tourists had ever seen. Giant groupers, ocean sunfish, octopuses, and sea turtles caught and put on display drew crowds of curious visitors. The Aquarium, built near the Casino in 1907, was filled with saltwater piped from the adjacent Pleasure Pier. It exhibited an array of marine life from Monterey Bay. This coupled with the opportunity to fish in the bay were even more reasons for newcomers to explore the Boardwalk and its environs. The U.S. Bureau of Fisheries eventually took over the Aquarium's operation and maintenance.

The capture of a giant ocean sunfish (*Mola mola*) and an octopus that measured twelve feet from tip to tip called for an exhibit of these two rarities, 1927.

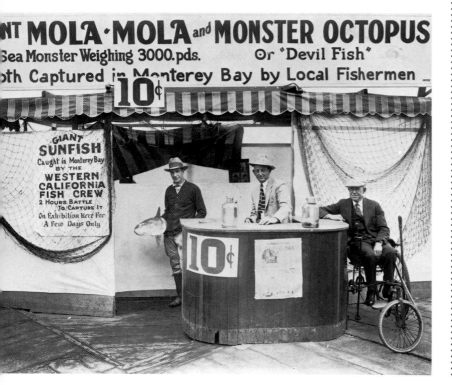

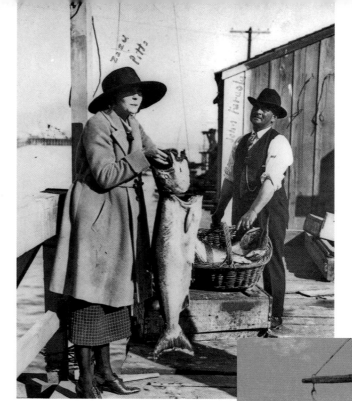

ABOVE: The actress Zasu Pitts poses next to a large salmon. Her admirer is John Faraola, who ran launches from the Pleasure Pier. In 1914, Pitts staged a benefit performance in Santa Cruz, using Fred Swanton as her agent.

RIGHT: A giant grouper caught by Louis Beverino in 1905 was displayed at the Pleasure Pier.

BELOW: A group waits near the Aquarium to ride the miniature steam train.

A BOUNTY OF BOARDWALK SOUVENIRS

Whether a reminder of a happy adventure, a gift for a friend or family member, or an object of envy to be displayed and delighted over, a souvenir was an essential part of any trip to the Boardwalk. Picture postcards were the most popular souvenirs, and there were hundreds to choose from. Inexpensive bric-a-brac, felt pennants, megaphones, or lapel pins might also fill the bill. And there were such quality items as decorative china and embossed or engraved silver spoons for collectors. Also available were memorabilia crafted by local artists, created using local materials: redwood, sea moss, mother-of-pearl, seashells, pressed flowers, and etched leather. Santa Cruz scenes hand-painted on redwood slices sold particularly well.

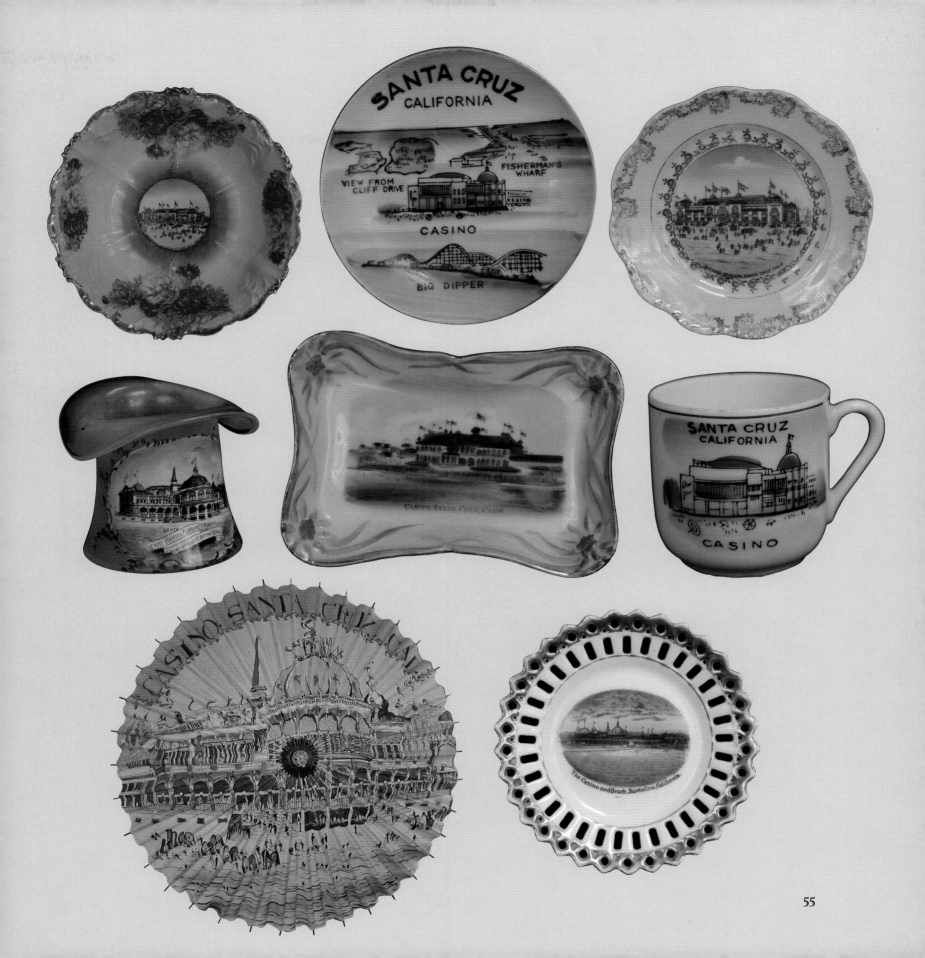

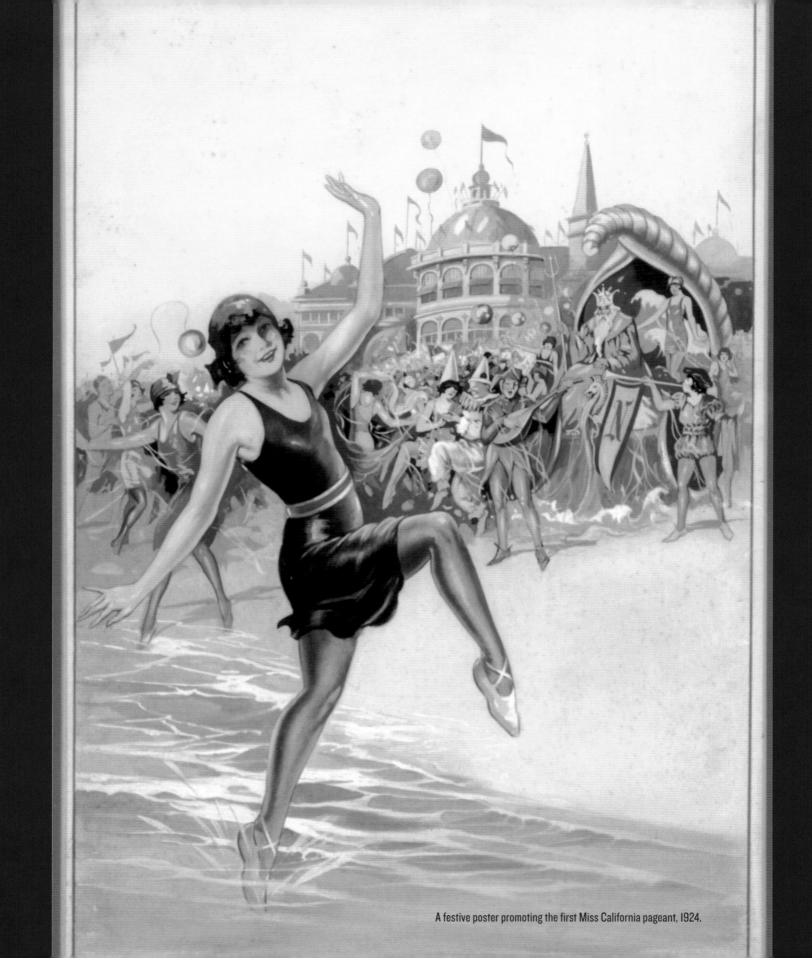

A festive poster promoting the first Miss California pageant, 1924.

The Santa Cruz Seaside Company

IN 1915, LOCAL BUSINESS experienced a downturn, and nowhere was it felt more than at the Boardwalk. The amusement park was faced with competition from the World's Fair in San Francisco and the effects of a declining economy. Consumer concern for the future affected tourism, as the idea of spending money on "playing" began to take on a frivolous note. The Santa Cruz Beach Company had gone bankrupt.

James R. Williamson and two other civic-minded gentlemen leased and guaranteed the operation of the Plunge, the Casino, and the ballroom, thus saving the beach enterprise. On December 12, 1915, a new organization, called the Santa Cruz Seaside Company, was formed. Its guiding purpose: "to furnish entertainment and amusements for individuals and the public." Stock held by the Santa Cruz stockholders represented only about one-seventh of the total. The remainder was held by out-of-town financiers. Williamson served on the board of directors for the new Santa Cruz Seaside Company for twenty-eight years, ultimately becoming president. His son-in-law, Wendell Van Houten, served on the board for three decades, and his grandson, James, currently serves on the board.

Soon, novel ways to attract attention and promote the Santa Cruz Beach Casino began to emerge. The hit of the summer season was the distribution of complimentary fresh flowers handed out personally by the wives of the Chamber of Commerce Board of Directors and the Ladies' Auxiliary of the Chamber of Commerce. A flower show and a spate of other attention-getting events were held at the Casino. It all seemed to work. The Seaside Company showed steady growth in the years that followed.

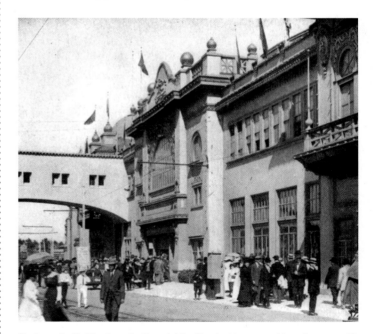

By the arched bridge from the Casa del Rey Hotel, visitors crowd into the street-side entrance that leads to the Casino's penny arcade and ice cream parlor, circa 1915.

TO PUT THINGS IN PERSPECTIVE

Here's what was happening:

1915 The Pan Pacific International Exposition opens in San Francisco. The first transcontinental telephone call is made.

1918 World War I ends.

1920 Prohibition begins. U.S. women gain the right to vote.

1921 Baseball's first radio broadcast takes place.

1922 The stock market booms.

1927 Charles Lindbergh makes the first nonstop transatlantic solo flight. *The Jazz Singer* hits theaters, the first motion picture with sound.

1931 "The Star-Spangled Banner" becomes the national anthem of the United States.

1933 Prohibition ends.

1936 England's Edward VIII abdicates the throne to marry an American divorcee, Mrs. Wallis Simpson.

1937 The Golden Gate Bridge opens to traffic.

1938 America is frightened by Orson Welles's radio broadcast of *The War of the Worlds*.

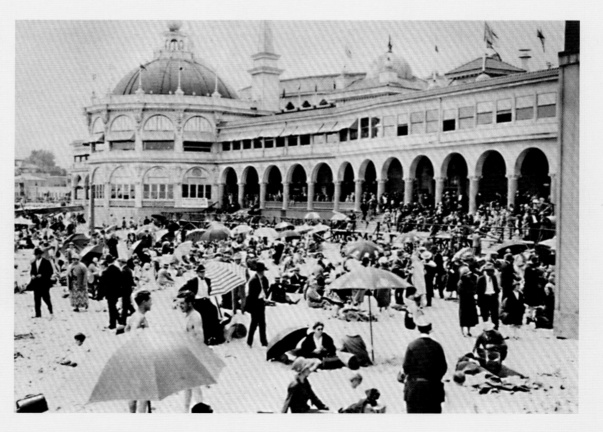

Proper beach attire in the 1920s was shifting from street clothes to swimwear.

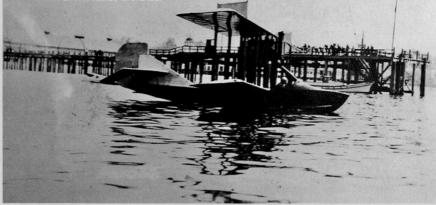

In 1917, a concessionaire offered airplane rides from the Pleasure Pier. These rides were risky and very exciting, since the planes had few instruments and no radios or brakes.

ON THE BOARDWALK

Beginning in 1915, with the opening of California's Highway 17, many long-term vacationers became day users of the Santa Cruz Boardwalk. Others took advantage of the casual accommodations of the new "auto courts," the forerunners of today's motels. In 1921, when the highway was finally paved with concrete, there was an even more dramatic increase in auto-oriented services and day-use facilities, such as restaurants and garages. People were on the move. That year the *Santa Cruz Sentinel* assured Highway 17 travelers: "If the speed limit of twenty miles per hour is held to, no road could be safer or more enjoyable."

By the 1920s, the Boardwalk was thriving, and streams of motorists traveled to the beach to ride the thrilling Giant Dipper, see the daring Miss California Pageant, and witness the lively Plunge Water Carnivals. M. C. Hall, an imaginative public relations man, was hired to promote appealing and compelling special events, which often received welcome national press coverage. As mayor of Santa Cruz, Fred W. Swanton was busy organizing car caravans and spreading the word about the lively town, extolled as "the land of a thousand wonders" in distributed literature. The police were occupied arresting men on the beach who insisted on wearing swimming trunks without their jersey tank tops.

FAR LEFT: Dorothy Carey and big sister Betty pose for a photo at a beach concession in 1925.

LEFT: Roller-skating was available at the Casino rink, as advertised in the *Santa Cruz Surf*, December 2, 1915.

BELOW: The Casino's theater offered such fare as the musical farce *So Long Letty*, as advertised in the *Santa Cruz Surf*, July 26, 1917.

59

PROF. KARNOH

THE WELL KNOWN TRANCE CLAIRVOYANT, PALMIST AND PHRENOLOGIST AT CASINO

Prof. Karnoh gives reliable advice on all affairs of life; all revealed nothing concealed. By his marvelous psychic power he has aided thousands to health, wealth and domestic happiness. If worried, unhappy, if anything goes wrong in your affairs, or young men or women try to decide on a life vocation; any or all who would increase their efficiency. Parents trying to understand their children; anybody or everybody heartsick or discouraged by failure. Prof. Karnoh will be pleased to consult with anyone. Located at **CASINO**, adjoining box ball. Hours 9 A. M. to 11 P. M. daily.

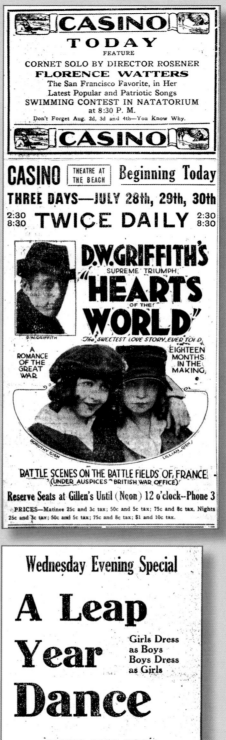

CASINO
TODAY
FEATURE
CORNET SOLO BY DIRECTOR ROSENER
FLORENCE WATTERS
The San Francisco Favorite, in Her Latest Popular and Patriotic Songs
SWIMMING CONTEST IN NATATORIUM
at 8:30 P. M.
Don't Forget Aug. 2d, 3d and 4th—You Know Why.

CASINO

CASINO — THEATRE AT THE BEACH — **Beginning Today**
THREE DAYS—JULY 28th, 29th, 30th
2:30 8:30 **TWICE DAILY** 2:30 8:30

D.W. GRIFFITH'S SUPREME TRIUMPH
"HEARTS OF THE WORLD"
The Sweetest Love Story Ever Told.
A ROMANCE OF THE GREAT WAR
EIGHTEEN MONTHS IN THE MAKING.
DOROTHY GISH LILLIAN GISH

BATTLE SCENES ON THE BATTLE FIELDS OF FRANCE
(UNDER AUSPICES — BRITISH WAR OFFICE)

Reserve Seats at Gillen's Until (Noon) 12 o'clock—Phone 3
PRICES—Matinee 25c and 3c tax; 50c and 5c tax; 75c and 8c tax. Nights 25c and 3c tax; 50c and 5c tax; 75c and 8c tax; $1 and 10c tax.

WANTED 50 BATHING GIRLS

For Moving Pictures **TODAY**

Five National Movie Companies will Photograph Bathing Girl Revue.

50 Extra Girls Wanted in These Pictures.

HAND NAMES IN AT CHAMBER OF COMMERCE BEFORE 12 O'CLOCK TODAY.

TOP LEFT: A 1917 *Santa Cruz Sentinel* ad touts the clairvoyant Professor Karnoh.

TOP CENTER: The director D. W. Griffith revolutionized the motion picture industry by altering camera angles in previously untried ways in such films as *Hearts of the World*, promoted in this 1918 *Santa Cruz Sentinel* clipping.

TOP RIGHT: The 1924 the *Santa Cruz Sentinel* advertised for "bathing girls," who were needed as extras in moving pictures.

RIGHT: The *Santa Cruz Sentinel*, June 7, 1924, advertised a "Leap Year Dance" to be held in the Casino ballroom.

FAR RIGHT: A 1921 advertisement for the beach announces concerts and dancing as well as saltwater tub baths, the Plunge, and the Scenic Railway.

Wednesday Evening Special

A Leap Year Dance

Girls Dress as Boys
Boys Dress as Girls

CASINO BALL ROOM and MARINE SALON

Kramer's Double Orchestra

Dancing Every Evening at 8:30 promptly.

Girl Revue De Luxe

9:15 p. m., 9:45 p. m., 10:15 p. m.
10:45 p. m., 11:15 p. m.

Attractive Specialties by Attractive Girls.

WHAT HO!

FOR THE BEACH
AL FRESCO CONCERTS
Every Night at 7:15

RIALTO DANCING—8 o'clock
PLUNGE—All Day

HOT SALT WATER TUB BATHS
Most refreshing after a hike. Prescribed by physicians for nervous or stomach diseases

SCENIC RAILWAY—Open All Day
BIG WEEK END FESTIVITIES

Holiday dance Saturday, September 2nd in Casino Ballroom and Grill
A Squawker Dance
Great fun, screams of laughter, the tourists' Eureka.

Second Annual Concessionaires' Fiesta
September 8, 9, 10

THE BEACH THE BEACH

HAM, HOT DOGS, AND ICE CREAM

Having fun went hand in hand with a healthy appetite, and the Boardwalk at Santa Cruz offered many delicious foods. Known as Sam the Ham Man, Sam Haberman ran one of the most popular booths in the early years.

Later, near the Pleasure Pier, Henry "Hot Dog" Miller set up his popular concession at the entrance to the colonnade. Miller's Original Famous Hot Dogs quickly became a Boardwalk institution. The purchase of a dog and a "cuppa java" was always served with salty commentary on the side: "Ah, hello dere. Come right in, young fella. Say, dat's a fine lookin' gal you got dere. Two hot dogs. You betcha. And help yourself mit mustard!"

Miller's friend and fellow promoter at the time, Stago Stagnaro, would help sell Miller's goods by means of the loudspeaker at Stagnaro's speedboat-ticket stand. One could often hear Stagnaro bellowing "A loaf of bread and a pound of meat!" to describe Miller's product, encouraging crowds to see if Miller would really fulfill the substantial promise.

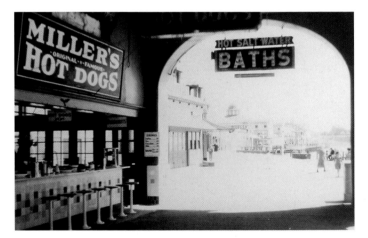

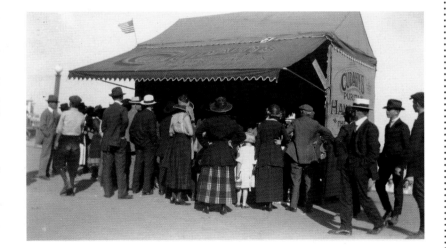

TOP: Henry "Hot Dog" Miller was a Boardwalk institution in the 1920s.

ABOVE: In 1927, Miller's famous hot dog enterprise was favorably placed at the entrance to the colonnade, leading to the Plunge; swimmers were always hungry for hot dogs.

LEFT: At the concession of Sam the Ham Man, customers spun a wheel in an attempt to win either a ham or a side of bacon, circa 1927. (Courtesy Special Collections, University Library, University of California at Santa Cruz)

61

In 1916, Adolph "Goldie" Goldstein, a butter maker by trade, opened the Sunshine Creamery in downtown Santa Cruz and produced everything in the front window of his establishment—in full view of the passing public. In April 1918, Goldstein was encouraged to start a concession at the beach. He opened Goldstein's Soda Fountain in the Casino and an ice cream cone stand in the Plunge building.

Ice cream was not Goldie's only interest. After enjoying success in the ice cream business, he branched out into heartier food, selling hot tamales for a dime in 1926. His advertising announced that his machine could spit out fifty tamales a minute. He also had an orange drink stand in the penny arcade, where his display of orange-colored liquid swirling through glass tubing was designed to make potential customers thirsty for his orange drinks. Perhaps best of all, Goldie invented the famous Sno-Ko machine. According to Goldie's son David, they sold twenty-eight hundred snow cones—at a nickel a piece—on July 4, 1927.

Goldie had his family to help him with his many enterprises. He was a great crowd-pleaser, a promoter, and a born salesman. He served as a director of the Santa Cruz Seaside Company and on the local Chamber of Commerce. He was even known locally as an accomplished amateur magician and once had himself locked in a safe at the *Santa Cruz Sentinel*'s office. Goldie opened the safe from the inside and walked out.

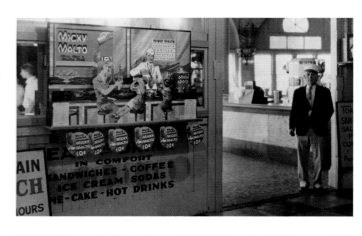

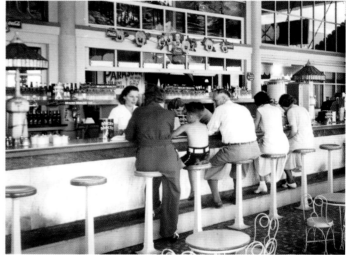

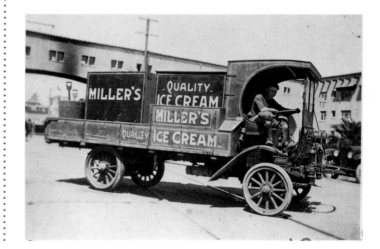

TOP: Goldie Goldstein stands in the entry of his soda fountain, circa 1928.

CENTER: Goldstein's soda fountain in the Casino rotunda, circa 1928.

BOTTOM: In the 1920s, Goldie's seventeen-year-old brother, Barney, made ice cream deliveries from Oakland to the family ice cream fountain at the Casino.

THE GIANT DIPPER

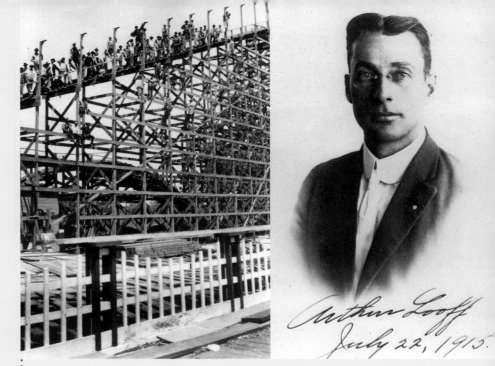

The Giant Dipper was built under the direction of Arthur Looff in 1924. His father, Charles I. D. Looff, a well-known manufacturer of carousels, had produced the merry-go-round installed at the Boardwalk in 1911. In June 1987, both the Giant Dipper and the antique carousel were designated as National Historic Landmarks by the U.S. National Park Service.

Arthur Looff's dream of building "a combination earthquake, balloon ascension, and aero plane ride" resulted in the 1924 roller coaster that still thrills today. Roller coaster buffs love the way the Dipper's cars dive from the loading station into the startling darkness of a tunnel. The red and white structure, with its spectacular view of Monterey Bay and successive dips and fan curves, has kept generations of riders coming back for more.

The Giant Dipper is also a media star. It can be seen in television commercials, videos, and movies, including *The Sting II, The Lost Boys, Dangerous Minds*, and *Sudden Impact*. Add to this the accolades from visiting VIPs, roller coaster experts, and such veteran riders as actor Vincent Price, and it becomes clear that the Giant Dipper is a legend in its own right. The great *San Francisco Chronicle* newspaper columnist Herb Caen once wrote that "the great roller coaster arose amid screams above the golden strand of the Santa Cruz Boardwalk. . . . It was a fine two-buck, two-minute ride, a tooth-loosener, eyeball-popper, and one long shriek."

The Giant Dipper graces the shoreline. More than fifty million riders have enjoyed its classic thrills.

ABOVE LEFT: The Giant Dipper roller coaster, shown here in 1924, was built in just forty-seven days, at a cost of $50,000. It remains the pride of the park.

ABOVE RIGHT: Arthur Looff (shown here in 1915) is credited with convincing Boardwalk management to replace the Scenic Railway with a modern wooden roller coaster.

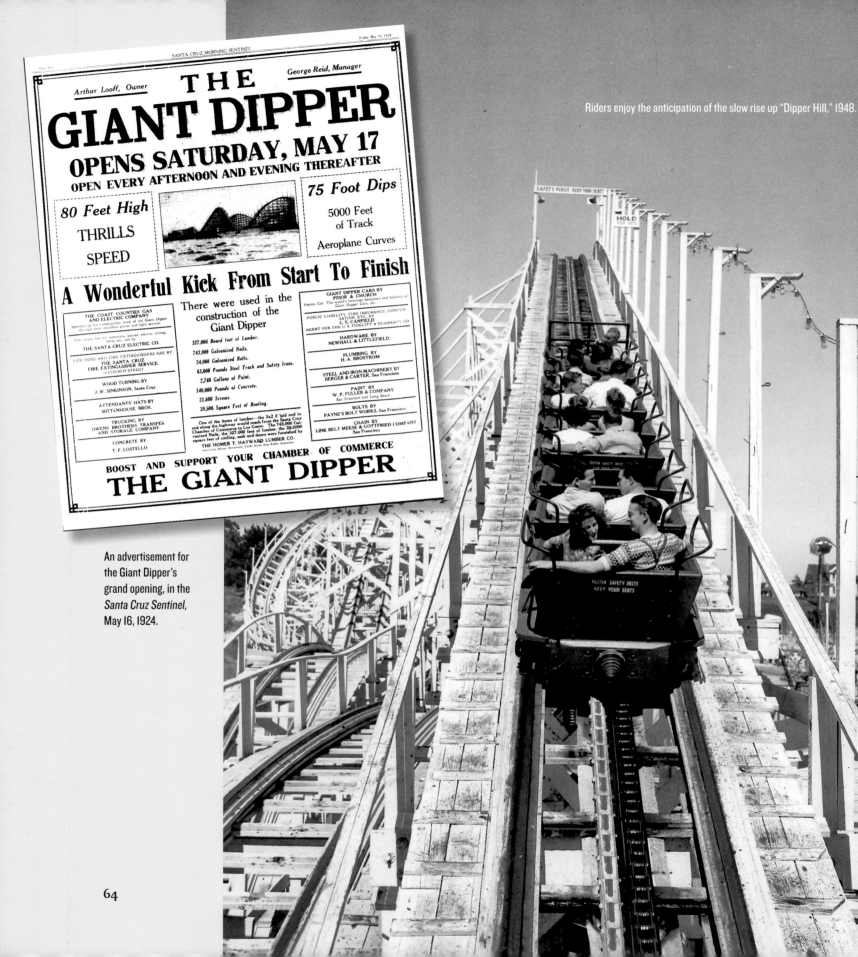

Riders enjoy the anticipation of the slow rise up "Dipper Hill," 1948.

An advertisement for the Giant Dipper's grand opening, in the *Santa Cruz Sentinel*, May 16, 1924.

This photo from the 1980s, with Santa Cruz Wharf in the background, shows the track's aesthetic dips and curves.

GIANT DIPPER TRIVIA

- Most riders in a day: 13,729 (June 27, 1987)

- Amount of paint needed to give the structure its necessary two coats: 862 gallons

- Number of light bulbs used to illuminate the structure: 3,150

- Combined length of the lumber used in the structure if the individual pieces were laid end to end: 14 miles

- One of the most unusual items lost by a Giant Dipper rider: a glass eye

ABOVE: Mechanics check the track in this 1951 photo. Today, four full-time mechanics are assigned to the Boardwalk roller coasters. To check for possible malfunctions, they walk the track every two hours when the ride is in operation.

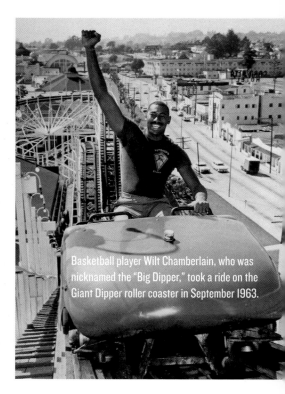

Basketball player Wilt Chamberlain, who was nicknamed the "Big Dipper," took a ride on the Giant Dipper roller coaster in September 1963.

BEAUTY AND THE BEACH

As chair of the executive committee that brought the Miss California Pageant to Santa Cruz, Fred Swanton regarded the pageant as the town's direct link to the annual Miss America Pageant held in Atlantic City and to its fantastic publicity machine. And he was right.

The first Miss Santa Cruz was selected in May 1924 at the St. George Hotel downtown. The first Miss California Pageant followed in June, when the franchise for the state finals was awarded to Santa Cruz. For the occasion, Pacific Avenue and the streets near the Casa del Rey Hotel were lined with flags. Laurel Grove Campground, located at the intersection of Pacific, Laurel, and Front Streets, was turned into the Court of Blossoms, with fifty thousand spectacular blooming gladioli framing a stage overlooking a lily pond. The Miss California parade began at the Court of Blossoms, looped through downtown and the beach area, and returned to the campground.

Not everyone was as enthusiastic about the competition as those initially in attendance. The pageant drew considerable opposition from some who felt the contestants were indecent. They wore too much makeup and showed too much skin. According to these critics, makeup was only for "shady" women, although Hollywood was soon to shatter that perception. And then there were those suits. Before

the 1920s, women's bathing suits were all-covering outfits. In 1922, several women in Chicago were arrested for indecent exposure after donning tank suits in order to swim. Only two years later, however, contestants in the Miss California Pageant wore the same style suit, by then considered the benchmark of a truly liberated woman.

Winsome and petite, Mary Black won the first Miss Santa Cruz title in 1924, and Faye Lanphier, Miss Alameda, won the Miss California crown and went to the Miss America Pageant in Atlantic City. Selected in 1925, the second Miss Santa Cruz was sixteen-year-old Yetta Haber. She was too young to become Miss Santa Cruz, but according to a 1973 story in the *Santa Cruz Sentinel*, Fred R. Howe, then mayor of Santa Cruz, told Yetta to "tell a little white lie" about her age. Yetta's brother, Lou, revealed that his sister entered the pageant only because Howe submitted her picture to pageant officials without first checking with her parents. They later agreed to let her participate.

In 1925, Faye Lanphier was again crowned Miss California and was serenaded with this coronation song: "There she stands in virginal array, / the model here of womanhood today. / From among the finest all around, / Miss California, you are found!" Publishing magnate William Randolph Hearst did not like the judges' choice. He denounced Lanphier in his newspaper, the *San Francisco Examiner*, questioning how she could be a bathing beauty if she didn't even know how to swim! Lanphier went to

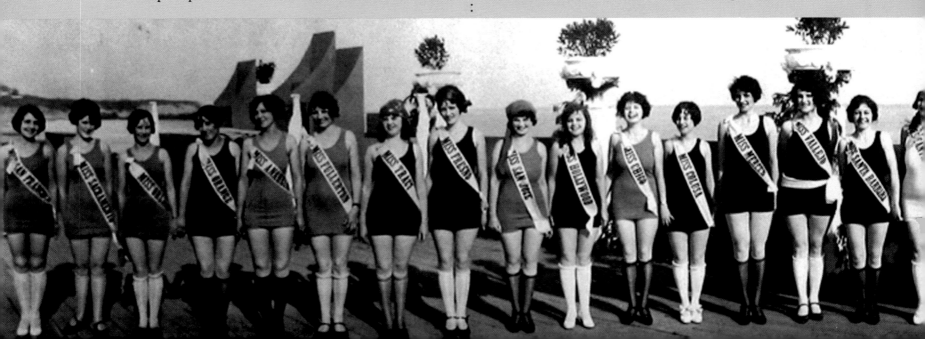

Atlantic City anyway, and this time she won and proudly wore the Miss America crown. As Miss America, she rode in then President Calvin Coolidge's private railcar to New York for a ticker-tape parade. Lanphier later starred in the movie *American Venus*, filmed in Atlantic City. In this era known as the Roaring Twenties, Miss America was head-line news across the continent.

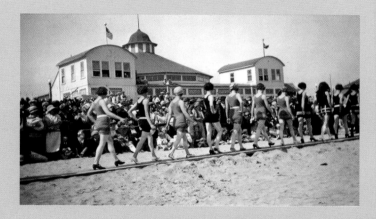

ABOVE: An enthusiastic audience welcomes Miss California contestants in 1924 as they parade before the judges. Fourteen flower girls showered rose petals ahead of the bathing beauties as they took their places on the reviewing stand.

BELOW: Quoted from the *Santa Cruz Sentinel*, June 9, 1925: "Dozens of amateur and professional beauties from the four corners of the state are now on their way to compete in their divisions at the Santa Cruz Pageant."

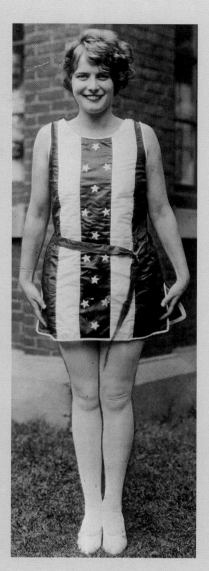

ABOVE: Yetta Haber, Miss Santa Cruz 1925.

LEFT: Faye Lanphier, Miss America 1925.

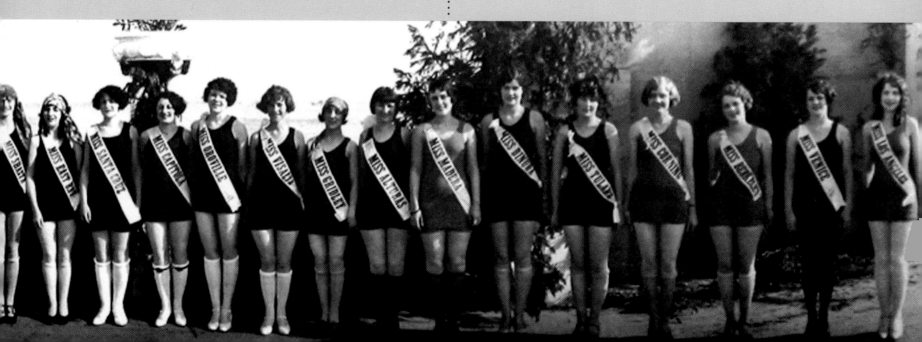

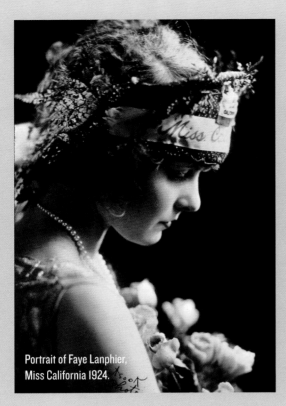

Portrait of Faye Lanphier, Miss California 1924.

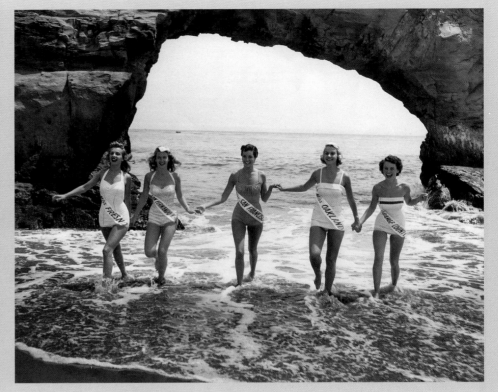

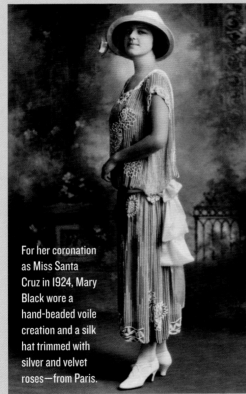

For her coronation as Miss Santa Cruz in 1924, Mary Black wore a hand-beaded voile creation and a silk hat trimmed with silver and velvet roses—from Paris.

ABOVE: Miss California contestants in 1954 are framed by an arch in Natural Bridges State Park. At center is that year's winner, a nineteen-year-old drama student named Lee Ann Meriwether. The following year, Meriwether became the first Miss America to be crowned before a live coast-to-coast television audience.

BELOW: The beauty pageant runway, pictured in 1936, extends far into the crowd.

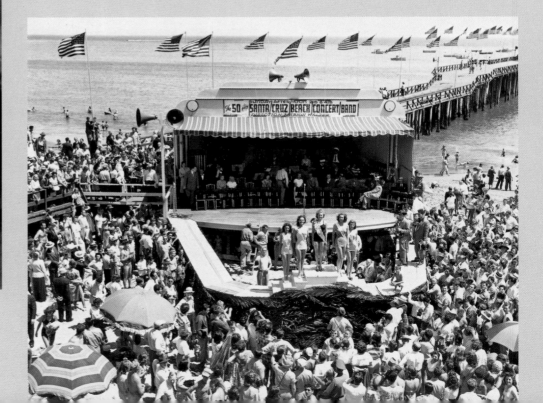

APARTMENTS FIT FOR A KING

The Casa del Rey Apartments opened in 1926 a block west of the Casa del Rey Hotel. As one newspaper explained it, "Castles in Spain were never erected all at one time, but units were added through the years and, as the mud dried each time, the color differed." Similarly, at the Casa del Rey each apartment varied slightly in shade from its neighbor. Walls of the courts were tinted in different colors, but all were finished using a mottled "antique adobe" stain. When the architect's renderings were shown in the spring of 1926, such elegant apartment features as fireplaces, built-ins, electric heat, and cooking gas were described.

At first the apartments attracted the carriage trade, later becoming residences for upwardly mobile locals. In 1968, the owner changed the name to La Bahia Motel, reflecting a change in tenants. There were fewer permanent residents then, and by 1977, four of the six buildings in the complex were rented only by vacationers.

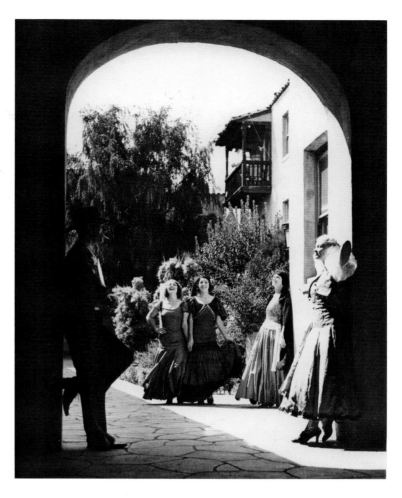

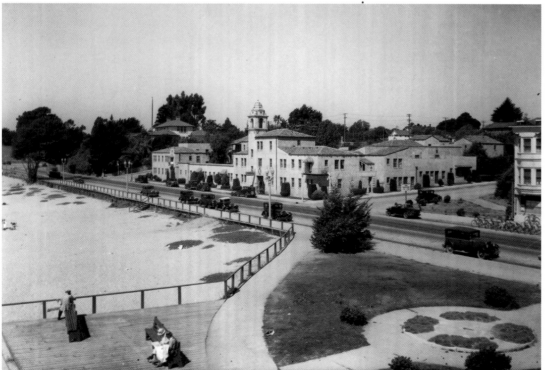

ABOVE: The Casa del Rey Apartments opened in 1926, with dancers in festive costumes.

LEFT: The Casa del Rey Apartments as they appeared in 1936.

SANTA CRUZ:
THE CONVENTION CITY

"Go to Santa Cruz and combine business with pleasure," the Casa del Rey's literature urged. Many did just that. Among them were the attendees of the following conventions held at Santa Cruz Beach in 1927: the Woodmen of the World, the American Legion, the California Retail Grocers and Merchants Association, the Camp Owner's Association, the Spanish War Veterans, the Order of De-Molay, the Kiwanis, the Order of Eastern Star, the Teachers Association, the Knights of Pythias, and the Native Sons of the Golden West.

A July 7, 1917, edition of the *Santa Cruz Sentinel* reported about a National Editorial Association convention picnic on the beach: "The breakfast at the beach on Monday morning for the 600 visiting members of the National Editorial Association was a great success. It was a simple and comparatively inexpensive means of entertaining our guests in a novel way."

After meetings were adjourned, convention attendees could enjoy speedboat rides, swimming, surf bathing, golf, tennis, the scenic beauty of the ocean and the mountains, fishing, and wonderful food. Santa Cruz had it all.

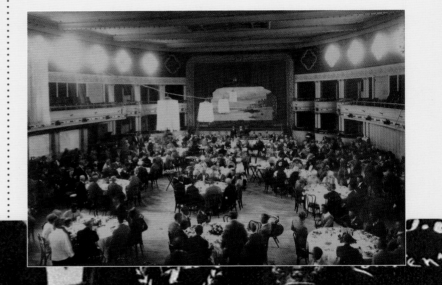

A large group gathers in 1914 for the International Bible Student Association Convention.

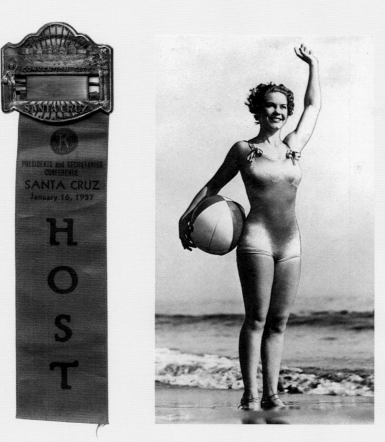

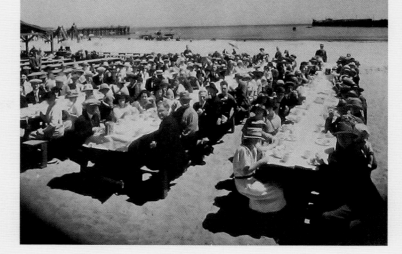

ABOVE: A convention picnic on the beach, circa 1920.

FAR LEFT: At the luxurious Casa del Rey Hotel, convention hosts wore these colorful ribbons.

LEFT: Cynthia Currall, Miss Santa Cruz 1936, promoted her city in the most used publicity shot of the 1930s.

OPPOSITE: Conventioneers are seated in the Casino ballroom, circa 1927.

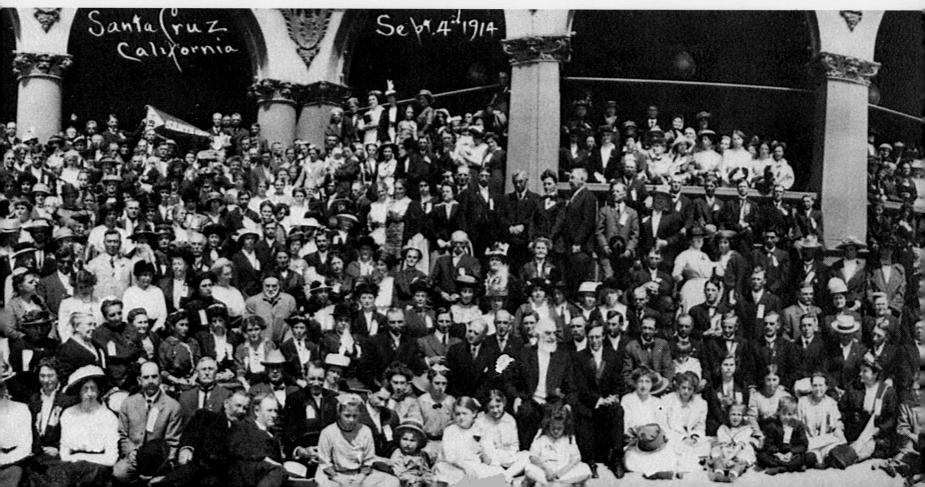

THE SWEET STORY OF THE MARINI FAMILY

"It's all for the kids' faces, all for their smiles."

—Joel Marini, Marini's Candies

The story of Marini's Candies began in 1915, when Joseph Marini III's great-grandfather, Victor A. Marini, who had a barbershop in Santa Cruz, bought the popcorn wagon on the Boardwalk. The wagon sold popcorn with real butter and bags of peanuts that had been roasted in their shells. In 1917, Victor bought Flo and Marty's Boardwalk Candy Store near the Casino and sold saltwater taffy made from Victor's recipe, round caramel krisps, lemon drops, ribbon candy, and

peanut brittle. The shop had a six-foot counter that pulled in from the Boardwalk behind roll-up doors at night. The Marini family's candy business was on its way.

Joseph V. Marini, later known as Joe Sr., started working for his father, Victor, at age ten, bagging peanuts. During the 1920s, Joe worked in the candy store in summer, making taffy (the original flavors were vanilla, peppermint, and molasses) by cooking it in big copper pots and pulling it by hand. He would throw the taffy up onto a big hook on the wall and stretch it out, over and over, taking a few steps back from the wall each time until he was five feet away. Sometimes a crowd would gather outside the shop's window, watching and waiting for the long rope of taffy to break and fall on the floor. It never did, and Joe loved putting on a show for the public. The taffy was cut by hand and wrapped in wax paper with the ends twisted closed. The Marinis pur-

LEFT: Victor A. Marini, founder of the Marini family candy business, circa 1915.

BELOW: Members of the Marini family, circa 1980: (left to right) Joe Jr., Joe Sr., and Joel.

BELOW: One day in 1948, Joe Marini Sr. (seen here in 1985) made a dozen caramel apples. They sold out, so he made two dozen the next day. They too sold out. To this day, caramel apples remain a Boardwalk favorite.

chased a taffy-pulling machine in 1922 and later bought an electric taffy wrapper. It is still in operation today.

Next to the candy store, Victor opened a cigar store and newsstand in 1928, and with Goldie Goldstein he operated the Mari-Gold stand by the Fun House. Cotton candy was offered in the candy store in 1930. Joe Sr. remembered that during the Depression era, cotton candy was five cents, and you couldn't give it away.

In the 1930s, the Bathing Suit Store became part of the story. Red cinnamon candy apples and caramel apples were first offered in the 1940s. Also in that decade a second candy store was opened at the east end of the Boardwalk. In 1968, the Marinis opened the Hide Tide Sandal Shop. In the 1970s, they added more flavors of taffy.

In 1982, after the extensive remodeling of the Cocoanut Grove building, Marini's operated the Santa Cruz'n men's store, Marini's Bikinis, a women's bathing suit store, and a yogurt shop in the Casino arcade. In the candy kitchen on

the colonade visitors could now watch saltwater taffy being made from start to finish.

Today, the Marinis have closed the clothing stores and returned to their roots—candy. Joseph Marini III continues the Marini's Candies story that was started by his great-grandfather Victor and his grandfather Joe Sr.

In 2004, the fourth generation of Marinis is still making customers happy: (left to right) Joe Marini Jr. and his wife, Carol; Joe Marini III; and Kathy Marini and her husband, Joel.

Joe Marini Sr. and his wife, Josephine, on their wedding day, 1938.

MORE TREASURES AND ATTRACTIONS AT THE BEACH

The late 1920s were a time of magic and mirth and merry-making—a time to see and be seen at the Santa Cruz Boardwalk. In 1927, the oil and gasoline company Shell organized the Shell Treasure Hunt. The event was advertised throughout central California as a colossal happening. On the appointed day, an unbelievable sixty thousand men, women, and children stormed Santa Cruz Beach in search of pirate treasure. Ten thousand dollars' worth of prizes had been buried in the sand. When a mighty cannon boomed, signaling the start of the search, thousands of treasure hunters leaped over barricades carrying shovels, rakes, hoes, and every other available implement. Wild confusion reigned on the beach, lasting for more than two hours, until every one of the two thousand prizes had been unearthed.

Shell also put on a Pirate Ball in the Casino and staged a Pirate Carnival and a Baby Pirate Parade on the Boardwalk. There were parades galore: Huge dragons carried bathing girls escorted by knights in armor and followed by the Horribles—a band attired in costumes meant to inspire terror and amusement in the viewers. There were also speedboat races, fireworks displays, fortune-tellers, swimming races, and ghost dancers.

The Pleasure Pier speedboats *Spendthrift* and *Vagabond* were only two of the attractions at the beach in the mid-1920s. Jennie Hagley, otherwise known as "Mother Sperry" while she worked as a demonstrator for the Sperry Flour Company, opened a concession selling hot Scotch scones and jelly and pancakes hot from the griddle.

According to an article in the *Santa Cruz Sentinel*, on May 9, 1925, Elizabeth Rounan brought Snooky the Humanzee from Hollywood to the Boardwalk. Due to her many motion-picture roles, Snooky was probably the best-known chimpanzee of the time. T. W. Ryan brought a mirror maze to the Boardwalk, and it proved to be a great attraction for the youngsters. This was followed by the Haunted Swing ride, the Mysterious Hand, and a cage full of monkeys. Ed Smith operated a shoeshine concession at the Casino's west entrance. A concessionaire named Carlyle opened a new Fun House that was billed as a good tonic for young and old.

In 1926, M. C. "Husky" Hall was hired as a full-time director of events and advertising for the Boardwalk. He drew thousands to the amusement park with events like the amateur ocean long-distance swim competitions; golf and invitational tennis tournaments; yacht and speedboat races; aquaplane contests; horseshoe competitions; and the unconventional aqua-archery promotion.

The Boardwalk also hosted the popular Midget Racers. One former rider, Don Passerino, remembers them fondly: "Midget Racers.

LEFT: Lillie Teshara, sister of local fisherman "Tony" Teshara, stands on the Santa Cruz Boardwalk in 1919, in front of a Kewpie doll concession. (Courtesy of Special Collections, University Library, University of California at Santa Cruz)

BELOW LEFT: Kewpie dolls were popular prizes at the Boardwalk in 1919. Wide-eyed, big-cheeked, and round-tummied, the dolls were first introduced in the early 1900s in the *Ladies Home Journal*. (Courtesy of Special Collections, University Library, University of California at Santa Cruz)

CLARK'S
ON THE BOARDWALK
KEWPIE DOLLS
VAMPIRES, THEDA BARAS
UKULELES
10c CANARIES and CAGES 10c
STATUARY
CHOCOLATES
and the
COUNTRY STORE
COME ON OVER

A 1919 *Santa Cruz Sentinel* ad promotes Kewpie dolls that looked like the actress Theda Bara.

A flyer promotes the Shell Treasure Hunt, which offered $10,000 in prizes buried on the Santa Cruz Beach.

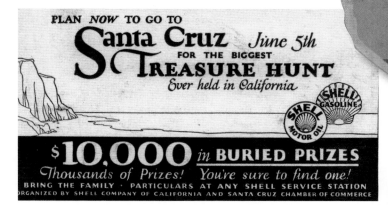

PLAN *NOW* TO GO TO

Santa Cruz *June 5th*

FOR THE BIGGEST

Treasure Hunt

Ever held in California

SHELL GASOLINE
SHELL MOTOR OIL

$10,000 *in* **BURIED PRIZES**

Thousands of Prizes! *You're sure to find one!*

BRING THE FAMILY · PARTICULARS AT ANY SHELL SERVICE STATION
ORGANIZED BY SHELL COMPANY OF CALIFORNIA AND SANTA CRUZ CHAMBER OF COMMERCE

SHELL-SANTA CRUZ TREASURE HUNT 5th June

SHELL GASOLINE

A promotional handout from the Shell Treasure Hunt. Prizes ranged from a 50-cent breakfast to a fishing trip.

That's where I learned how to steer a car. The cars were little gas-powered racers, and you drove around on an oval track. The only way to stop them was by a rubber device that was flipped up across the track: as you rode over it, it would disengage the clutch, causing you to glide to a stop. If you were clever, you would turn at an angle when your car crossed over the rubber device, and you and the racer could go for another trip around the track—much to the disapproval of the game operator."

The Boardwalk has had several auto-related rides, including Auto Scooters, Dodge 'Ems, the Autorama, and the Great Auto Race.

In 1927, the Santa Cruz Seaside Company changed the name "Casino" to "Auditorium," believing that it would prevent the Boardwalk from becoming another "Coney Island jumble of games of chance and cheap amusements." In a February 26, 1927, article printed in the *Santa Cruz Sentinel*, M. C. Hall, the company's events manager, stated: "No more bathing parades for Santa Cruz. The people of Santa Cruz know that a bathing parade does not appeal to the type of people we want to attract as permanent summer residents of Santa Cruz. We have turned to things we consider of a higher nature, such as a bicycle race from Long Beach to Santa Cruz, a long-distance swim for amateurs, and such attractions."

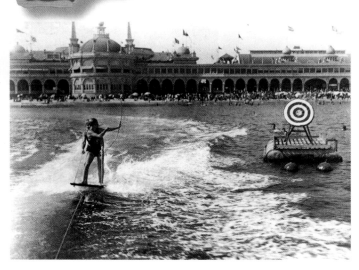

Promoter M. C. "Husky" Hall had some inspired ideas for the Boardwalk, like the aqua-archery promotion shown, 1926.

The popular Midget Racers allowed people to drive their own race car, 1928.

ON THE ROAD TO SANTA CRUZ BEACH

California's Highway 17 winds its way over the Santa Cruz Mountains through some of central California's most picturesque scenery and emerges near the beach at Santa Cruz. This rare combination of mountain and seashore motoring drew streams of tourists. Gloria Scurfield, who has been coming to the Boardwalk since she was a child, remembers her family's treks over the mountains to Santa Cruz: "Dad would drive us over in our 1929 Oakland Roadster. This car was something people gathered around. It had real wire wheels. I'd be in the rumble seat, and Mother would be mad as hops 'cause Dad took off the top all the time and he installed an air horn. We'd go on the old mountain road, where you'd go through Holy City.

"Then we'd come around a turn, and there would be that insurance sign with the guy running with the sack of money in his hand, saying, 'Harry E. Murray, he pays in a hurry.' Then Dad would say, 'We're almost there.' We'd come around that turn and shout, 'There it is!' And I'd see the ocean. Well, that was the key to happiness, being in Santa Cruz.

"There was a Mr. Scott who had a real estate office on Seabright Avenue. Mother would call him, and he'd secure us a cottage. I think we stayed in every single one on Brook and Mott Streets, or Cypress. They would rent for fifteen dollars and fifty cents a week. At one time there was a cottage for sale on Brook for six hundred dollars, and my father thought that was absolutely terrible."

TOP: There was a day when the horse was king, and visitors to the Neptune Casino arrived by horse and buggy, 1906.

CENTER: Autos approaching Santa Cruz Beach had to travel up the rugged, old Glenwood Highway, circa 1921. Although the mountain pass was usable as early as 1915, it wasn't paved until six years later.

BOTTOM: This 1940 GMC Mountain Woodie (front, left) makes its way over Highway 17, on the way to Santa Cruz.

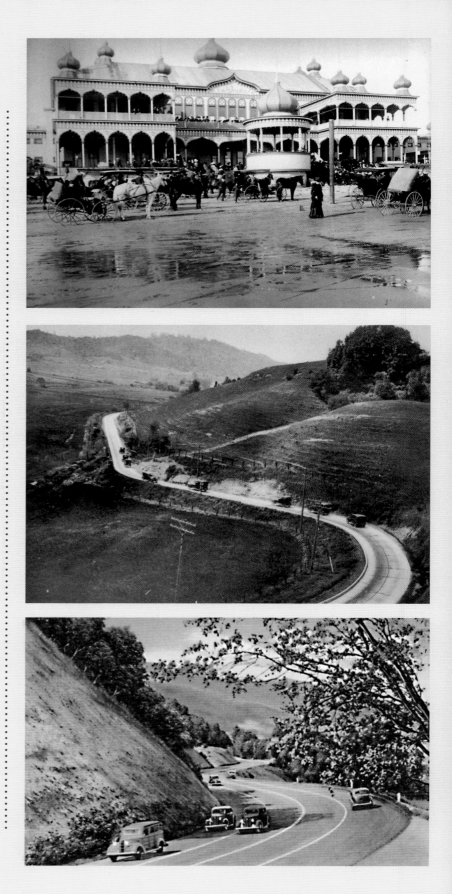

ALL ABOARD THE SUN TAN SPECIAL!

During the 1930s, tourists from the San Francisco Bay Area, seventy-five miles north of Santa Cruz, could take the Southern Pacific Railroad's Sun Tan Special right to the Boardwalk. Except for the years 1941 to 1947, trains ran from San Jose, Oakland, and San Francisco and also connected Santa Cruz to Watsonville and Los Angeles. In 1932 alone, the train delivered as many as thirty-five hundred people each Sunday to Santa Cruz, where train cars were greeted with a blast of brass from the Beach Band.

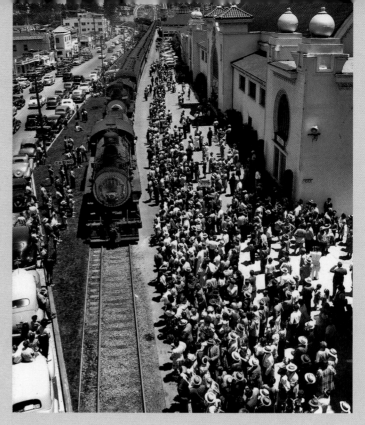

The 1947 Sun Tan Special sits at the Casino Station.

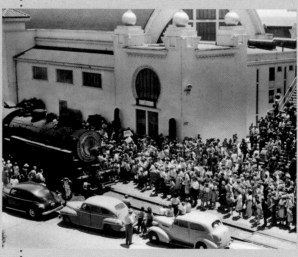

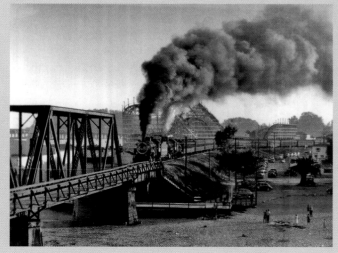

ABOVE: The 1947 Sun Tan Special arrives at 11 A.M. and is greeted by the Beach Band.

ABOVE LEFT: The 1936 Sun Tan Special, with the Casa del Rey Apartments in the background.

LEFT: The Giant Dipper's tracks can be seen in the background as the 1940 Sun Tan Special heads over the San Lorenzo River.

KEEPING THE SUNNY SIDE UP: THE DEPRESSION YEARS

Across the country, amusement parks had fallen on hard times. A combination of Depression-era incomes and the new automobile-oriented recreational options made the situation difficult to overcome. By 1936, the fifteen hundred amusement parks that existed in 1919 had dwindled to about five hundred. In Santa Cruz, however, even in 1932—the height of the Depression—this was not the case. With big bands in the ballroom, the success of the Plunge Water Carnivals, and the help of the popular Sun Tan Special train, the Seaside Company continued to grow.

Marketing continued to fight for advertising dollars for the Santa Cruz Beach Boardwalk, arguing that to gain more publicity would require creating new and even better events at the beach. The reasoning was that a substantial amount of the money allocated for veteran bonuses as part of the Federal Reserve Act of 1938 would end up at the Boardwalk in the form of tourist dollars. So advertising and promotional expenditures continued much as they had during the pre-Depression years. Santa Cruz residents were once again encouraged to send postcards to friends and relatives urging them to visit the area. The Los Gatos–Santa Cruz Highway (then known as the Glenwood Highway) was improved.

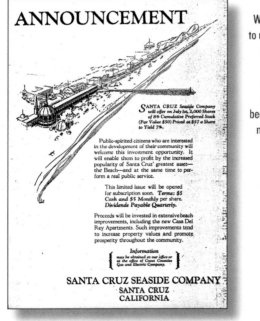

AT RIGHT: When Hollywood began to use color film, healthy glows and sun-kissed cheeks became a necessity. Basking on the sand at the beach became the new California image, as shown in this 1935 photo.

From the *Santa Cruz Sentinel*, June 24, 1926: "Further developments at the beach offered Santa Cruz residents an investment opportunity by which they would profit twice—once through purchased stock and again by the expansion of Santa Cruz as a year-round resort."

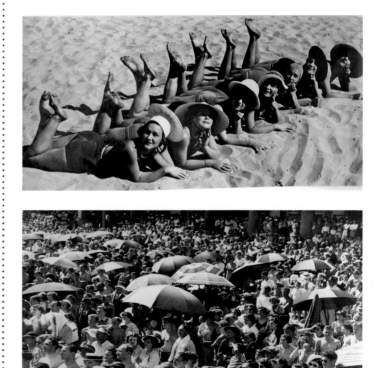

On June 23, 1935, a crowd of about twenty thousand spectators in front of the Casino watched as Dick Keating of the Fairmont Hotel Plunge won the first annual Santa Cruz Ocean Swim race, in forty-four minutes and thirty-four seconds.

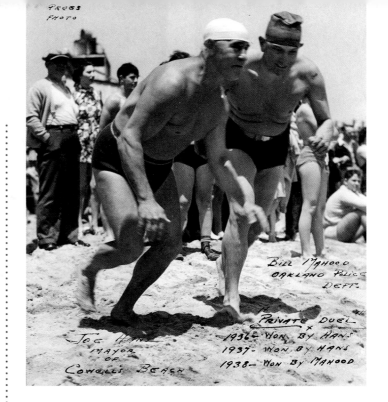

And it all seemed to work. During the 1930s and 1940s the Casino ballroom (renamed the Cocoanut Grove in 1934) thrived. People were looking for a world in which to escape, and they were drawn to the lively dance concerts, odd sideshows, safe but exciting rides, and special foods at the Boardwalk. When it came right down to it, the Great Depression had little effect on Santa Cruz tourism. A privately financed tourism agency indicated that in 1931, more than one million visitors came to California. The money these tourists spent within the state is often cited as one reason that California suffered less than the rest of the country during this era.

There was so much to do and so many events to see on sunny days at the Boardwalk. Sunday afternoon programs on the beach bandstand were often led by "Accordion King" Dave Ferrari and his orchestra. In the spring, Ferrari often acted as master of ceremonies for the annual Beach Easter Egg Hunt. In 1937, an estimated two thousand children hunted for five hundred eggs.

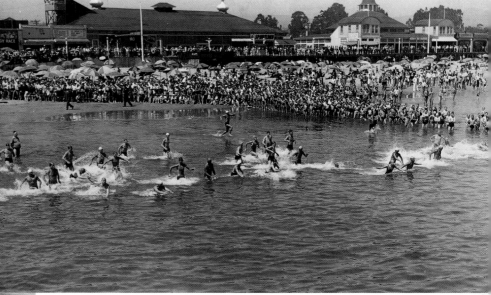

BELOW: Swimsuit models on Santa Cruz Beach, 1936.

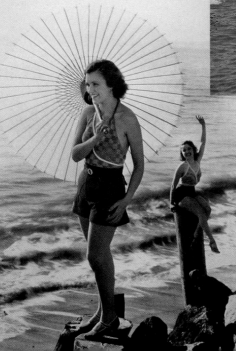

ABOVE: Modesto, California, resident Dottie Sanders enjoys the sun at Santa Cruz Beach, 1940. Every summer, from 1957 to 1965, Dottie brought her two daughters to Santa Cruz for a beach vacation. Before leaving Modesto, she'd tell everyone she was going to come home "brown as a berry and ten pounds lighter." When they got back, she'd tell everyone she was "red as a lobster and ten pounds heavier!"

TOP: The grueling men's race in the Fourth Annual Santa Cruz Ocean Swim featured a continuing private duel between police officer Bill Mahood (right) of Oakland and the "mayor of Cowell Beach," Joe Hans, an officer with the Santa Cruz police force. Hans had bested Mahood in 1936 and 1937 but lost the following year. He blamed his defeat on cramps in both legs.

ABOVE: This 1936 *Santa Cruz Sentinel* photo shows the second annual Santa Cruz Ocean Swim, held east of the Pleasure Pier.

79

MORE CONCESSIONAIRES AT THE BEACH

The Stagnaro family operated the speedboat at the end of the Pleasure Pier from 1933 until the pier was taken down in 1962. Malio H. "Stago" Stagnaro was a speedboat skipper with style. At the Pleasure Pier, his loudspeaker designed to attract customers would blare "Hi-de-ho and away we go! Speedboat rides going right out!"

"They had these games you could play in order to win a goldfish," Boardwalk visitor Gloria Scurfield remembers, "and I used to win. When we had to drive home, I'd be going home with the bowl in my lap, sloshing around, with the goldfish in it. Or a turtle. Oh, it was such fun. We had a lot of fun times. There's something about the Boardwalk that puts a smile on your face. And, oh, the candy apples. That's when some of the things in the Casino were a penny. Imagine! Some of the things you put coins in, like the Wheel of Fortune, were a penny or a nickel. And the little soccer players—I think that game was only a nickel. Hard to believe, isn't it?"

Winifred Blaisdell operated the popular Winnie's Turnover Pies concession with her husband, Ed. To those who loved her and her freshly baked pies, she was known as "Winnie." More than seventy years later, Gloria Scurfield has vivid memories of Winnie's Turnover Pies: "Oh, that was paradise. I loved the apricot ones. Ten o'clock was when the apricot pies would come out, and my mom would let me come over and get some. They were hot, and they were delicious, and Winnie was there for years and years and years."

The Cottardo Stagnaro II family, photographed in 1965 (top row from left): Malio H. "Stago" Stagnaro, Joseph E. Stagnaro, Batista "Dodie" Stagnaro, and Robert "Big Boy" Stagnaro; (front row from left): Mary Stagnaro Herman, Estrella Stagnaro, Battistina Loero Stagnaro, Malio J. Stagnaro (uncle to Malio H. "Stago" Stagnaro), and Gilda Stagnaro.

ABOVE: Winifred Blaisdell stands behind her counter at Winnie's Turnover Pies, 1933.

LEFT: Models for a 1933 Boardwalk promotional campaign pose in front of the Mari-Gold concession, owned by Goldie Goldstein and Victor A. Marini and operated by Victor and Wade Hawkins in the former Fun House building.

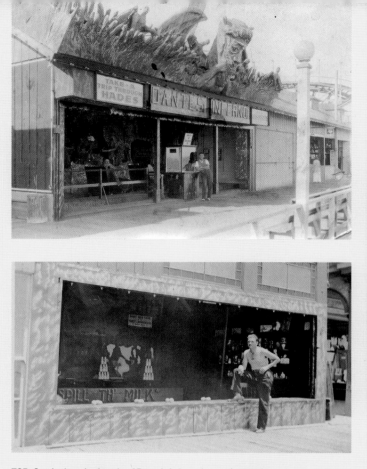

TOP: One look at the façade of Dante's Inferno let you know what you were in for.

ABOVE: "Doc" Reicher's popular 1930s Milk Bottle Game was housed in the corner of the merry-go-round building.

Ed "Doc" Reicher was born in Brooklyn and grew up on Coney Island, where his love of amusement concessions started. An entrepreneurial young fellow, he owned and operated his first game at Coney Island when he was only fifteen years old. Around 1918, Doc came to Santa Cruz. Over the years, Reicher had five different operations going strong along the Boardwalk, including the Unborn (1931), Dante's Inferno (1932–33), and Laff-Land (1934–35).

Dante's Inferno was the first dark ride at the Boardwalk. Billed as "A Trip Through Hades," it featured six motor-driven cars that took riders through a dark cavern. Reicher developed the whole ride himself and was very proud of it. A sign on the exit door read: "Watch 'em come out!" People's end-of-the-ride expressions must have been worth waiting for and probably enticed more riders. Santa Cruz Seaside Company president James R. Williamson was perplexed as to why this little ride would gross more on weekdays than his pride and joy, the Giant Dipper roller coaster. Reicher had to explain that sometimes young couples wanted to ride alone . . . away from others . . . in the dark. In 1934, Dante's Inferno was reconfigured into Laff-Land, a new amusement featuring clowns.

In 1934, Reicher introduced Skee Ball at the Boardwalk by buying a battery of ten alleys from Coney Island and bringing them to the West Coast. The game had been invented in 1909 by J. D. Estes of Philadelphia. When it was first created, it had thirty-six-foot lanes, but since most people weren't strong enough to send the ball that distance, the lanes were soon reduced to fourteen feet, and eventually to ten. Skee Ball quickly became a hit, even though in some places it was considered to be a form of gambling because of the prizes it offered. Today Skee Ball is found in almost all arcades.

Herb Cunningham, shown here as a child (middle, with shovel), enjoyed a lifetime affiliated in some way with the Santa Cruz Seaside Company.

Joe Lane, 1938.

FITZSIMMONS AND TWISSELMAN: A PROMINENT BOARDWALK PRESENCE

In 2007, a key Boardwalk family celebrated seventy-three years at the amusement park. Charles J. Fitzsimmons began his career at the Boardwalk in 1934. During the World War II years at the Boardwalk, Fitzsimmons ran the Cat Rack, basketball and baseball games, as well as the celebrated Fascination game. Later he added Skee Roll, Pokerino, Bazooka, and balloon games.

In 1965, Fitzsimmons sold his games to Canfield Concessions and intended to retire, but instead he found himself employed as operations and personnel manager for the Seaside Company. In 1967, Fitzsimmons opened Casino Imports, a two-story retail shop and souvenir store at the east end of the Plunge. In 1978, the shop—with its metal spiral staircase that led customers to the glories of the second floor—was sold to Marshall and Kathy Miller, who continued to operate the store for a time.

Joe Lane had been a Seaside Company superintendent for ten years when he left the company in 1935 to run frozen custard stands. Lane's popular businesses were recognizable by their snappy black-and-white or red-and-white exterior tiles. His specialties were vanilla custard and chocolate-malt soft ice cream.

Herb Cunningham was the assistant secretary-treasurer of the Santa Cruz Seaside Company in 1929. In 1935, he left to run several game concessions, including the Derby (a horse race) and the Piggy Race. Herb and his wife, Helen, also operated the souvenir photo stand in the main arcade area until his retirement.

This prize coupon was given at the Piggy Race Game. Multiple coupons were needed to win bigger prizes.

A 1940s Cat Rack cat. The goal of the game was to knock a cat over with a ball to win a prize.

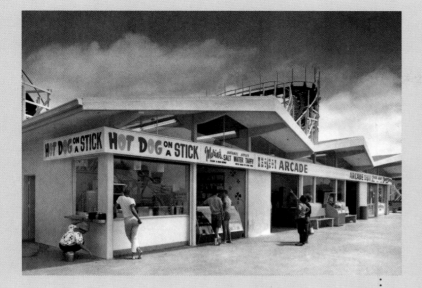

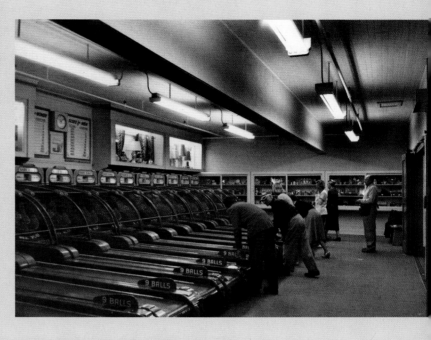

In 1971, Fitzsimmons and his daughter, Audrey Twisselman, took over Hot Dog on a Stick and added an adjoining concession, Chicken in a Basket. When Charles retired, Twisselman ran the business, followed by her son, Matt, whose first job as a teenager in the family business was as a corn cooker. When Matt took the reins in the 1990s, he remodeled the space and added California Wraps and BoardWok, which feature rice bowls, wraps, and other freshly prepared items. Today the family also runs World Grill.

ABOVE LEFT: The Hot Dog on a Stick menu today is almost the same as it was in 1965, when this photo was taken.

ABOVE: A Skee Roll game on the Boardwalk in the late 1930s.

ABOVE: A balloon game winning prize coupon from the 1950s

LEFT: Charles Fitzsimmons stands at the counter of one of his balloon games, circa 1950. The objective of the balloon game is to throw a dart, pop a balloon, and claim a prize.

Concessionaires Audrey Twisselman and her son, Matt Twisselman, 2006.

THE COCOANUT GROVE HEYDAY

Built in 1907 to replace the destroyed Neptune Casino, "Cocoanut Grove" now refers to the entire Casino building as well as to the ballroom. Entering the lobby and the ballroom today has been likened to stepping out of a time machine into the early 1900s.

Remodeled, redecorated, and renamed under the direction of J. V. "Jot" Troyer, the Cocoanut Grove ballroom first opened on May 5, 1934. More than 250 real palm trees were positioned around the dance floor and in the balconies and boxes for a South Seas look and feel. A year later, Paul Whiteman (a former San Francisco Municipal Band member) brought his forty-four-piece orchestra to the Cocoanut Grove, opening his performance with a new composition from George Gershwin—"Rhapsody in Blue."

"My folks used to go to the dances in the Cocoanut Grove, and I'd sit in those boxes on the side . . . with the dog," remembers Boardwalk visitor Gloria Scurfield. "We'd come across from the Casa del Rey's Trocadero Room, which was a dinner, dance, and cocktail lounge. Or we'd come across the bridge from the hotel. My parents used to call it—after Venice—the 'Bridge of Sighs.'"

Although the appeal of the big bands faded in the 1950s, orchestras led by Billy May, Tex Beneke, Les Elgart, Hal McIntyre, and Si Zentner kept their memory alive. By the 1960s, the Cocoanut Grove ballroom attracted teen crowds with dances featuring more contemporary artists like Sonny and Cher, the New Christy Minstrels, and the Four Freshmen. But a decade later, the big band sounds were back. In 1977, the ballroom and main lobby were redecorated again. The original opulent style returned. Les Brown and His Band of Renown performed for a crowd of fourteen hundred. By 1981, the site had undergone additional renovation to the tune of ten million dollars, and a beautiful six-thousand-square-foot, ocean-view room, with a retractable glass ceiling, had been added.

Before 1924, most of the music for dancing at the

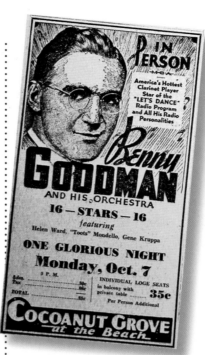

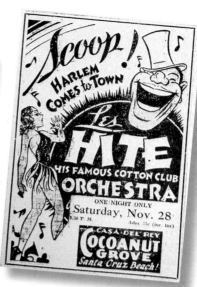

These two *Santa Cruz Sentinel* newspaper ads dated October 4, 1935, and November 26, 1936, announced major acts of the day.

A dance show card from 1956.

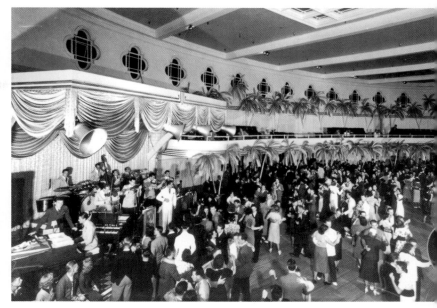

The Buddy King Orchestra performs at the Cocoanut Grove ballroom, 1946.

ABOVE: On one evening in 1941, Kay Kyser's College of Musical Knowledge drew a record crowd of 3,896 celebrants—well over the modern-day limit—into the Cocoanut Grove.

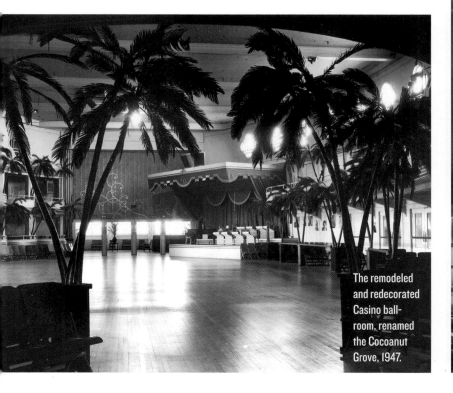

The remodeled and redecorated Casino ballroom, renamed the Cocoanut Grove, 1947.

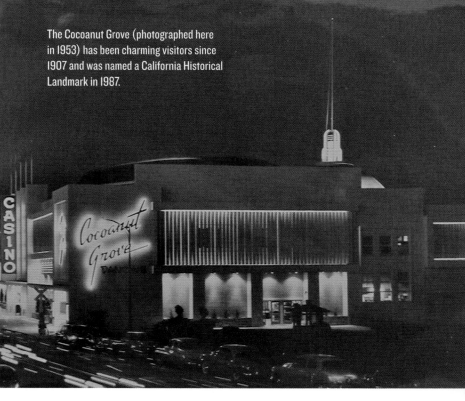

The Cocoanut Grove (photographed here in 1953) has been charming visitors since 1907 and was named a California Historical Landmark in 1987.

beach was provided by beach concert bands, some of them under the batons of Professor George Hastings, Lou Williams, Joe Enright, and Walter Rosener. But when a new instrument called the saxophone, playing a new style of music called "jazz," entered the picture, it was the beginning of the end for dance concert bands. When the Philpott's Midshipmen band arrived, with its saxes and snorting trombones, it proved that a new dance era had begun on the beach. By 1928, Tommy Simmons and William Johnson had taken over the Cocoanut Grove and were happily advertising "music by jazz bands."

In 1932, the phenomenon of big-name bands burst on the American scene, and the golden age of ballroom dancing came into being. The Troyer Brothers, Gifford, Bill, and "Jot," were quick to seize the opportunity. The Troyer triumvirate was among the original organizers of the Santa Cruz Convention Bureau. During the war years, they operated the Casa del Rey Hotel for the Seaside Company while it served as a naval convalescent hospital. Later, the Troyers managed the Cocoanut Grove.

The parade was on: Ben Bernie, Griff Williams, Ted Fio Rito, Benny Goodman, Isham Jones, Phil Harris, Skinny Ennis, Joe Reichman, Buddy Rogers, Glen Gray, Vincent Lopez, Henry King, Anson Weeks, Xavier Cugat, and the King of Jazz himself, Paul Whiteman. Whiteman was one of the most popular band leaders in America from the 1920s to the 1940s. Bing Crosby gained his stardom while singing with Whiteman's band. The marquee at the Cocoanut Grove changed from Dick Jurgens to Tommy Dorsey to Russ Morgan to Kay Kyser and Harry Owens and back again.

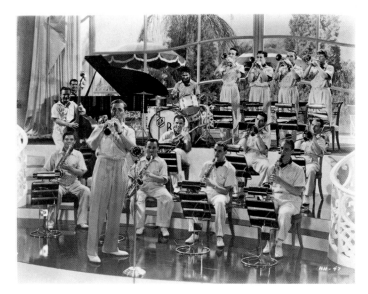

The Benny Goodman Orchestra, with a bit of brass, performed in the Cocoanut Grove in 1935.

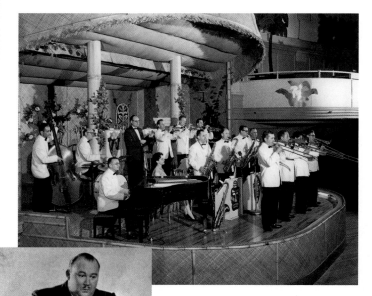

The Karl Bruhn Orchestra played at the Cocoanut Grove in 1961.

Singer and saxophonist Tex Beneke had his debut with Glenn Miller's orchestra in 1938. Beneke became famous for his lead vocals on the hit "Chattanooga Choo Choo." He brought his own band to the Cocoanut Grove in the 1980s.

Paul Whiteman brought his forty-piece orchestra to the Cocoanut Grove in 1937.

TOP LEFT: In 1959, bandleader Freddy Martin brought his "singing saxophone" and his orchestra to the Cocoanut Grove.

TOP RIGHT: The New Christy Minstrels shared "one glorious night" with Boardwalk visitors at the Cocoanut Grove in the mid-1960s.

BOTTOM LEFT: A Four Freshmen show card from the mid-1950s.

BOTTOM RIGHT: A Les Elgart show card from the 1950s.

BELOW: The open walkway space of the original Casino building and Natatorium, 1938. In 1981, this space was filled by the Sun Room, complete with a retractable glass ceiling.

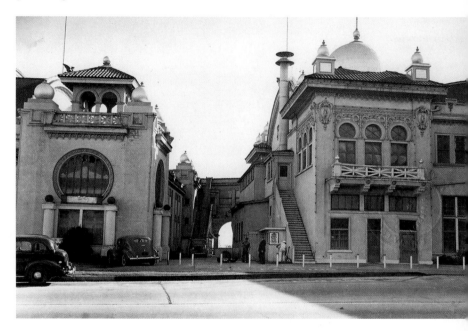

The Cocoanut Grove, circa 2004.

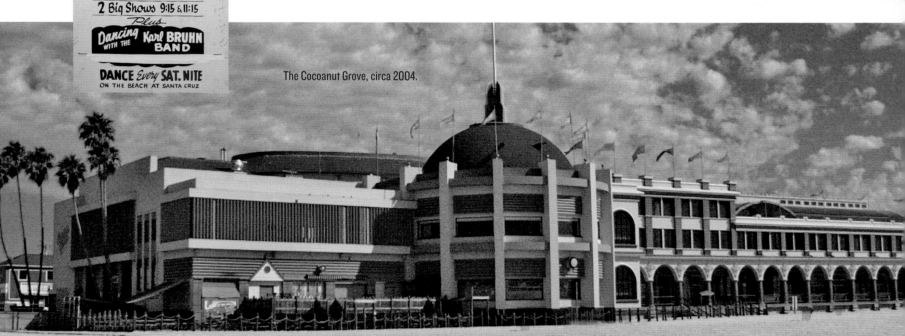

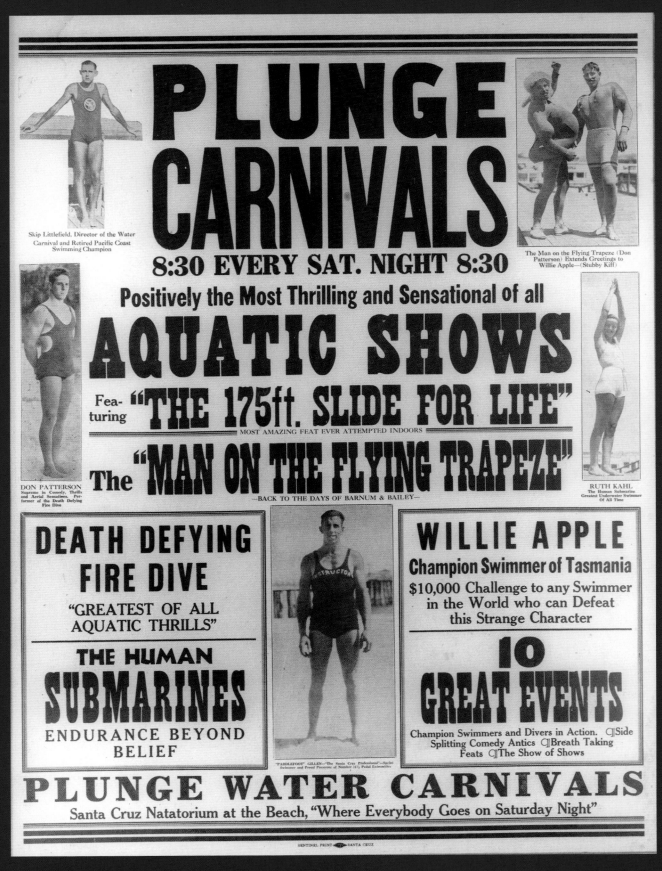

Poster depicting the Saturday night Plunge Water Carnivals, 1936.

A Time Like No Other

FROM THE TURN OF the twentieth century through World War II, performers and competitors alike flocked to Santa Cruz to participate in the most eagerly anticipated and highly publicized amateur water shows in the country.

Folks came to see everything from tub races to Olympic greats like Duke Kahanamoku; from novelties like six-year-old stunt divers to local legends like Don Patterson, Ernest Kiff, and Skip Littlefield. It was wet; it was wild—it was Santa Cruz at its splashiest.

TO PUT THINGS IN PERSPECTIVE

Here's what was happening:

1939 *The Wizard of Oz* premieres. World War II begins.

1940 Americans laugh at Burma Shave roadside verses. Fibber McGee starts a national radio tradition.

1942 Corn dogs are introduced at the Texas State Fair. RCA creates the first gold record to honor Glenn Miller's "Chattanooga Choo Choo."

1943 The jitterbug dance craze sweeps the nation.

1945 World War II ends. A Gallup Poll asks "Do you know what television is?" and many Americans do not.

1947 The World Series is telecast for the first time; the Yankees win.

1948 Leo Fender invents the electric guitar.

1949 RCA introduces the 45 rpm record and player.

1951 Color television is introduced.

Water Carnival performer Don Patterson is "The Daring Young Man on the Flying Trapeze," wearing muscle-bulging green tights, with medals hanging from his massive chest.

PLUNGE PERFORMANCES

The Plunge Water Carnivals featured far more than swimming and aquabatics. During the 1930s, a portable stage would sometimes cover a corner of the small swim tank or a platform would be erected on the east end of the balcony, so that professional acts might perform without getting wet. At the west end, a two-level balcony platform was the stage for many performers. In those years and during the 1940s as well, Maurice Kealoha and his Polynesian Band (also called the Tahitians and the Water Carnival Hawaiians) played on Saturday nights, as the mighty Don "Bosco" Patterson thrilled the crowds with his stunt dives. Band members were swimmers, singers, and accomplished musicians. Patterson would dive through a hole in the roof, plunging into nine feet of water.

Other headliners included Scotty Weston and his famous troupe of youthful dancers as well as the Dick, Dot, and Dottie trio. In the early 1940s, the *Santa Cruz Sentinel* took particular note of one act: Emil and Evelyn, the King and Queen of the Teeter Board. The two were an acrobatic and balancing team that performed their feats from Chicago to San Francisco. In one stunt, Emil jumped off a tall pedestal onto the teeter board, propelling Evelyn high into the air. Swiftly, Emil ran and caught Evelyn in a hand-to-hand stand after she had completed a double somersault in midair.

Norman "Count" Hanley, the San Francisco Olympic Club's great aquatic comedian, was also a Plunge Water Carnival star. His act featured such stunts as demonstrating the art of indoor surfing, less-than-graceful diving, and misadventures with a rubber trapeze. The Count and Bosco Patterson were a great comedy diving team.

Thirty thousand people witnessed the summer performances each year. It was the home of the world record–holding Underwater Natators (aka the Human Submarines), flying trapeze artists, fire divers, Stratosphere Plungers, water ballet performers, and Slide for Life daredevils. The annual saltwater epic inspired newspaper spreads in the *San Francisco Examiner*, the *San Francisco Chronicle*, the *San Francisco Call Bulletin*, and the *New York Times*. *Ripley's Believe It or Not!* highlighted the show's Ruth Kahl, holder of a world record for underwater distance swimming. Curley Grieve, sports editor of the *San Francisco Examiner*, wrote that the Water Carnival was a "hometown production that, for thrill action, surpassed the celebrated Billy Rose World Fair Aquacade in 1938."

Carnival performers ranged from toddler to octogenarian, from local swim club hero to Olympic champion, from serious endurance swimmer to aquatic clown.

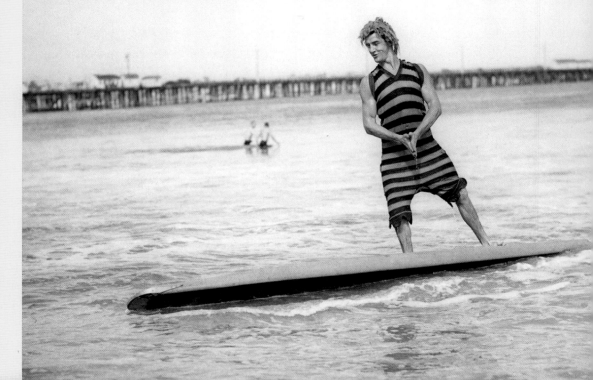

Norman "Count" Hanley, circa 1939.

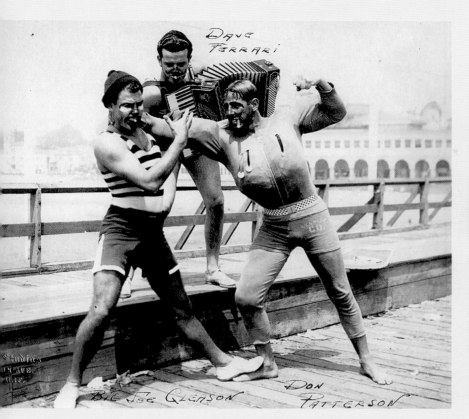

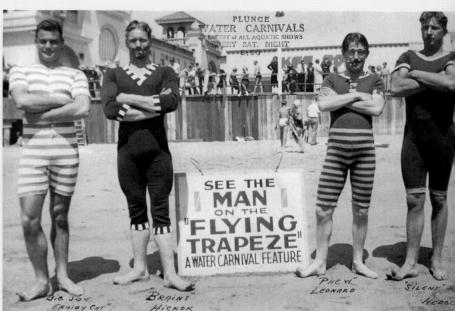

ABOVE: Cutting up in 1936 are "Big Joe" Gleason, a member of the Water Carnival comedy diving team; accordionist Dave Ferrari, who was in his ninth year of furnishing music for the Water Carnivals, playing tunes like "The Daring Young Man on the Flying Trapeze" and "Asleep in the Deep"; and Don "Bosco" Patterson of Slide for Life fame.

ABOVE: Water Carnival clowns were also part of the amusements (left to right): "Big Joe Fraidy Cat" Gleason, "Brains" Hickok, Hugh "Phew" Leonard, and "Silent Ray" Hedgepeth, 1936.

BELOW: Some of these 1928 Plunge Water Carnival performers were lifeguards. From left: Skip Littlefield, Curly Costa, Jack Ritter, Bosco Patterson, Pete Morris, and Ernie Kiff.

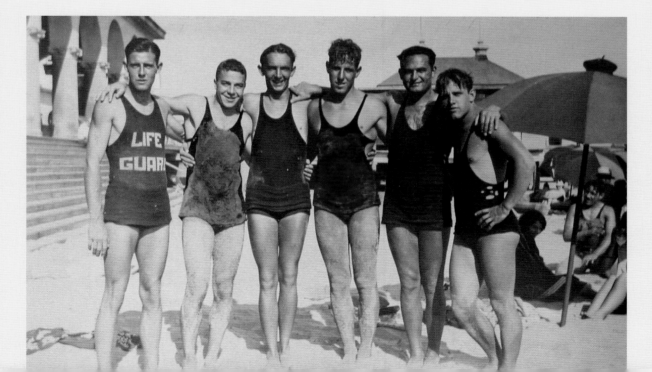

SKIP LITTLEFIELD: A LIFETIME AT THE BOARDWALK

You could almost say that Warren "Skip" Littlefield grew up on the Santa Cruz Beach Boardwalk. A native of Santa Cruz, Skip spent his youth on the waterfront, and by age eleven, he was working as a pin boy at the Boardwalk's ball pitch game. He witnessed firsthand the sensational promotional antics of Fred Swanton and M. C. Hall, and these made an impression. In 1927, as Pacific Coast swimming champion out of Stanford University, Littlefield was hired as the first beach lifeguard. He went on to serve as chief of the lifeguard corps from 1934 to 1967. He began participating in the Plunge Water Carnivals, sometimes racing to try to beat his own swim records. In 1928, Littlefield became manager of the Plunge, and by 1936, he was named director of the shows themselves, all while announcing acts and continuing as a featured swimmer.

In the 1930s, Littlefield picked up where the early promoters left off, instilling enthusiasm and providing showmanship for the Water Carnivals. He was the master of ceremonies, and the shows he put on drew thousands of visitors to the beach to see trapeze artists, the Slide for Life, and great athletes. He brought the great Hawaiian waterman and Olympic champion Duke Kahanamoku to the Boardwalk in 1938 to give his last Plunge swimming exhibition. Kahanamoku visited two or three times after 1939, always accompanied by Hilo Hattie and a Hawaiian band. When Kahanamoku was at the Plunge, Water Carnival performer Helen Graham would take swim lessons from him.

Littlefield brought in other acts and performers, too. Harry Owens and his Royal Hawaiians, one of the most popular big bands of the day, played in the Plunge as well as the ballroom. Littlefield also became emcee for the annual Miss California Pageant that was held at the Boardwalk. Rarely seen without a smoke stuck in the corner of his mouth and a hat on his head, he liked to spin yarns about Swanton and the Boardwalk's early days. Early on, Littlefield took responsibility for being the amusement park's first unofficial historian, and he enjoyed sitting down at the typewriter and pounding out stories about the waterfront and the characters he met and loved. His archives are voluminous and the source of much of the information we have today about the Boardwalk.

LEFT: Plunge manager Warren "Skip" Littlefield, photograph circa 1936, spent more than fifty years as an integral part of the Boardwalk, from the late 1920s into the 1980s.

BELOW: This section from a 1938 Plunge Water Carnival Poster features the Carnival's most talented performers.

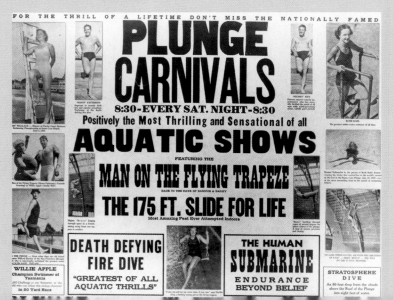

SWIM STARS AND STARLETS

The Boardwalk was a big treat for high school kids, who would spend time at the penny arcade and the Plunge. Betty Lewis, a local historian in Watsonville, recalls watching schoolmates Helen Graham, a champion swimmer, and Marilyn Sullivan, a champion diver, practice in the Plunge after school. Many Santa Cruz youths took their first strokes in the Plunge pool as part of the Red Cross Learn to Swim programs.

Ruth Kahl, from Merced, California, was sixteen when she beat the world record for underwater swimming and was recognized by Robert L. Ripley's *Believe It or Not!* In 1937, Kahl astounded the Water Carnival audience by swimming underwater a length of 303 feet. Swimming legend Duke Kahanamoku was once quoted as saying that Kahl was "the greatest underwater swimmer I have ever witnessed."

Dido "Submarine" Scettrini, also known as the Human Submarine, learned about underwater swimming from Ralph S. Miller, then the manager of the Plunge. Scettrini was the first Santa Cruz Human Submarine. From 1919 to 1930, he performed in the Plunge and the Water Carnivals, and in 1928, he held the unofficial world's record for underwater distance swimming: 341 feet. His performances were billed as "Endurance Beyond Belief," which no one ever contested. Most subsurface swimmers of the time used a straight breaststroke, but Scettrini preferred a scissors kick with a double arm stroke.

The Red Cross offered Learn to Swim programs in the Plunge. In this 1942 photograph, the adults (left to right) are Red Cross representative George Hughling and Water Carnival performers and swim instructors Ernest Kiff (also a Plunge lifeguard) and Billie Cruze (also a water ballet performer).

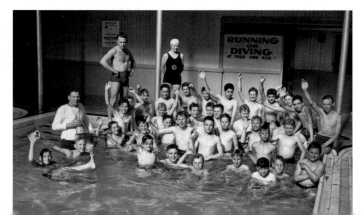

Helen Graham, great Santa Cruz sprint swimmer and Plunge Water Carnival star, relaxes at the pool's edge, 1944.

ABOVE: Ruth Kahl's feats at the Plunge as an underwater swimmer were recognized in this 1938 edition of the *San Francisco Examiner.*

RIGHT: Dido "Submarine" Scettrini, aka the Human Submarine, held the unofficial world's record for underwater swimming in 1928.

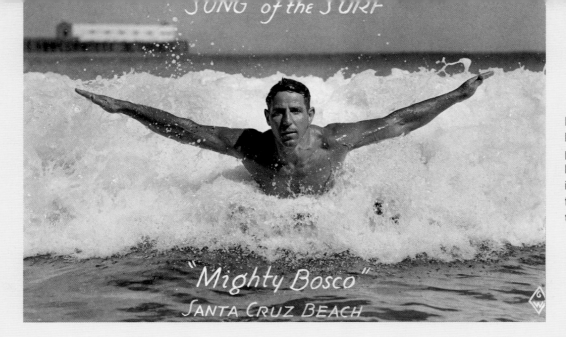

SONG of the SURF

"Mighty Bosco"
SANTA CRUZ BEACH

Don "Bosco" Patterson—bodysurfer, lifeguard, surfboard king, and trapeze performer—was dubbed "Song of the Surf" by Plunge Manager Skip Littlefield, expanding Bosco's sky-high local reputation even further when this 1938 photo appeared in two hundred U.S. newspapers.

THE MIGHTY BOSCO DIVES AGAIN

In an article that appeared in the *Santa Cruz Sentinel* on September 24, 1961, Don "Bosco" Patterson recalled the events that led to one of his most daring stunts—the spectacular Stratosphere Dive:

"Skip Littlefield was the master of ceremonies, and he used to keep building me up—telling the crowd that next week I would be diving from a higher platform. So during the week I'd have to make good for the crowd by climbing higher for a practice dive," said Patterson.

"He finally promised the crowd that I would dive from the steel girders in the ceiling. That was a sixty-five-foot-plus drop."

He got so he could do a one-and-a-half from the girders and once even tried a back flip.

One week after a particular spine-wrenching dive, Patterson told Littlefield sarcastically: "I suppose you'll be cutting a hole in the roof next to get me a little higher."

About two days later Littlefield called Bosco to the pool and together they lifted their eyes upward.

There, eighty feet above the surface of the water was a small hole cut in the roof.

"There she is," beamed Littlefield. He had taken the opportunity to cut the hole when the company president was out of town.

"I climbed up on the roof and looked down through the hole. You can't print what I thought. Then I walked slowly down the length of the roof and thought it over," he said. "The conclusion that I arrived at was that if I was ever going to make it, I'd have to walk straight for that hole in the roof and jump.

"That's what I did. It felt like anything but water when I hit."

Eventually, Patterson even put a twist on the spectacular dive. He would jump from a platform some twenty feet above the roof, through the hole, and then do a one-and-a-half somersault—having to wait to clear the girders before he began his turns.

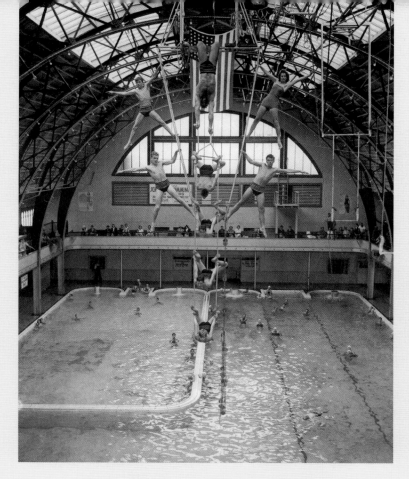

In a 1938 Plunge Water Carnival practice session, Don "Mighty Bosco" Patterson holds five hundred pounds of young performers suspended from the rigid trapeze. Harry Murray is at Bosco's right and Virginia Smith at his left. On the next level, (left to right) are Nelson Dean, Ditty Thomas, and Bill Mitchell. On the ladder below (top to bottom) are Freddie Baldwin, Bill Lidderdale, and Jasper Ayres.

Handsome Don McNair, a 1939 record holder for underwater swimming, poses for a Jantzen swimsuit ad.

RIGHT: Esther Fields Rice, member of the Santa Cruz Plunge swimming team, coached by Mac Alpine, 1924.

FAR RIGHT: The Plunge Carnival Water Ballet Team poses in 1941.

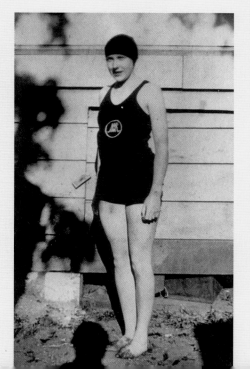

95

DUKE KAHANAMOKU

Native Hawaiian Duke Kahanamoku is the only man to be elected to both the international Swimming Hall of Fame and the Surfing Hall of Fame. Kahanamoku was an all-around waterman, a veritable machine in the water. During the 1920s, the so-called golden age of sports, he tied the world record for the fifty-yard freestyle. He was already an Olympic champion when he gave a swimming exhibition at the Plunge in 1920, having taken the gold for the United States in the one-hundred-meter race at the 1912 Stockholm games. Just two months after his Santa Cruz appearance, Kahanamoku repeated his Olympic gold-medal performance, winning at the 1920 Antwerp games and beating his own mark.

"Duke swam an eight-beat crawl," Santa Cruz Beach Boardwalk historian Skip Littlefield later wrote of his Hawaiian friend. "He wore a size 13 shoe and his flat feet were the biggest paddles in competition. It is ironic that the world will never know how fast Duke could actually travel. He often told this writer that when he was young he never swam for time—only fast enough to win. If modern scientific training standards had been applied to the Hawaiian in his prime, the record book would have been a discouraging outlook for future swimmers."

Recognized as the father of modern surfing, Kahanamoku put his board to new use—as a rescue device—one day in 1925. Witnessing a fishing boat capsize off Corona del Mar, California, he jumped into the surf and rescued eight passengers with only his wooden board. Thirteen years later, in 1938, on another visit to Santa Cruz, Kahanamoku helped generate local interest

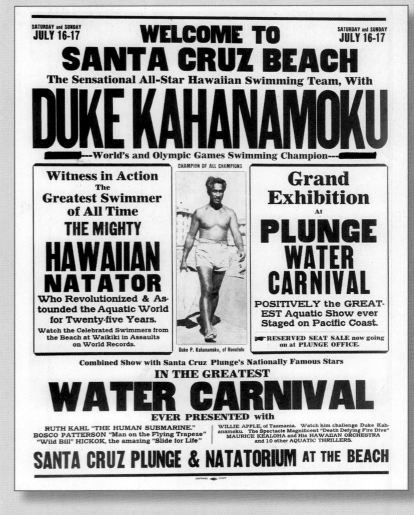

ABOVE: This 1938 poster for the Plunge Water Carnival spotlights Duke Kahanamoku.

LEFT: Duke Kahanamoku, 1938.

in surfing by riding his fifteen-foot board through the surf off the western end of the beach.

During that same trip, Kahanamoku put on what would be his final show at the Plunge. Nearly fifty years old and a little gray at the temples, he "concluded a half-hour's exhibition by thrashing through fifty yards in 24 seconds flat," according to Littlefield, who witnessed the feat. Embarrassed by his time—almost identical to his best at age twenty-one—the five-time Olympic medalist confessed that he was "out of shape."

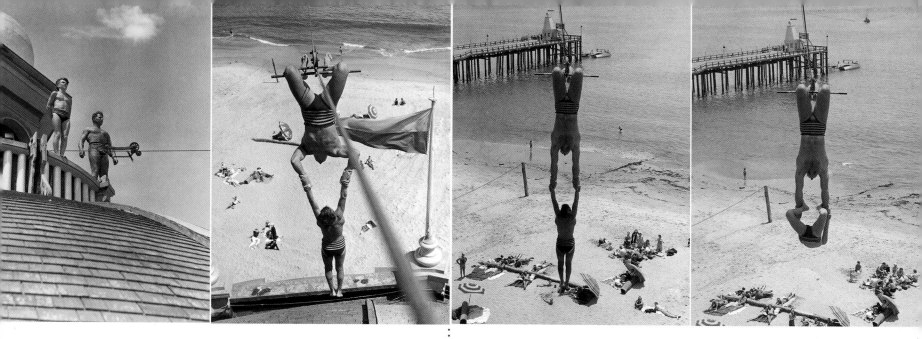

THE SLIDE FOR LIFE

Karl Wallenda was known as the greatest wire walker of the twentieth century, but even this amazing aerialist is quoted as saying he would not want any part of the Santa Cruz Boardwalk's Slide for Life. That didn't seem to concern Don "Bosco" Patterson as he stood atop the Casino roof on a fine summer day in 1940. As the Mighty Bosco surveyed the crowd on the sand more than one hundred feet below him, spectators strained to see his swim-trunk-clad body and that of his twelve-year-old assistant, Harry Murray, silhouetted against the sun's warm reflection on the dome.

From where Bosco and Harry Murray stood motionless, a taut cable stretched 750 feet to a winch house at the end of the Pleasure Pier. With the crowd silenced, Bosco grasped the handlebars of a trolley carriage attached to the cable. With no safety net and his partner clinging to him, the Mighty Bosco hurled his body down the cable until—in the last seconds before the trolley slammed into the pier—they dropped to the ocean waters.

The twelve-second Slide for Life ride was one of the events that brought fame to the Beach and Boardwalk. In 1940 the State of California deemed the stunt "too hazardous for minors." Harry Murray was replaced with Marion Blake, another Water Carnival performer.

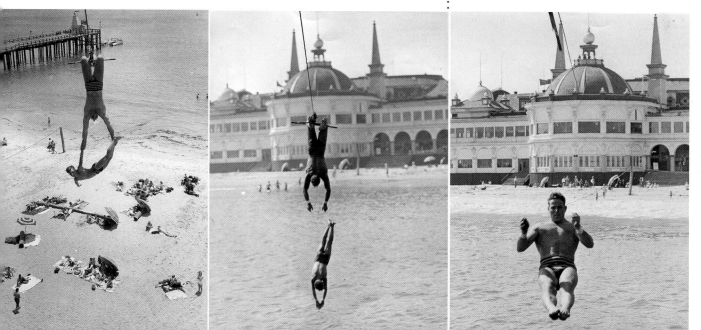

In this Slide for Life photo sequence "Mighty Bosco" hangs from the cable on a speeding trapeze, with young Harry Murray suspended below, 1940. Many versions of this stunt were performed until 1945.

THE FIRE SLIDE FOR LIFE

So many people packed Santa Cruz Beach that the sands could hardly be seen. The Fire Slide, one of the most dangerous stunts ever achieved, was also the most popular.

The performers who did the Fire Slide were daredevils of the first magnitude. For this act, Don Patterson would put on layers of sweatshirts and sweatpants, and on top of that he wore an old two-piece bathing suit. With his head wrapped in wet towels, Patterson was doused with gasoline. A flaming matchbook was thrown at him, and he dove through the darkness into a saltwater pool forty feet below—or more than seven hundred feet from the top of the Casino to the Pleasure Pier.

Plunge performer Ernie Kiff describes the stunt:

We used to have this man named Costa who did the fire dives. He always told you how dangerous it was, and how many times he'd been burnt. Well, one night he got too much wine in him, and he couldn't go up. So Skip said, "Ernie, get his clothes and you go up." I said, "I don't want nothin' to do with it." So he turned to me and said, "You have to do it." So I got into his things, somebody came in and grabbed me, and got me numerous sweatshirts, and sweatsuits, and several towels around the head, wrapped with a sort of peak here [shelving out below the face, like a barricade] so the flame would come up and then go out and around . . .

We had fire extinguishers and everything up there, because we didn't know what was going to happen . . .

Oh, we'd stay ignited from the top of the Casino to the end of the Pleasure Pier, ten to twelve seconds . . .

We'd wear heavy socks. We always had an oversize bathing suit. Just before take off, we would douse the bottom part of the suit in gasoline, and then pull it up on our legs. Gasoline burns pretty fast, and pretty hot.

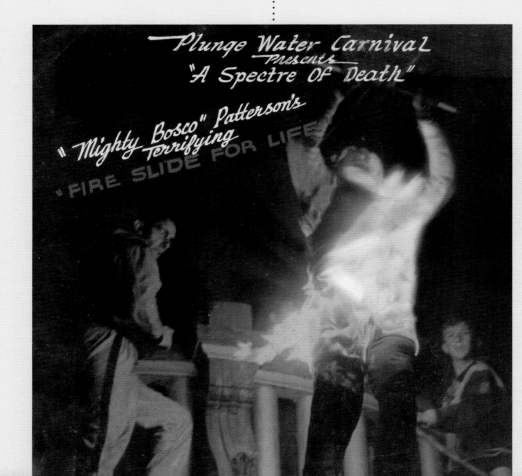

On the top of the Casino in 1940, Moreland "Paddlefoot" Gillen (left) ignites the Mighty Bosco as young Harry Murray (right) stands back and watches.

A HAVEN DURING THE WAR YEARS

December 7, 1941—Pearl Harbor is attacked. The United States shifted into war mode, and fun and frivolity soon seemed distant memories. The Santa Cruz Chamber of Commerce optimistically felt that American tourists, deprived of the opportunity to vacation in Europe, might find pleasures closer to home; but it wasn't to be.

Gasoline and tire rationing contributed to a cutback in travel. The Southern Pacific Railroad ceased operation of the Sun Tan Special. Many of the Boardwalk's workers were called into military service, leaving only a skeleton crew and a limited maintenance staff. The need for paper in the wartime economy led to restrictions on newsprint,

This July I, 1941, Associated Press photo appeared in more than two hundred newspapers. In the early 1940s, Dorothy Decker headed the Plunge Water Carnival water ballet team and was called "the lass with a million-dollar smile." Her sisters, Elaine and Mary, were also water ballet performers.

and advertising was therefore vastly curtailed. If you could not get the word out, there was even less chance that tourists would come.

By 1943, the popular Casa del Rey Hotel, a former mecca for tourist and convention business, was converted into a naval hospital. The Plunge was pressed into duty as a therapy pool for the injured and a temporary training facility for Coast Guard lifesaving instructors, while the 963rd Amphibious Brigade set up camp near the banks of the San Lorenzo River.

Some Boardwalk games featuring the bombing of Pearl Harbor, or Hitler, Mussolini, and Japanese warplanes as targets, reflected fear of invasion along the California coast. The Home Guard patrolled the beaches on horseback, lights on the Boardwalk were dimmed, and canvas blackout curtains were hung along the Boardwalk from the Casino to the mouth of the San Lorenzo River. It all led to one conclusion: the war was dealing a dramatic blow to tourism in Santa Cruz.

RIGHT: Cousins Stella Loero and Malio "Stago" Stagnaro pose for a publicity photo in 1941 for Day on the Bay aboard Joe Loero's lampara launch, *Cella Bessie.*

BELOW: Friends Mary Moreland, Nancy Stone, and Betty Tyson on the Santa Cruz Boardwalk, Easter Week 1945.

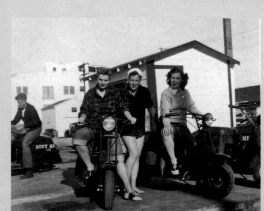

Boardwalk artist Mary Pedri did quick-profile sketches at the Casino in the 1940s, as well as at the San Francisco World's Fair in 1939. She recalls: "It was the Big Band era and dances were held on Saturday nights. It was also wartime, and soldiers were recuperating at the Casa del Rey Hotel. I did my sketching at the center of the Casino. The profile sketches were done simply with colored chalk, always aiming for the likeness. At the same time, I volunteered to sketch at the USO."

TOP: Artist Mary Pedri at work, 1940s.

ABOVE: One of Mary Pedri's wartime profile sketches.

During World War II, the Pleasure Pier was renamed the United Nations Pier after thirty U.N. flags were hoisted on the pier during a 1943 Memorial Day program. This photo captures the 1946 Fourth of July holiday.

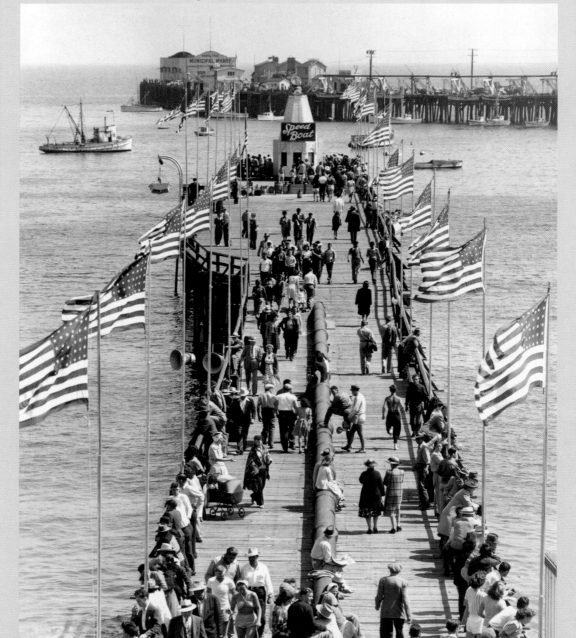

In October 1999, Rae Whiterose presented these two letters to the archives of the Santa Cruz Seaside Company. They were written to her father, Barney Segal, working at the Boardwalk's Bright Spot Concession, during wartime.

Servicemen in the Casa del Rey read letters from home, 1940s.

Barney Segal

c/o Bright Spot
Santa Cruz Calif

Postmark:
Jul 19, 1942

Free Mail
Passed by Censor

July 12–42

Hello Barney,

How's the Coke man coming along. Fine and dandy I hope and preparing to put away a good deal of Cokes so that when Sandy and I come back to your place again we won't have to worry about going dry.

Say Barney, in your spare time how about keeping an eye on Linda & Kitty for us and give us the low down on how many dog faces (soldiers) they date. I don't mind if they go out with Marines but I can't see what they can see in some soldiers.

How was business on the fourth? I imagine it was pretty good. I sure wish I could've been there to enjoy the blondes, I mean fireworks. Were they very good. The fireworks I mean or didn't they have any.

By the way, the next time you pass the Fun House tell Dorothy I said "hello" and also the blond in the frosted malt shop. She sure was a honey. It's too bad I couldn't have more time with her.

Well Barney this ends all for the time so will close with the ·

Your Staggering Maine Friend

P.F.C. N.J. Meakins
USS Boise
c/o Post Master
San Francisco
Calif

P.F.C. Wm. Sanders
USS Boise, M.D.
c/o Fleet Post Office
San Francisco, Calif.

Mr. Barney Segal
c/o Bright Spot
Santa Cruz, Calif.
Free Mail

July 13, 1942

Hi Barney,

How are you getting along now days? O.K. I hope. Meakins & I are still kicking & ready to see you again. How was the 4th of July? I'll bet you really had a time & how was the crowd. Sure wish that I could have been there with you to help celebrate.

It was just another day for us & nothing happened.

Does Kittie ever say anything to you about me or vice versa. Sure miss the kid and the whole bunch.

Meakins says hello.

Well guess I will have to close now because I can't think of anything else to say.

A Pal
Sandy

P.S. Give Dorothy (Fun House) my love & Linda also. Did a tall blond ever say anything to you about me. Will tell you about it someday.

P.F.C William E. Sanders

RIGHT: At the entrance to the Pleasure Pier, hundreds of upturned faces focus on the 1950 Fourth of July fireworks extravaganza.

FAR RIGHT: For many vacationers, sun, sand, and sea air led to romance, 1946.

FORGET YOUR WORRIES— VACATION IN SANTA CRUZ

As tourism dropped off during the war years, Santa Cruz did its best to lift the spirits of families at home. The bowling alley was closed, and Miss California Pageants were cancelled for the duration, but that didn't keep the sun off the sand or the beauties off the beach. Santa Cruz was filled with kid-again optimism. It became a home away from home for lads in uniform and their often newly found girlfriends. It was a Saturday playland for apple pie–eating kids and families who wanted to forget their cares for a while. Crowds continued to pack the Friday and Saturday night dances at the Cocoanut Grove. Sometimes it seemed that all of Santa Cruz County—and half of Santa Clara County—was squeezed onto the dance floor. The Boardwalk and beach felt young, they were filled with life, and they offered something for everyone—all wrapped up in a striped saltwater taffy wrapper.

In 1944, Santa Cruz Seaside Company president Lewis W. Jenkins Jr. and the people of Santa Cruz knew they had

something good—a haven from the war—and they wanted to make it better. So instead of grousing about gasoline shortages, they installed a new auto scooter ride. Instead of camouflaging themselves in military drab, they hung Allied flags and colorful banners in support of the war.

Until the early 1950s, the Drive-A-Boat ride sat near the east end of the Giant Dipper, where the Boardwalk came out and curved toward the river trestle. The freshwater tank was placed on pilings installed long before World War II. Gas engines powered the little plywood boats, which were not connected to any track but could be steered freely around the tank.

Blackout curtains may have masked the Boardwalk's glittering façade and wartime may have dimmed the bright lights, but enthusiasm just couldn't be dulled. The Santa Cruz Beach Boardwalk was still a great place to be happy. "I was at the Boardwalk," recalled Tony Olanio, a Boardwalk regular, "on a very busy Fourth of July about fifty years ago, searching for a girl I had met in a local office who was something special. It took me two days but I found her— and now we've been married for forty-eight years. I love the Boardwalk and still come down often to enjoy it."

RIGHT: Children found great fun in crashing the boats into one another at the Drive-A-Boat ride.

FAR RIGHT: As young adults, cousins Kathleen Lorence and Doris and Joyce Thompson would drive to the Boardwalk from San Jose to "flirt with the sailors."

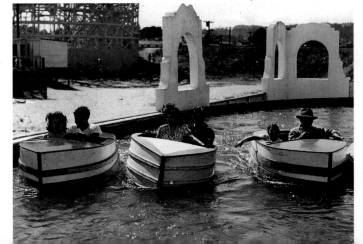

Mary Lee Washburn poses for a Sun Tan Special publicity photo, 1948.

THE POSTWAR ERA AT THE BOARDWALK

The postwar era brought the Baby Boom and a thriving economy—which meant more children, more leisure time, and more disposable income. What better conditions for a revival of the Santa Cruz Beach Boardwalk? With attractions to please those from seven to seventy, Santa Cruz was the place to go. If you liked indoor swimming, the saltwater Plunge ranked as one of the best swimming tanks in the West. For outdoor enthusiasts and daring surfers, the area offered the finest swimming on the coast and the breakers at Cowell Beach. There was sand and sunshine. There were concerts and outdoor shows. There was dancing every night at the Cocoanut Grove, and there was music for jitterbuggers and Big Band lovers alike. And ah, yes, there was food. Hot dogs, hamburgers, red candy apples, soft drinks, turnovers, and saltwater taffy.

Discontinued in 1941 because of the war, the Sun Tan Special train resumed in 1947, bringing huge crowds back to the beach. In June 1947, it contributed to the largest crowds since the previous Fourth of July. And on one Sunday, the Plunge saw its best business since July 4, 1936. Hungry visitors consumed every hot dog on the Boardwalk before the sun set, and an estimated twenty thousand funseekers enjoyed the beach and surf from the wharf to the San Lorenzo River.

Music lovers continued to enjoy performances at the Boardwalk. They relaxed on the sand and enjoyed beach concerts. According to Skip Littlefield, then publicity and advertising director for the Santa Cruz Seaside Company, Santa Cruz was one of four California cities, and the only one of its size, holding regular Sunday concerts for the public. The other cities were San Francisco, Oakland, and San Jose.

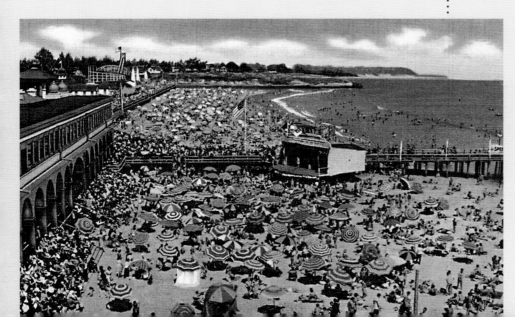

Music fans enjoy a beach concert at the Santa Cruz Boardwalk, 1946.

SUMMER FUN AT THE BOARDWALK

In 1946, visitors poured into town by bus and automobile. Freedom from war gave visitors freedom to have fun with friends and family, to feast on hamburgers, french fries, and ice cream, and to soar and shriek unrestrained on Boardwalk rides.

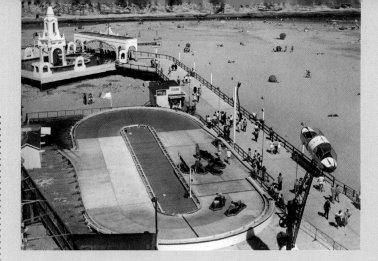

LEFT: Three friends goof around on the Casino's beach, with the Pleasure Pier in the background, in the 1940s.

TOP RIGHT: At the eastern end of the Boardwalk near the Drive-A-Boat ride, freewheeling Auto Speedway drivers raced around the wide, oval track, 1947. From 1928 to 1932, the structure had been used for open-air dancing.

CENTER RIGHT: The original Auto Scooters ride, 1948.

BELOW: Friends from the San Joaquin Valley, Theresa Silveira and Lucy and Mary Garcia stop for an ice-cream cone, circa 1946. At age eighty, Theresa remembered her favorite Boardwalk foods were hamburgers and ice cream, and her favorite ride was the merry-go-round.

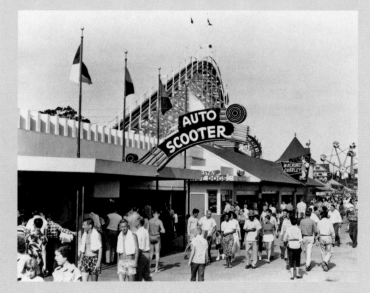

A new concrete deck has replaced the old walk made of boards in front of the Auto Scooter, 1954.

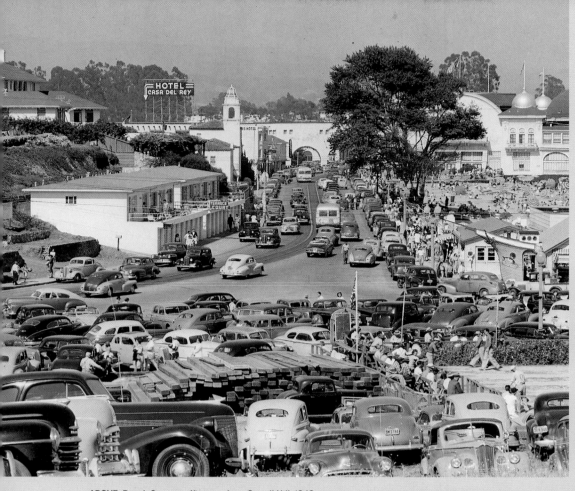

ABOVE: Beach Street traffic seen from Cowell Hill, 1946. Visible are the Hotel Casa del Rey (at upper center) and the arch over Beach Street. Behind the crowd of sunbathers and umbrellas (at upper right) is the Cocoanut Grove's main entrance.

BELOW: 1946, left to right: Mary Garcia; siblings Peter, Theresa, and Joaquin Silveira; and Eddie Furtado cool off in the ocean by the Pleasure Pier. The group had driven over the old Santa Cruz Highway to the beach; they never brought picnic lunches because they loved the food at the Boardwalk. Joaquin was stationed at Fort Ord in Monterey during the war years and later continued to visit the beach and Boardwalk. The friends usually visited Santa Cruz in July to attend the Portuguese fiesta and escape the summer heat of the Central Valley.

BELOW RIGHT: In 1946, the Roll-O-Plane stood across the Boardwalk from the river end of the Giant Dipper (seen in the background). The ride operator looks upward, keeping a close eye on his swooping, spinning passengers.

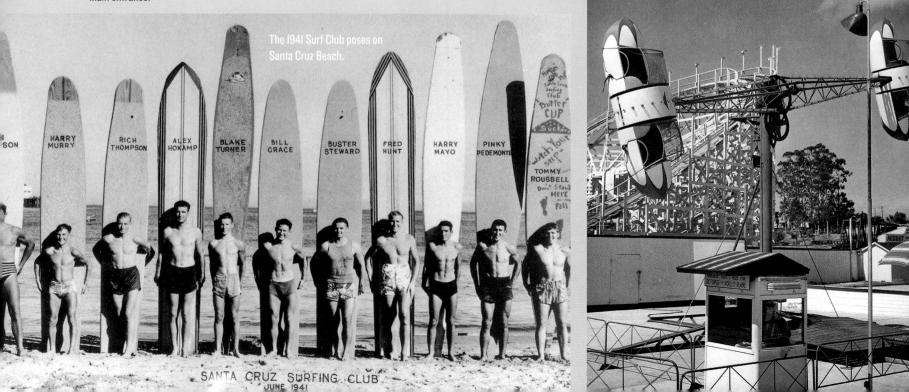

The 1941 Surf Club poses on Santa Cruz Beach.

SON HARRY MURRY RICH THOMPSON ALEX HOKAMP BLAKE TURNER BILL GRACE BUSTER STEWARD FRED HUNT HARRY MAYO PINKY PEDEMONTE TOMMY ROUSSELL

SANTA CRUZ SURFING CLUB
JUNE 1941

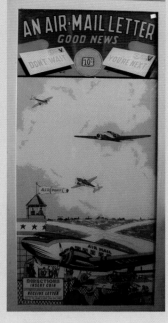

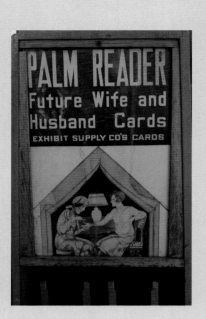

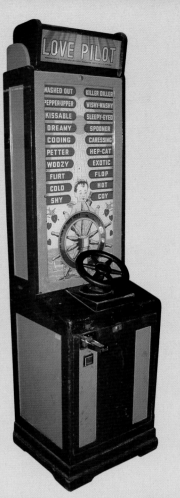

ABOVE: The 1956 Crane machine offers no prizes. With four buttons, the player operates a toy steam shovel to scoop up beans in a given amount of time, racing the clock for a high score. The machine measures the beans moved and rates the player's skill. Arcade operators were cautioned to use only lentils as the gravel.

ABOVE: In 1944, everyone knew what it was like to wait for a letter, and An Air-Mail Letter promised "good news." Insert a dime, squeeze the handle, and there was a letter—just for the player.

ABOVE: The 1950s Palm Reader dispensed Future Husband and Wife cards.

AT RIGHT: This 1938 Love Pilot machine determined the player's personality type.

ABOVE: The Ace Bomber of 1941 gave aspiring pilots four anti-aircraft batteries to shoot at a moving airplane.

RIGHT: The Three Wise Owls considered such important questions as, "What do I need to be happy?" A few answers were: "Outsmart 'em," "Be pigheaded," "Get rich," and "Take a chance."

ABOVE CENTER: The Peps-U-Up in a Jiffy machine called for players to "revive your tired feet and legs." Those who partook would slip in a coin, stand on a plate, and this vibrator would massage your tired feet, benefiting your legs as well.

ABOVE RIGHT: Once a player found out who his or her future mate would be, this machine was the next step in family planning.

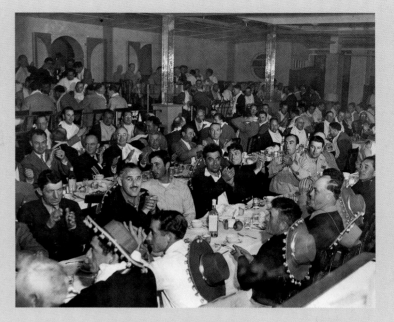

Johnny Cecchini, Malio Stagnaro, and Salvatore Ferranti sang "Rancho Grande" at the 1939 Day on the Bay banquet. They gave a repeat performance for the 1941 KDON radio program of songs from the Santa Cruz Commercial Fishermen's Singing Society.

At this Day on the Bay cioppino banquet at the Casa del Rey, members of the Santa Cruz Commercial Fishermen's Singing Society can be identified by their Spanish Don hats, 1946.

For years the Boardwalk was home to annual Day on the Bay banquets, a promotional event in which newspapermen were wined and dined to encourage them to write about Santa Cruz Beach. Most of the men who sang for the banquets at the Casa del Rey Hotel during the 1930s and 1940s were members of the town's pioneer fishing families: the houses of Bassano, Beverino, Bregante, Canepa, Carniglia, Castagnola, Cecchini, Faraola, Ferranti, Getchell, Ghio, Gomez, Loero, Oliveri, Perez, Pieracci, Piexoto, Simoni, Stagnaro, Teshara, Thevinen, Uhden, Wilbur, Zolezzi, and many others. These names are engraved on the pages of Santa Cruz history, and their descendants are an important part of the community.

By 1946, Beach Street traffic had really picked up, and Cowell Hill was used as a parking lot. On Memorial Day weekend, when the weather was beautiful, there was a special beach bandstand performance, and naval ships stationed off the coast attracted thousands of visitors to the beach. An early July day was just as crowded, when revelers filled the Boardwalk to bursting, forcing the Plunge to stop selling tickets at three o'clock because the pool was full.

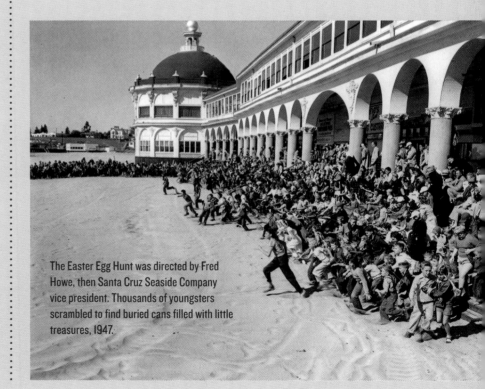

The Easter Egg Hunt was directed by Fred Howe, then Santa Cruz Seaside Company vice president. Thousands of youngsters scrambled to find buried cans filled with little treasures, 1947.

107

THE BOARDWALK'S GAME BOYS: A FAMILY EXPERIENCE

The Santa Cruz Beach Boardwalk has always been a family experience, and the Whiting family has been a part of that experience for eighty years. In 1927, S. Waldo Coleman, president of the Seaside Company, hired Joseph "Ross" Whiting to be superintendent of the Casa del Rey Hotel. Whiting later joined the company and became superintendent of the Boardwalk itself. He was responsible for the first widening and paving of the Boardwalk. In 1938, the Seaside Company introduced a miniature, gas-powered, streamliner train—engineered and built by Ross Whiting—that ran from the Pleasure Pier to the end of the promenade up the San Lorenzo River.

In 1946, Whiting left the Seaside Company and, with his wife, Sara, operated the shooting galleries that had been run by gunsmith James O'Connor. The guns used live .22-caliber ammunition—ten shots for a quarter.

Joseph "Ross" Whiting, circa 1935.

Whiting's Killer Beez was a popular game where guests competed for stuffed animals.

When Ross, and his second wife, Butchie, retired in 1972, his son, Ed Whiting, took over the concessions, which had long since been converted to games of skill. Ed was a mechanic at the time, but says he was happy to take over the business with his wife, Jeanne, after growing up around the Boardwalk. His son and daughter, David Whiting and Heidi Whiting-Sussman, have grown up in the family business, which over the years has operated such games as TicTac, Frogger, Killer Beez, Darts, Pitch-In, and Clown Toss. Another branch of the Boardwalk's Whiting family business began with Ross Whiting's brother, Dr. Les T. Whiting, who started Whiting's Food Concessions in 1953, when he bought the Bright Spot concession.

This red-and-silver streamliner train, introduced in 1938, had an engine on each end to make turning around unnecessary. In its day, it was an extremely modern attraction.

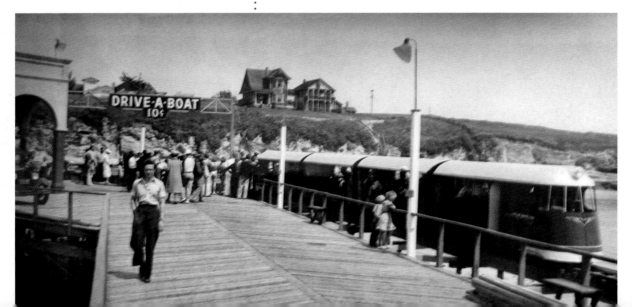

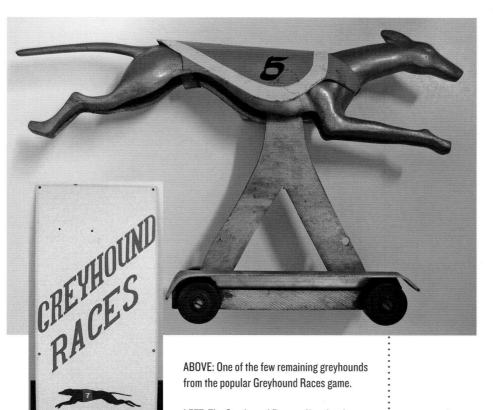

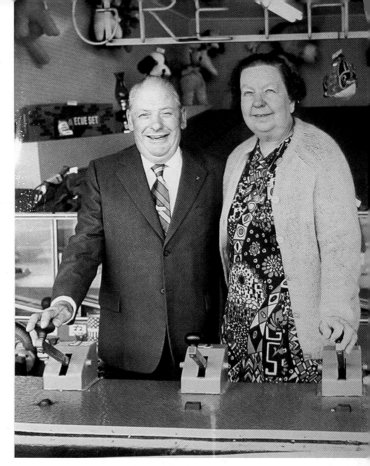

ABOVE: One of the few remaining greyhounds from the popular Greyhound Races game.

LEFT: The Greyhound Races offered a chance to compete for prizes for only 25 cents a game.

ABOVE RIGHT: Domenic "Jimmy" Giovinazzo and his wife, Betty, 1973.

Domenic "Jimmy" Giovinazzo and his wife, Betty, came to Santa Cruz in 1922 with the intention of going into the nursery business. Even after beginning his Boardwalk career, Giovinazzo was always known to have a large vegetable garden at his home on Columbia Street. In 1933, with an eye for opportunity, Giovinazzo and a partner, Homer Barker, bought out a Boardwalk concession operator named Raymond Smith. Smith operated Greyhound Races. During play, a recorded voice cried, "Where's my doggie? Where's my doggie?" with the sounds of barking dogs in the background. Giovinazzo and Barker bought the business for two hundred dollars. After the first season of operation, the partners had just seventy dollars left over. This was not enough for Barker, who left the partnership. And what about Raymond Smith? Years later, he moved to Reno, opened a little place called Harold's Club, and became one of the founding fathers of the Nevada gaming industry.

Giovinazzo stayed on at the Boardwalk, however, operating his concession with Betty and their family. His philosophy was to keep his business open year-round. In the 1930s, he would open 365 days a year, always looking for a stray nickel. Rarely seen without his trademark yachting cap, Giovinazzo would talk to customers in his thick Italian accent. He also operated the Walking Charlie game, where players would throw baseballs at moving mannequins wearing various hats. Knock off a hat and you were a winner. Next to that was his Cat and Cane target game. Giovinazzo retired in 1973, and Canfield Concessions purchased his operation.

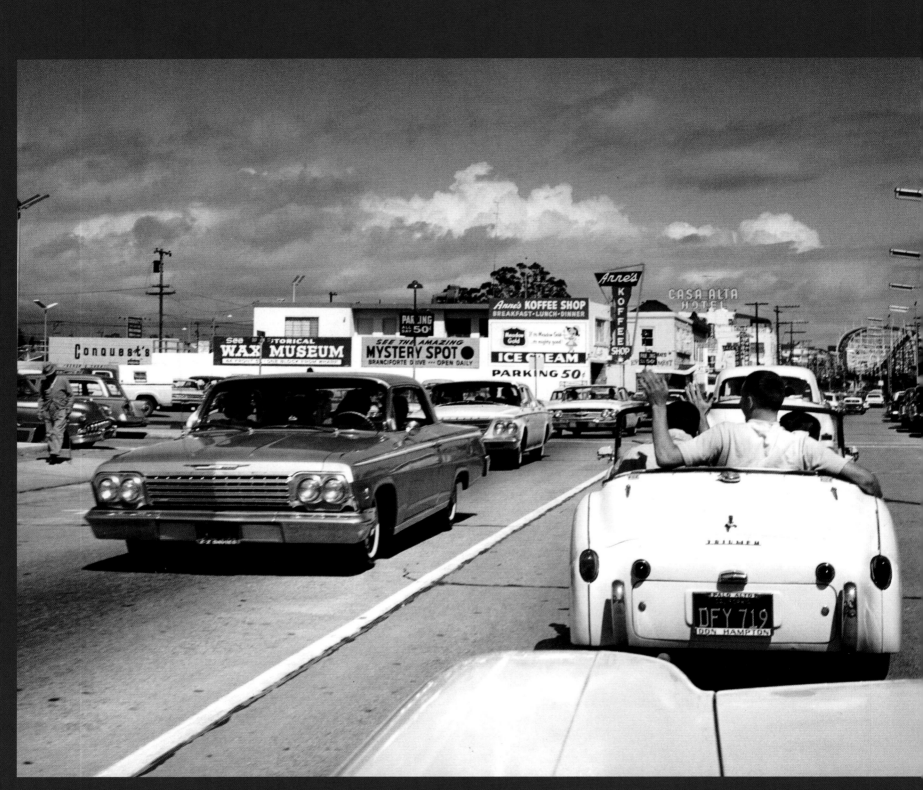

In the 1950s and 1960s, Beach Street was bustling. In this circa 1958 photo, teenage boys cruise up and down the street.

The Vacation Parade

IN THE 1950s AND 1960s, Santa Cruz Beach wasn't just a stretch of sand; it was a family vacation destination—and California families loved road trips. People came to the Santa Cruz Beach and the Boardwalk because their parents had. And those parents had learned to love it from *their* parents. "The beach" was a magical phrase, filled with memories of fun and frolic that had been passed from generation to generation. By the time the first wave of Baby Boom kids hit the sands, it was a full-fledged love affair of sunshine, surf, and suntan lotion.

The 1950s brought a booming population and a booming economy to the country, but this period also brought dramatic change to the amusement park industry. Tourists demanded more action and newer rides. Across the country, many parks fell into disrepair, and some were even forced to close. In 1955, the biggest threat to the traditional amusement industry was unveiled: the first massive theme park—Disneyland—opened its doors.

Small and sparsely populated, Santa Cruz depended on its important three-month summer tourist season. But it would not be intimidated by shifts in taste or the rise of the theme park Goliaths. Before long, efforts were made throughout the town to increase the valuable tourist trade. Modernization efforts were under way, and the Dream Inn Hotel and several smaller motels were built. New advertising campaigns were launched. Perhaps most fortunately, in 1952, Laurence Canfield, longtime member of the Board of Directors of the Santa Cruz Seaside Company, had taken over as president. Under Canfield's direction, the Casino underwent a total facelift. The largest paved parking lot in Santa Cruz County was built. And the Boardwalk introduced the Wild Mouse, billed as the "most sensational ride of the century."

Slowly, over the next ten years, many older buildings were demolished, making way for modern facilities with features fitting the times. A miniature golf course replaced the Plunge, and a new merry-go-round building was constructed. The Miss California Pageant drew record-breaking crowds to Santa Cruz Beach. The Boardwalk in tenacious Santa Cruz—the little town that could—held on. The songs of the Beach Boys and others served to raise the profile of California and the sport of surfing. Surf movies and the surfer lifestyle became all the rage. As the popularity of surfing spread, surfers were no longer seen as beach bums; rather, they were now considered fun-seeking outdoor types who embraced a healthy lifestyle—one that would greatly influence fashion, language, and music in the decades to come. Looking for relief from valley heat, people came to the beach year after year, renting a place for two weeks, a month, or the entire summer.

TO PUT THINGS IN PERSPECTIVE

Here's what was happening:

1950s Transistor radios become available and are common on the beach.

1952 Pat McCormick wins the gold for the United States in both the platform and springboard diving competition at the Helisinki Olympics.

1953 The word "virgin" used in the film *The Moon Is Blue* leads to picket lines.

1954 54 percent of American homes have television sets.

1955 Disneyland opens its doors.

1957 The space age begins with Sputnik, the first orbiting satellite.

Local teenager Marilyn Matthews was featured in this billboard promoting Santa Cruz, 1952.

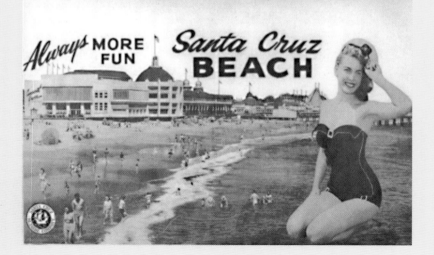

1960 The song "Itsy Bitsy Teenie Weenie Yellow Polka Dot Bikini" is released.

1960s The Beach Boys hit the charts with some of their earliest tunes: "Surfin'," "Surfin' Safari," "Surfin' U.S.A.," and "Surfer Girl."

1961 Alan Shepard becomes the first American in space.

1963 Martin Luther King Jr. tells civil rights marchers in Washington, D.C.: "I have a dream."

1964 The Beatles appear on the *Ed Sullivan Show.* Twenty-eight-year-old Dana Point filmmaker Bruce Brown releases the surfing documentary *The Endless Summer.*

1969 The Woodstock Festival is billed as "three days of peace and music."

1970 The first tan-through bathing suits are introduced.

1976 The Apple I computer is released.

1979 The CD is invented. Bo Derek shows off her tan in *10.* George Hamilton is the first-ever tan Dracula in *Love at First Bite.*

1981 MTV begins on cable TV.

1982 Michael Jackson's *Thriller* sells twenty-five million copies.

1983 Sally Ride is the first American woman in space on the *Challenger* shuttle. Internet domains get names instead of hard-to-remember numbers.

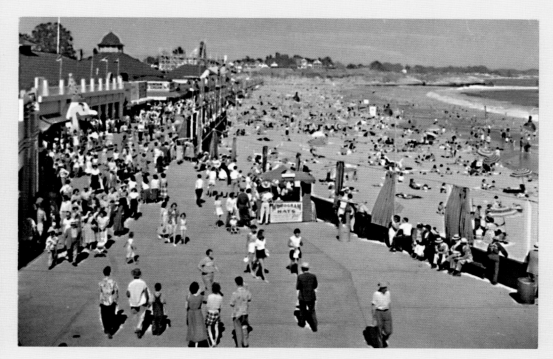

Blackout curtains from World War II are used as wind blocks, 1957.

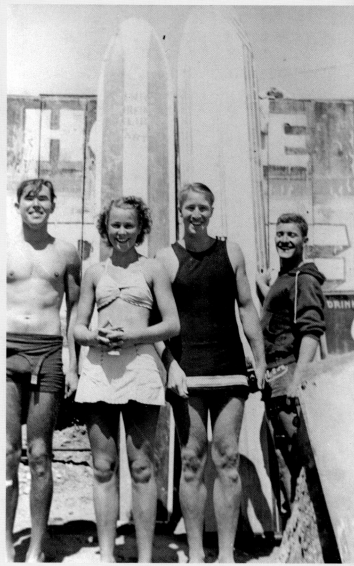

Dorothy and Leo Denevan share time under the Boardwalk with their children in the early 1950s. A later addition to the family, Tish, recalls that each summer for years the family would stay at the Surfside near Second and Cliff Streets: "I have some incredible memories. . . . I loved the old spin art and the flying 'cages.'"

Local surfers (left to right) Jeep Allen, Pat Collings, Fred Hunt (a member of the Santa Cruz Surfing Club), and Lee Sparrow, circa 1940s.

Throughout the 1950s and 1960s, the Boardwalk's outdoor stage shows were particularly entertaining. The type of acts presented might have been seen years earlier in vaudeville; vaudevillians were once again being featured on early television variety shows. Jim Penman performed as the Gabby Trickster in 1952 on the Boardwalk's bandstand stage. A juggler by nature and profession, his gift of gab and subtle humor produced contagious laughter and boisterous crowds. He had a long career in vaudeville, film, and television. Stan Lewis and his Teknicolorettes were a top favorite with youngsters. His laughing, singing, wisecracking marionettes gleefully overacted on a specially designed stage. The years 1953 and 1954 saw performances by Lorraine Stevens, the Juggling Unicyclist, and the Amazing Charltons, a thrilling aerial acrobatic act.

Mary Matsuyama, billed as the "Japanese dancing star whose blazing feet beat a tattoo on the hearts of occupation forces" in Japan after World War II, performed in 1959. Also that year, the Boardwalk welcomed Ma and Pa O'Hagan, with Gay Nineties fun; organist Wally Newbury; Gus and Ursula, a noted European juggling team executing a fast-moving routine of gymnastic impossibilities; Bob Fischer, comedian par excellence; and the Princess White Buffalo Troupe from the Mandan tribe of the Sioux Nation, performing ceremonial dances.

By 1966, surf rock and pop music by such groups as the Beach Boys and Jan and Dean, *Beach Party* movies, and the TV series *Gidget* kept thoughts of the beach fresh in people's minds. Beach culture affected fashions, which became more youthful and casual. Women put on two-piece bathing suits and Sea & Ski suntan lotion, trying for a "healthy-looking" tan. Some families still spent their entire summer vacations at the beach, but there were increasing numbers of day visitors to Santa Cruz as well. After relaxing on the beach, snacking on cotton candy and caramel apples, and riding a few rides, these visitors headed back home.

By the 1980s, the Baby Boomers were bringing *their* kids to Santa Cruz—to dig holes in the sand as their parents had, to ride the Giant Dipper that had terrified their grandparents, and to watch the surfers hang ten. This generational passage of the Boardwalk's visitors continues to this day, bringing joy and fond memories to those who can come and experience its timeless innocence and magic.

RIGHT: In 1966, as in 1906, Santa Cruz was still the perfect spot for dreamy days on the sands.

FAR RIGHT: Kathie Keeley (left), who later became director of sales for the Santa Cruz Seaside Company, is shown with friends Jane Sanders and (right) Rhona Pendergraf outside their spring break rental, one block away from the Boardwalk, 1963.

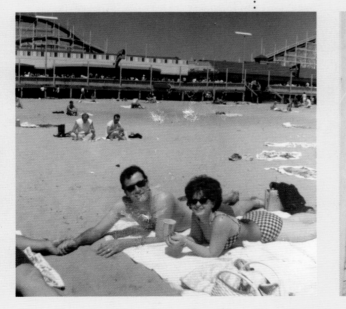

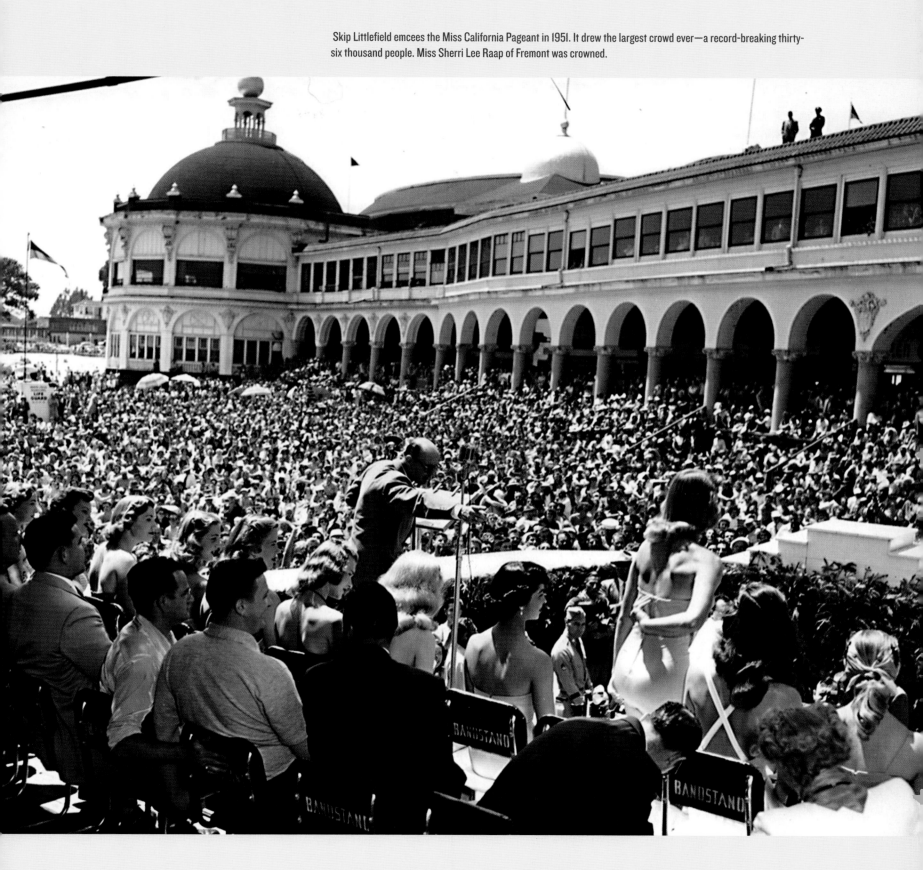

Skip Littlefield emcees the Miss California Pageant in 1951. It drew the largest crowd ever—a record-breaking thirty-six thousand people. Miss Sherri Lee Raap of Fremont was crowned.

THE CANFIELD FAMILY: A RICH BOARDWALK LEGACY

The history of the Santa Cruz Beach Boardwalk and the Santa Cruz Seaside Company would not be complete without including the Canfield family. Charles L. Canfield is the current president of the Seaside Company, which owns and operates the Santa Cruz Beach Boardwalk. But preceding him were three generations of Canfields, a family legacy richly interwoven in local history.

Charles's great-grandfather, Colbert Austin Canfield, was the first resident physician at the Presidio in Monterey, California. A zoologist and the county coroner, Dr. Canfield was also recognized for his scientific writings as a conchologist. In the late 1880s, Colbert Canfield,

Laurence Canfield, 1950.

one of the doctor's sons, became manager of the Dolphin Bath House on Santa Cruz Beach. His brother Charles E. Canfield—known as C. E.—worked as a grocer, later began successful insurance and real estate businesses, and served on the city council. C. E.'s son, Laurence, a graduate of Stanford University in the mid-1920s, was an extremely capable and ambitious young businessman. With his family's love for Santa Cruz and an eye to the future, Laurence invested in the Santa Cruz Seaside Company not long after college.

Laurence joined his father's insurance business right out of college, and he began running the firm after C. E. died in 1943. But he was also vice president of the Santa Cruz Seaside Company and had been on its board of directors since 1928. When Louis W. Jenkins, the head of the company, died in 1952, Laurence took over the reins as president. Today, Laurence's son Charles remembers his father saying that he had all his money

Framed photos honor all Santa Cruz Seaside Company CEOs up to and including Laurence Canfield.

SANTA CRUZ SEASIDE COMPANY

S. WALDO COLEMAN
PRESIDENT
1915 - 1928

ROBERT L. CARDIFF
PRESIDENT
1928 - 1933

JAMES R. WILLIAMSON
PRESIDENT
1933 - 1944

LOUIS W. JENKINS, JR.
PRESIDENT
1944 - 1951

LAURENCE P. CANFIELD
PRESIDENT
1952 - 1984

FRED W. SWANTON
DIRECTOR - GENERAL
SANTA CRUZ BEACH COMPANY
1904 - 1912

FRED R. HOWE
VICE-PRESIDENT
1932-1948

BERT B. SNYDER
VICE-PRESIDENT
1952 - 1955

LESTER H. WESSENDORF
VICE-PRESIDENT
1952 - 1969

CHARLES L. CANFIELD
VICE-PRESIDENT
1969 -

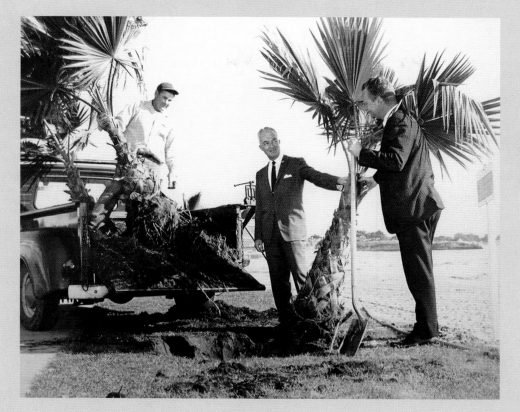

Laurence Canfield planted forty-two palm trees along Beach Street in 1962 and donated them to the city. Left to right: Bill Hawkins, Laurence Canfield, and Carl Bengston.

Charles Canfield and concessionaire Domenic "Jimmy" Giovinazzo with "Walking Charlie," 1973.

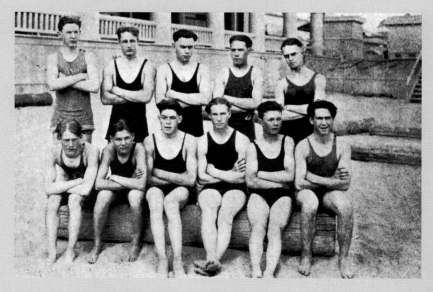

The Santa Cruz High School Swim Team, 1922. Standing, left to right: D. Lent, F. Cooper, L. Harris, C. Royse, and Laurence Canfield. Sitting, left to right: T. Hill, J. Sault, R. Mathis, F. Fletcher, J. Sowder, and W. Ray.

invested in the Seaside Company. "Since there's no one else to run it, I guess I will," he said.

Now in charge, Laurence Canfield traveled to amusement parks across America and Europe, learning from what was done right and what wasn't. Back home, he quickly put his vision for the future into action. Everything from electrical to aesthetics benefited from his attention—he even planted a beautiful row of palm trees that still stand today. Canfield added an extensive basement system to the Boardwalk facilities, for much-needed storage and work space. He understood the importance of the automobile to the survival of business, so he expanded the Boardwalk property to include the county's largest parking lot. He gave the Boardwalk new respectability, and he smartly took a cue from the new phenomenon—thriving parks like Disneyland—by adding new theme rides like Autorama, the Cave Train, and the Logger's Revenge.

In 1984, following Laurence's death, Charles Canfield rose from vice president to president of the Seaside Company. Charles had been a ride operator during his teenage years and became a concessionaire when he returned from serving in the U.S. Navy, so the Boardwalk was truly in his blood. He was his father's son, after all, and had even gone on that European fact-finding trip. Charles's goal was simple: to continue his father's legacy by adding new rides and keeping up with the changing times, while never losing sight of the need for historical integrity and a feeling of nostalgia. True to his roots, yet with a keen instinct for modern trends, Charles has improved not only the park and its attendance but also its image as an original seaside amusement park. It's a labor of love. It's also been the family legacy: to serve the community, to reinvest in the company, and to do whatever necessary to keep the Boardwalk open.

Tom Canfield, vice president of operations, represents a third generation of the Canfield family to be directly involved in the Boardwalk. Here he looks over plans for a 1997–98 renovation project with his father, Charles. After the 1997 summer season, work began that included the underground and ground-level areas at the river end of the Boardwalk.

Charles Canfield and his wife, Cherri, enjoy the annual company picnic in 1998.

BEACH PATROL

Before 1934, the beach bathhouses (and later the Seaside Company) hired lifeguards. The lifeguards' first concern was the Plunge, but if there was trouble in the surf, the lifeguards would head swiftly down the beach on bicycles to reach swimmers in need of help. After a series of tragic surf drownings on Easter Sunday in 1934, the City of Santa Cruz coordinated with the Red Cross to form a beach lifeguard corps administered by the police department. Skip Littlefield was named to train and direct the corps, using the Plunge as its headquarters. Appointed an inspector

BELOW: On Labor Day in 1950, Officer Tom Leonard horses around with (left to right) lifeguards Ted Johnson, Doug Thorne, and Bill Lidderdale.

BOTTOM LEFT: Known as "the mayor of Cowell Beach," Joe Hans was a fixture on the beach.

of the police department, Littlefield served as chief of the lifeguards from 1934 to 1962. When the Plunge closed, the Parks and Recreation Department took over the lifeguard service.

At well over six feet tall, Officer Tom Leonard was a cop to be reckoned with, and the Boardwalk was his beat. When a teenage rowdy got out of hand, Leonard would use the terrible threat that always restored order: "Stop that, or I'll tell your old man!" Lifeguard Joe Hans was one of the better-known waterfront characters. He was popularly known as the "mayor of Cowell Beach" for his years as a lifeguard at the beach. Before that, Hans was a fierce competitor in the popular ocean swims staged in front of the Casino. Even at fifty years old, he was one of the strongest swimmers on the waterfront. Hans was fired three times by Skip Littlefield and rehired three times by Chief of Police Al Huntsman.

BELOW LEFT: The municipal lifeguards got their first motorized equipment in 1946—a World War II jeep. Bill Lidderdale, at the wheel with Princess in his lap, trained many Santa Cruz lifeguards.

BELOW RIGHT: Legendary surfer Sam Reid (center), captain of the 1950 Santa Cruz Police Department lifeguard crew, holds a daily workout using new paddleboard lifesaving aids in the water just off the Casino beach. Other personnel (left to right) are Shannon Bunjes, Bill Lidderdale, Danny O'Brien, Sam Reid, Henry Ingerman, Lou Padini, and Doug Thorne.

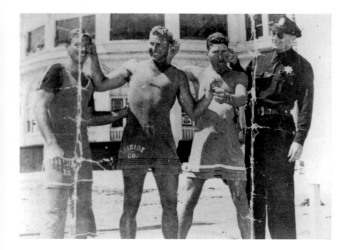

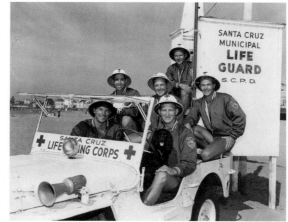

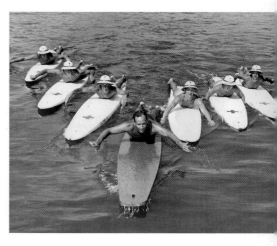

BOARDWALK RIDES

Games of skill are fun, and special foods are a treat, but for hair-raising, spine-tingling, rip-snorting excitement, Boardwalk rides can't be beat. Every year Boardwalk guests seem to have a favored ride. Beginning in 1908, and for the next fifteen years, the gentle hills and the mild twenty-five-mile-an-hour downslopes of the L. A. Thompson Scenic Railway were considered a thrilling adventure. Boardwalk visitor Jean Trimingham rode it as a young girl in the early 1920s and admits, "I was scared—my older sister went with me and she was scared too. It was so fast and so exciting!"

The Scenic Railway must have seemed like a stroll in the park when riders climbed aboard the Giant Dipper, introduced in 1924. As the Boardwalk hits its one-hundredth anniversary, the Giant Dipper's design has proved to be immune to time. Its dark, high-speed tunnel entrance, banked turns, and earthquake shake still galvanize roller-coaster lovers.

The Octopus began making hearts beat faster in 1940. The 1958 Wild Mouse, with its short radius turns and absence of protective railings, gave riders the terrifying illusion they were about to fly off through space. The 1963 Ferris wheel was slow but prompted a keen, delicious anxiety, and the high-flying 1965 Paratrooper sent pulses pounding. As for the 1972 Jet Star coaster, it just plain took your breath away. Ride designers, engineers, and mechanics can spend hours talking about tracks and trusses, conduits and control systems, motors and blowers and black light. But Boardwalk visitors just want to get down to the basics: How high? How fast? How long will it last? Is it fun?

The Jet Star ride opened in 1972.

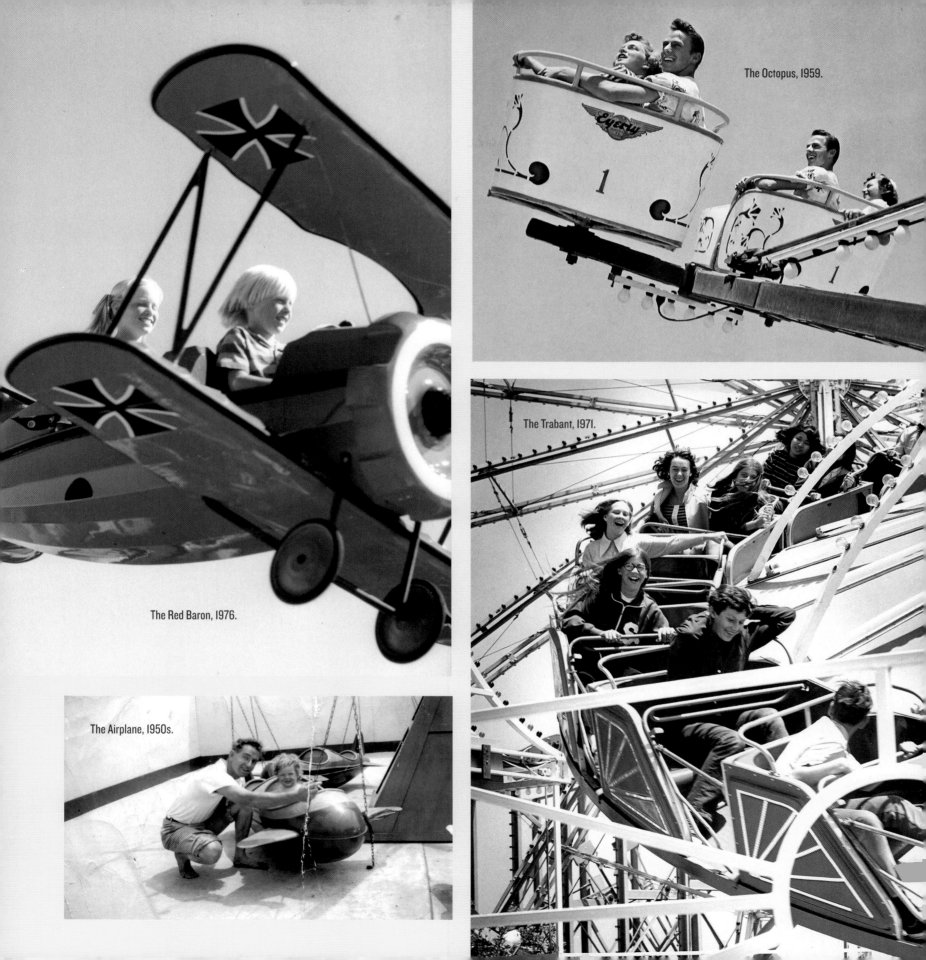

The Octopus, 1959.

The Trabant, 1971.

The Red Baron, 1976.

The Airplane, 1950s.

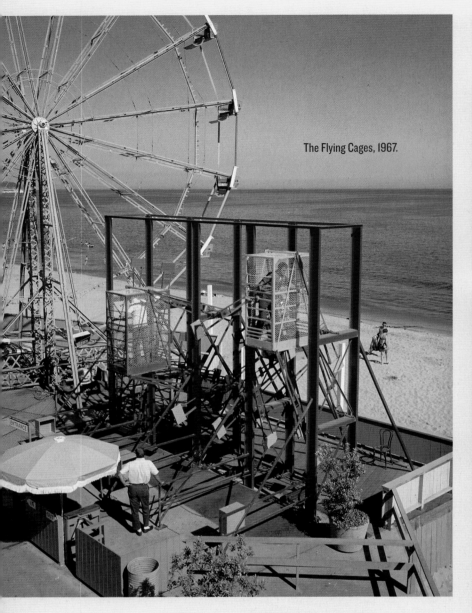

The Flying Cages, 1967.

Bulgy the Whale, 1975.

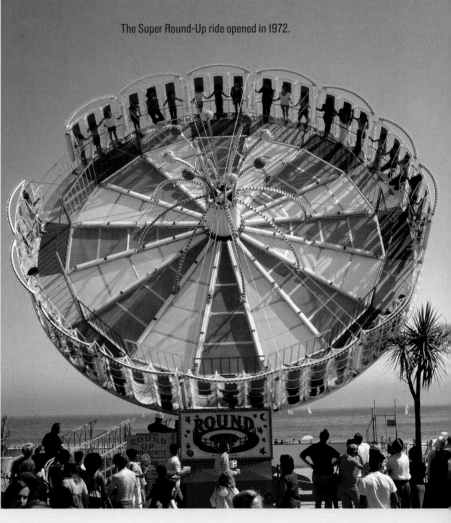

The Super Round-Up ride opened in 1972.

In 1967 the Boardwalk introduced the one-thousand-foot-long Sky Glider, which gave riders a bird's-eye view of the beachfront scene. Using technology developed in the ski-lift industry, designers could create a compact ride that fit the Boardwalk's limited space.

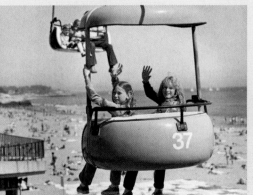

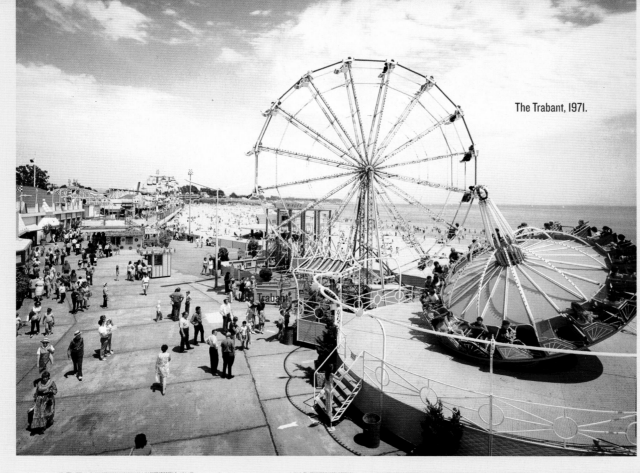

The Trabant, 1971.

BELOW RIGHT: In this hair spray ad from the 1970s, they got the name of the Giant Dipper wrong (they called it "the Big Dipper").

BELOW LEFT: A young Willie King rides the Kiddie Land Train with older brothers, 1957. Willie would later become director of the Boardwalk Bowl.

BOTTOM LEFT: In 1977 the Logger's Revenge, a large flume ride, replaced the Wild Mouse. Water rides have been popular in amusement parks nationwide since the first Shoot the Chutes dumped folks in the drink in 1895 at Coney Island's Sea Lion Park.

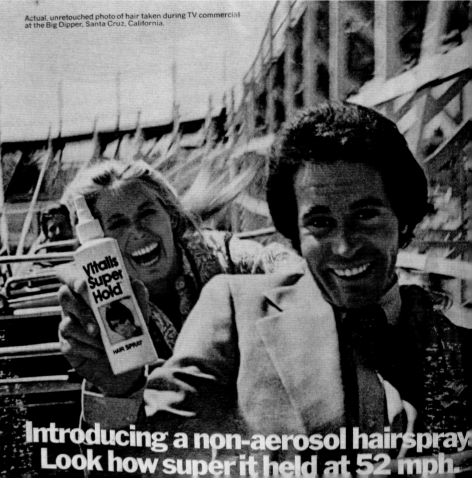

Actual, unretouched photo of hair taken during TV commercial at the Big Dipper, Santa Cruz, California.

Vitalis Super Hold HAIR SPRAY

Introducing a non-aerosol hairspray. Look how super it held at 52 mph.

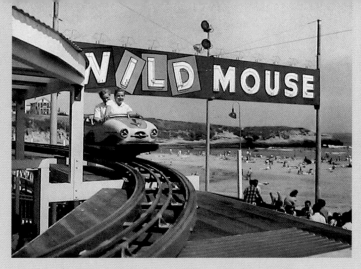

ABOVE: Exciting turns and a great view of the beach made the Wild Mouse a favorite "date ride."

BELOW: At the top of the Wild Mouse, 1960s.

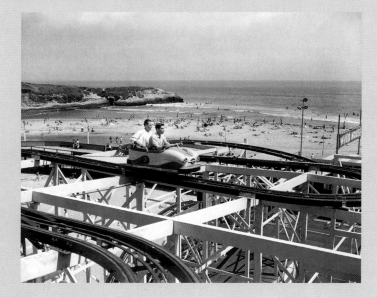

Caught in the Wild Mouse Trap

In 1958, the Wild Mouse ride opened to rave reviews. A mini-coaster ride imported from Germany, the ride was filled with exciting turns and great views of the beach. With a track approximately half a mile long, and short radius turns that gave the illusion of traveling through space, the Wild Mouse was situated directly east of, and at right angles to, the Giant Dipper. Longtime Santa Cruz Boardwalk visitor Gloria Scurfield remembers her first visit to the mouse that roared:

"We came across the trestle, and here was a new ride, right at that curve. I said, 'Oh, look. They've got a children's roller coaster.' All these years I've never been on the Giant Dipper. Never. Never. I can't take things like that at all. Anything that goes off the ground, I don't want any part of.

"So I said, 'Here's a children's roller coaster. I'll take you boys on it.' So Geoff and Greg are in a car, and I get in the next car, and I've got John in front of me holding onto him. I think it's a children's roller coaster, and it's called the Wild Mouse. I'd never seen it before—it was brand-new. It started up and I'm waving to Geoff and Greg up ahead of us, and it gets to the top—oh, my God, I thought I was dying! I thought I had a defective car for one thing, because it was rattling. Then when it went right out straight, and I thought we were headed for the sand, and then it made that abrupt turn. Oh-oh! I couldn't scream. And I kept saying, 'It's okay, Johnny.' And I was dying. I'll never get over it.

"I got off of that and everyone on the beach heard about it that day. I swear. And I thought it was a children's roller coaster. That was our introduction. I would never have gotten on that thing."

LEFT: Ed Whiting and Jeanne Piexoto were dating when they posed for this promotional photo in 1958. Ed and Jeannie first met at the Boardwalk when Jeannie was working for the Turnover Pie Shop; they later married and became concessionaires.

A Ride Through the Dark

Since 1935, on a stretch of Boardwalk between the Giant Dipper and the Carousel, many dark rides have operated, such as Dante's Inferno, Laff-Land, Treasure Island, Pirates Cove, and the Haunted House. Now the spot is home to the Haunted Castle, which takes visitors in an open train car through a devilishly dark tunnel, past hauntingly horrible sights. In spite of the ghastly surroundings, it's a good place to cool off on a hot day.

The Haunted Castle opened in 1973 and has been providing creepy and startling gags ever since. A giant rooftop spider was added in 2005.

RIGHT: By 1932, a go-getter named Ed Reicher had a concession in the building with more pizzazz than a bowling alley. Reicher called it Dante's Inferno, and it was billed as a "Trip Through Hades"—the Boardwalk's first dark ride.

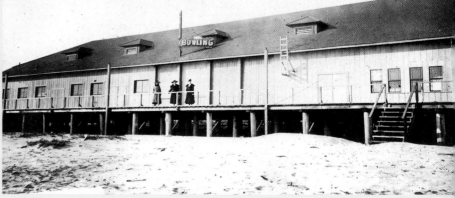

The Bowling Alley (shown here circa 1912) originally occupied the space where the Haunted Castle now stands.

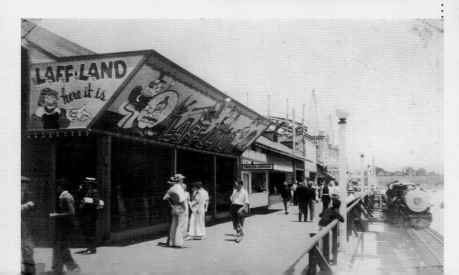

LEFT: In 1934, Ed Reicher replaced Dante's Inferno with Laff-Land, or the Laff in the Dark ride, in which visitors rode through tunnels decorated with clown figures. Next to Laff-Land is a frozen custard stand, which still exists today and can be found easily because of its black-and-white checkered tile. The Sun Tan Jr. train (at right) ran along the Boardwalk from 1928 to 1935.

125

The Fun House

When it was built in 1925, the Fun House was deemed by the *Santa Cruz Sentinel* "a good tonic for young and old."

From the roaring twenties to the radical sixties, generations of Boardwalk visitors enjoyed staggering, sliding, and slipping around in the Fun House. Everyone had a favorite feature, whether it was the giant hardwood slide, the spinning barrel, or the revolving wheel, which could spin you off if you lost your footing. It was such a popular attraction with kids that many parents considered it "babysitting headquarters." When the Fun House was finally demolished in 1971, after a nearly fifty-year reign, the mirrors were saved and installed in what is now the Neptune's Kingdom building.

Tish Denevan was one of those Fun House–crazed kids. "I adored the Fun House because it was a wondrous place where my eleven-year-old self could run, slide, jump and climb," she recalls. "I was an integral part of the wooden slide, the spinning disk, the rocking wave, and the barrel. It was cheap. Fifty cents got me a chance to stay inside the Fun House for as long as my mom would allow. I think I would have spent all day in there."

Denevan remembers: "First thing I did when I walked in was to take off my shoes and hop around in my socks in anticipation of the rides that awaited me. I took in the sights in a quick glance and ran to my favorite: the wooden slide. I grabbed a sack on my way up the steps. I'd race up to the top, my socks shimmying down my ankles as they caught on tar paper on the steps. On the way up, kids and adults whizzed past me on their burlap sacks and gave out yelps of delight or terror as they slid down on the honey-colored slide. At the top of the slide, a large window covered by chicken wire let in a breeze smelling of popcorn and saltwater. My throat would catch when it was my turn, because although I loved the ride, I was, truthfully, scared of it too. My turn. I only had seconds to get ready. I quickly placed my burlap sack on the top of the flat part of the slide and climbed on, clutching the front of the sack like it was a toboggan. A green light. I pushed off. Yeeeeeehaaaaaaa! I whooped as I flew down."

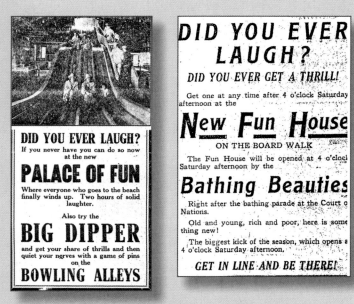

Fun House ads pulled in visitors to experience the new attractions, 1920s.

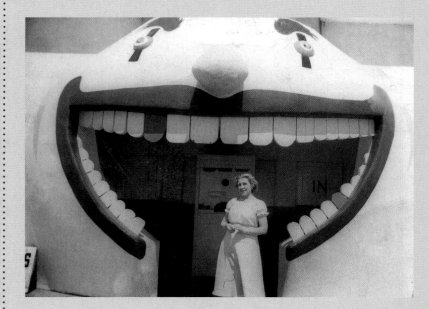

Boardwalk visitor Dorsey Scott, shown here in the 1930s. Years later, Dorsey's grandson John Scurfield would become operations director of the Boardwalk.

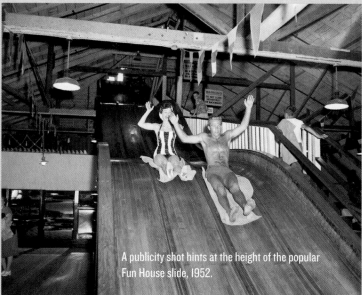

A publicity shot hints at the height of the popular Fun House slide, 1952.

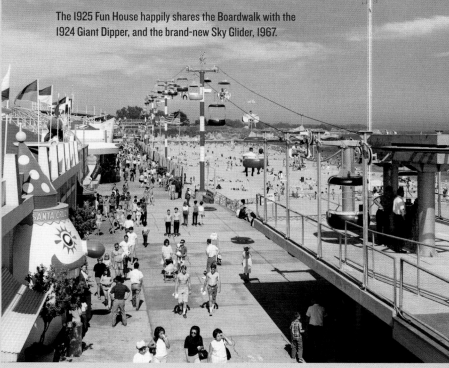

A group of youngsters stumble through the Fun House barrel, circa 1950s.

TAKE YOUR GLASSES OFF

The 1925 Fun House happily shares the Boardwalk with the 1924 Giant Dipper, and the brand-new Sky Glider, 1967.

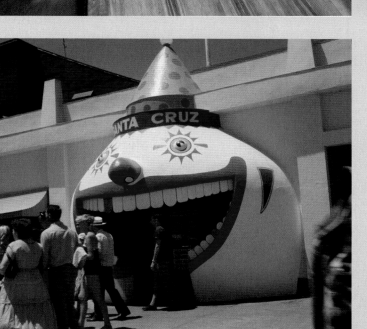

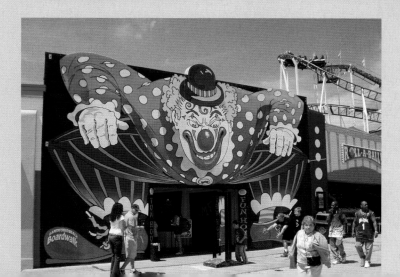

ABOVE LEFT: The Fun House entrance as it looked during the 1950s.

LEFT: The 3-D Fun House clown leered at patrons from 2001 to 2004.

Traveling through the Lost World, the Cave Train (far left) encountered dinosaurs, a caveman experimenting with dynamite (left), an earthquake, prehistoric bats, mysterious grottoes and caves, stalactites and stalagmites, and a caveman roasting dinner over an open fire while his "mousetrap" attracted another meal.

The Cave Train and the Autorama

In late June 1961, when dark rides were part of a new trend in amusement parks, the lovable, kitschy Cave Train to the Lost World opened at the Boardwalk. The train and track were built by Arrow Development, an innovative ride manufacturer that participated in the creation of Disneyland, but the Boardwalk's maintenance staff primarily designed the ride, the characters, and the scenes.

The prehistoric Cave Train ran along its track next to the Autorama, a futuristic gasoline-powered sports car ride. Here, twenty scale-model sports cars, with electric headlights and hydraulic brakes, had a center-limiting rail that allowed drivers considerable freedom in steering but removed the need for curbs. On the Autorama, even small children developed enough skill to avoid the center rail.

The late Bill Fravel, who was the maintenance superintendent at the time, fondly recalled tackling the underground project near the river. He said the Cave Train was a great example of why he worked at the Boardwalk for thirty-two years: "You always had a chance to use your imagination and think up crazy things." Shortly after its debut, the Cave Train and the silly antics of its cavemen and dinosaurs became one of the park's most popular attractions. In the pool above the Cave Train leading to the Lost World Station, there was Dangerous Dan the Dinosaur, coming up for a look every five minutes. He would turn his head to watch Autorama cars, the Cave Train, and Boardwalk visitors. He was eighteen feet long, made of fiberglass molded and shaped over a steel framework. In 1999, some of the Cave Train's track was rerouted due to

changes in the underground maintenance shop area and the rearrangement of rides above. After a complete renovation, it reopened for the millennium year as Cave Train 2000.

ABOVE: Maintenance Superintendent Bill Fravel (in plaid shirt), and Walt Disney (center, with cigar). Disney visited the Santa Cruz Boardwalk in 1962 for a look at the guidance system on the new Autorama. Later he converted a Disneyland ride to the same system.

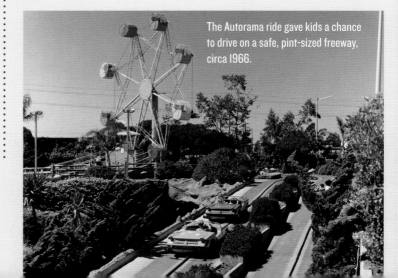

The Autorama ride gave kids a chance to drive on a safe, pint-sized freeway, circa 1966.

CONCESSIONAIRES: BOARDWALK BUSINESS PARTNERS

"Working here is not just a job—it's a way of life."
—Ted Whiting III

For concession owners, working the Santa Cruz Boardwalk was a lifestyle, not a job. For the Santa Cruz Seaside Company, the concessionaires were more than employees or tenants; they were business partners. Everybody had their favorite concession, and for many people it was the Turnover Pie Shop. Bill Kincannon took over Winnie's Turnover Pie Shop, ran it for a while, and turned it over to Thelma and R. E. "Buck" Dahlman a few years later. In the 1960s, Charlie and June Booth took the reins of the Pie Shop. Noted for their love of practical jokes, the Booths are well remembered for having an electrified silver dollar glued to the front counter. Unsuspecting tourists who tried to pick up the coin got a little jolt and a lot of laughs with their serving of Charlie and June's pie.

In 1947, Art Malquel assumed the mantle of "Hot Dog" Miller, and took over Miller's stand, renaming it Art's Hot Dogs. Art was an accomplished master chef, having taken the helm as chef of the Casa del Rey Hotel for a time. He was also a professional photographer and took many of the Miss California Pageant photos. He was very unlike his predecessor, having a quiet, unassuming way about him. Art always wore a starched shirt and tie when he worked. He was a very private person, not the kind you would expect to see hawking his wares at the Boardwalk, but he was an expert when parked over a griddle.

Business was brisk, so a second Art's Hot Dogs location appeared on the Boardwalk in the 1950s, next to the Bumper Car ride. When Ray and Marge Carpenter took over this stand a decade later, they changed the name

This fringed pillow with depictions of the Casino, the Jet Star, the Giant Dipper, and the Cave Train was sold at John Fulmer's gift store in the 1970s.

to Ray's Hot Dogs. In the 1960s, under the ownership of HTH Enterprises (whose Ed Hutton became general manager of the Boardwalk in the 1980s) and then Merrie Ann Handley, the name changed again to the All-American Hot Dogs. In 1981, when the Santa Cruz Seaside Company took over operation, the stand became Barnacle Bill's.

In 1971, Art sold the hot dog business to John "Chachie" Ottaviano and his wife, Peggy. Chachie was a nephew and cousin of the Marini candy clan. The business continued to operate under the same name of Art's Hot Dogs until the space was converted into the Sun Shops when the Cocoanut Grove and colonnade were remodeled in 1981.

At the Whiting food concessions, Ron Whiting remembers that during the 1950s when the Sun Tan Special train came in from San Francisco, Oakland, and San Jose, business would be especially brisk. When business was slow in the winter, Ted Whiting Jr. might open for a few hours or take frequent coffee breaks out on the wharf, checking back at the stand from time to time to see if he should open. Most concessionaires believed in the motto: "Don't worry. If the weather was bad in July, it will be okay in August. Everything will balance out." And it usually did.

It was 1969 when Howard "Hodgie" Wetzel gave up his job as a Santa Cruz motorcycle officer and took over the much more enjoyable job as owner of Ruth's Hamburgers across from the Carousel. He purchased the business from Vic and Mary Marini. Vic was the brother of Joe Marini Sr., of Marini's Candies. Two years later, Hodgie and his wife, Barbara, renamed the place, appropriately, Hodgie's. Wetzel literally grew up at the Boardwalk (his mother sold

tickets to the Giant Dipper). Innovator that he was, Wetzel added unique food items to his menu. His grandmother's deep-fried artichokes, using her special batter recipe, were a family favorite, and they became a favorite at Hodgie's as well, so he added deep-fried zucchini and mushrooms. He also expanded his menu to include corn dogs, clam chowder, and fresh deli sandwiches. Years later, Wetzel came up with the idea for the Brussel Sprout Festival, although he later said the suggestion was half made in jest.

In 1963, Chuck and Esther Abbott opened a Belgian waffle concession. The Abbotts had discovered the waffles at the Seattle World's Fair and brought the concept to the Boardwalk, with a plentiful assortment of toppings. Tragically, during their time at the Boardwalk, the Abbotts' son, Mark, was killed while surfing at Steamer Lane. In his memory, they funded and built the Mark Abbott Memorial Lighthouse, which today houses the Santa Cruz Surfing Museum. The Abbotts were also instrumental in developing the Pacific Garden Mall in Santa Cruz.

For more than twenty years, F. Roy "Fullhouse" Fulmer ran the Gift and Souvenir Shop just east of the carousel, and the Curio Shop in the Casino. During this time he served as mayor of Santa Cruz from 1942 to 1946. He bought the gift concessions from C. B. Bender in 1943 and sold his goods with irrepressible enthusiasm.

Holding a vase made from genuine solid redwood burl, he addressed groups of customers: "My friends, it takes ten years to age good whiskey. By the same token, you are now privileged to gaze upon an item which nature has taken five thousand years to fashion." The vase was, he said, "grown right here in this sun-kissed county . . . guaranteed superior to Honduras mahogany, Chinese teak, or Russian bird's-eye maple." Roy Fulmer was a master salesman.

Fulmer's son John took over the business in 1966. The Santa Cruz Seaside Company operated it for a few years in the 1990s, until it was purchased by Marshall and Kathy Miller and became a gift shop called Octopus' Garden.

The Wonderful World of Whiting's Food

The Whiting clan has a long connection to the Santa Cruz Boardwalk. Ross Whiting was the superintendent of the Seaside Company for many years and then left to take over the game concessions. But when his brother, Dr. Les Whiting, bought the Bright Spot concession from Fred Russell in 1953 (Les's son, Ted Jr., had discovered the place while delivering milk to the Boardwalk), it was the beginning of a family love affair with the food business. That first season the whole family staffed the concession—including Les's father-in-law, Fred "Pop" Knowles. Pop was known for tending the popcorn machine with one hand while reaching for his ever-present plug of chewing tobacco with the other (and, luckily, he never got mixed up). Young Ted

The Whiting kids with their great-grandfather, 1958 (left to right): Ron, Sybil, Mike, Fred "Pop" Knowles, Ken, Peter, and Ted Whiting III.

BELOW LEFT: Señor Ted's hit the Boardwalk scene in 1996.

BELOW RIGHT: Dippin' Dots are "The ice cream of the future, here today." Millions of Dots have been sold on the Boardwalk since the 1990s.

Whiting III was just a little guy then, but he tried to help by sitting on the counter and ringing up sales, with some help from his grandmother and great-grandfather.

A year later, the family bought Lane's frozen custard business, and Ted Jr. became the full-time general manager. The concession included three ice cream locations faced with red-and-white or black-and-white tile. They added a fourth site—conveniently located next to Kiddie Land, where the Dime Toss is today—and called it Bright Spot #2. Eager young Boardwalk visitors could easily spot its tower roofline and run over for soft drinks, sno-cones, popcorn, and cotton candy. When the Boardwalk's lower end deck and basement were added in 1960, the Bright Spot #2 building was moved to its current location near the San Lorenzo River. The Whitings put in a short-order

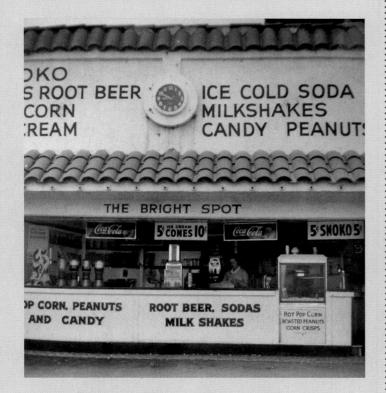

In the early 1940s, Leslie Newell did counter duty at the Bright Spot. Operated by Barney Segal at the time, the concession was a popular hangout for servicemen. Les Whiting purchased the concession in 1953.

kitchen to feature hot dogs, hamburgers, french fries, and milk shakes; they added candy apples to the menu of sweet treats.

All of Ted Jr.'s and Esther's eight children worked during their teenage years. Some went off to college, the military, and other professions, but they always returned to the Boardwalk. From the first generation to the fifth, there have been Whitings in the concessions without interruption. In the 1970s, sons Ted III, Ron, and Ken joined the business full-time. The family added other food concessions, replaced the former Bright Spot with a pizza parlor in the new Bumper Car building, and introduced portable food carts to the Boardwalk. Margie Whiting Sisk came into the business full-time in 1979.

These days, Ron's sons Nik and Dan, who are fifth-generation Whitings, serve as operations managers of Whiting's Foods, and many of their cousins work at the Boardwalk. Ted Jr. still keeps on eye on things from retirement, while Ron, Ken, and Margie actively manage the family business.

For five generations, the Whitings have been a part of the Santa Cruz Boardwalk. Three generations gathered in summer 2000: (top row, left to right) Jamie, Megan, Allyson, Christy, Kendyll, and Ashley Adams; (center row, left to right) Jeff, Margie Whiting Sisk, Ken, Ted Jr., Ron, Aaron, and Dave Anderson; (front row, left to right) Nik, Matt Anderson, Jim Anderson, and Dan.

FALLING IN LOVE WITH THE BOARDWALK

In the Summer of Love, Kathy and Marshall Miller were teenagers and both working at the Santa Cruz Beach Boardwalk. She sold cotton candy and he was a parking lot attendant. Kathy wouldn't give Marshall the time of day that first summer; but by the second season, they had finally started to date and had fallen in love—with each other and with their jobs at the Boardwalk. For several more summers and weekends, they worked at the boardwalk as they earned their degrees at UC Berkeley, hoping to become teachers.

But the Millers changed course and, in 1971, decided to open their own Boardwalk store selling candles. "We realized that we could have the opportunity to work with kids and have more freedom than in teaching," says Kathy.

Marshall and Kathy Miller in their first shop, the Candlelight, circa 1971. By 1976, they owned and operated the Candlelight, the Boardwalk Bugle, and Sun Shops.

In fact, Kathy and Marshall both say that connecting with their young employees is what they enjoy the most, adding that it's the employees who have made a success of the many Miller-owned operations: Sun Shops, Beach Shack, Octopus' Garden, Sol Beach, the Screaming Images, Sea Serpent Images, and Splashing Images, as well as the shops on the Wharf, Beach Street, and downtown Santa Cruz.

The Millers admit some of their ventures, like a pearl store and patch and sticker businesses, didn't work; but the successes have definitely outnumbered the failures. "Things just worked our way," says Marshall. In retail, the pair say, the name of the game is "how fast can you change." They still enjoy starting up businesses, so it's likely that the Millers (including the next generation, T. J. and Marcella Moran) will have new Boardwalk ventures ahead. Of course, Marshall points out, they have a long way to go: compared with the Marini, Twisselman, and Whiting families, "we're still newcomers."

T. J., Marcella, Jackie, and Josie Moran with Marshall and Kathy Miller, 2006.

The Fascination game has been at the Boardwalk since the World War II years.

"Fascination" at the Beach

Tish Denevan, a Santa Cruz Seaside Company employee for more than twenty years, recalls years of joy at the Boardwalk. "My mom would give me and my brothers, Jim and Dan, a dollar apiece to spend at the Boardwalk in 1972. One dollar would get us one game of mini-golf, one ride, and some saltwater taffy. Sometimes, instead of the saltwater taffy, I spent my last dime or two on a game of Fascination. To a twelve-year-old, it felt very exotic and very adult to walk into what I thought of as a gambling den. There were grizzled regulars slouching in their chairs, chain-smoking and flicking the ball with intensity and focus. Dimes plinked off the glass as the game operator made change from a dollar while taking the ten cents to play.

"The monotone drone of the operator at the raised dais explained the rules of the game into a 1940s-style microphone. Red, rubber balls bounced, bounced, and then dropped finally into a slot. A light appeared on the board showing which hole the ball had fallen in. When I played, I felt intimidated watching regulars with their smooth delivery. As an infrequent player, I was not as adept, and I fretted as the ball bounced interminably around the holes but didn't quite go in. Even so, I did beat the hardcore regulars once in a while. Inevitably, I would get the evil eye for daring to play and win on their turf."

ONLY AT THE BOARDWALK: CELEBRATIONS, PERFORMERS, AND FESTIVALS

Since the early days of Fred Swanton's promotions, the Santa Cruz Beach Boardwalk would delight crowds with the spectacle of fireworks on the Fourth of July. In fact, when Swanton was in charge, almost any occasion was reason enough for pyrotechnics: the Canvas Casino or summer season opening, the New Year, special beach concerts, or just having fireworks left over from a previous event. Annual Fourth of July fireworks shows continued for decades, postponed only for war or weather. But in the mid-1970s, weather, an accidental power outage, and a scheduled display that attracted too many people led to the annual event's demise.

Plans for the 1974 display included 439 pieces of dazzle and flash, whistles, comets, and hummers. At the end, four huge, thirty-six-inch magnesium shells would be fired and light the beach from the San Lorenzo River to Cowell Beach. The plans were glorious, but went astray. Fog rolled in around 8:30 P.M. For visibility, the fireworks show would need a ceiling of fifteen hundred feet, and the ceiling was only two hundred feet. The display was cancelled, and the huge crowd—fifty thousand strong— became disappointed and then belligerent. At ten o'clock, an underground power line failed, and Beach Street and the wharf were thrown into darkness. The Boardwalk's emergency lighting system returned light to the Casino

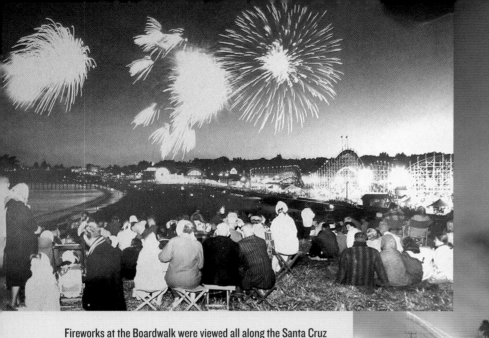

Fireworks at the Boardwalk were viewed all along the Santa Cruz waterfront. These families watched the 1950 show from a prime spot on the cliffs between the San Lorenzo River and Seabright Beach.

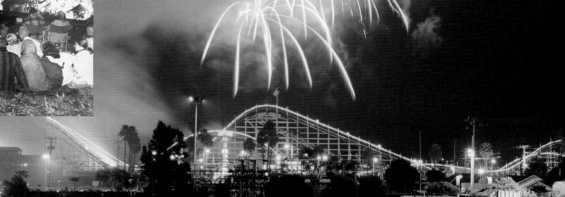

In the 1990s, firework displays made a comeback for the City of Santa Cruz Birthday Celebration. (Photo courtesy of Shmuel Thaler)

games and rides, but all the concessions were closed at 10:45 P.M. The mass exit of frustrated spectators created traffic gridlock.

It became clear to organizers that the area could not safely accommodate a crowd of fifty thousand for such an event. The following year, Santa Cruz Seaside Company President Laurence Canfield announced: "In the interests of public safety, the Beach Boardwalk has been forced to forego future fireworks shows." These annual events are still sorely missed today.

Aerialist Karl Wallenda brought his internationally renowned family of high-wire walkers to the Santa Cruz Boardwalk in 1975. Family patriarch Karl is still known as the most famous high-wire artist of the twentieth century. The high-wire acrobat Malikova often ended her performances at the Boardwalk using a unique piece of aerial equipment called the laddercycle. Pedaling it with care to the center of the high wire, she slowly, gingerly mounted each of the ladder's steps until she reached the top, where she balanced triumphantly in the spotlight.

In August 1976, performers Steve "Unique" McPeak and Stephan Wallenda planned to walk the thousand-foot length of the Boardwalk's Sky Glider cable, in an attempt to break the amusement park high-wire walk record of eight hundred feet set by Stephan Wallenda's great-uncle, the legendary Karl Wallenda. On Saturday night, rain made the rigging slippery and dangerous, but Sunday morning dawned clear and dry, so the decision was made to go ahead. With thirty-four men along the route steadying the cable with guy wires, and wind gusting up to twenty-five knots, a crowd of ten thousand watched as Wallenda and McPeak traversed the entire length of the cable without a mishap, successfully setting a new record.

Three times a day, from August 29 through September 7, 1981, the show on the beach bandstand was Moore's Mess of Mutts, ten dogs who were graduates of the SPCA school of acting. They performed acrobatics and comedy and were veterans of national network talk shows in Las Vegas. Trainer Sid Moore said he let the dogs do what they wanted to do, rather than wasting time trying to teach them to do tricks they didn't like.

"Performing feats of skill and balance with incredible ease, and utter disregard for her own safety," emcee Skip Littlefield announced in 1976, "ladies and gentlemen, the incomparable Malikova!"

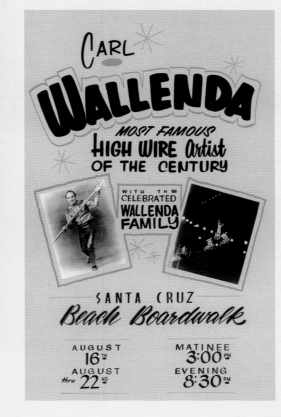

CARL WALLENDA

MOST FAMOUS HIGH WIRE Artist OF THE CENTURY

WITH THE CELEBRATED WALLENDA FAMILY

SANTA CRUZ Beach Boardwalk

AUGUST 16TH AUGUST thru 22ND

MATINEE 3:00 PM

EVENING 8:30 PM

A poster announces a performance of the celebrated Wallenda family of aerialists at the Boardwalk, 1975.

The act known as Grey and Diane performed at the beach in 1952. Years earlier, they had performed in the Water Carnivals at the Plunge.

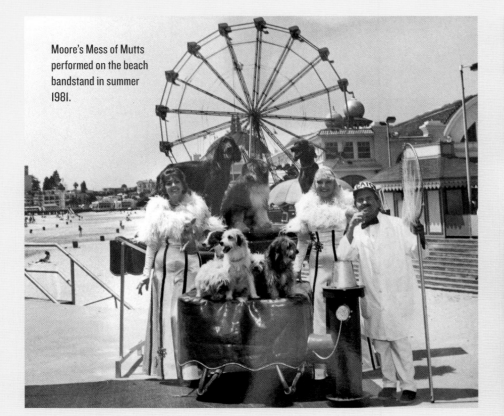

Moore's Mess of Mutts performed on the beach bandstand in summer 1981.

In August 1976, performers Steve "Unique" McPeak and Stephan Wallenda walked the thousand-foot length of the Boardwalk's Sky Glider cable.

During the 1982 Brussels Sprout Festival, restaurants featured such sprout delicacies as deep-fried sprouts, sprout soup, sprouts and cheese, and "guacasprout" dip. Unusual food items included sprout cotton candy, candy sprout on a stick, sprout-chip cookies, chocolate-covered sprouts, and sprout-water taffy. Boardwalk concessionaires displayed sprout T-shirts and buttons, while face painters planted little sprout faces on children's cheeks. Games included the Sprout Toss for the individuals who disliked sprouts.

Local growers were very interested in the Brussels Sprout Festival, which began in 1981, since 90 percent of all Brussels sprouts are grown in the coastal region near the Boardwalk. The idea came about when Boardwalk concessionaire Howard "Hodgie" Wetzel was out drinking with his friends who happened to be Brussels sprout growers. Half joking, Wetzel suggested the festival, and the grow-

ABOVE: At the festival, Russel the Brussels Sprout rides the Great Auto Race.

BELOW: During the 1982 Brussels Sprout Festival, games included the Sprout Toss, designed for those who wanted to distance themselves from the odiferous veggie.

The comic strip *Sherman's Lagoon*, by Jim Toomey, gave the Boardwalk's Brussels Sprout Festival national attention years after the festival was discontinued . (Copyright © 2006 Jim Toomey. Used with permission from the artist.)

ers jumped at the opportunity. The unlikely promotion was treated with the respect due a serious food festival, while people said, "The what?" and snickered behind their hands. The Boardwalk was laughing at itself, and they loved it.

Also during the 1970s, usually on the Fourth of July and Labor Day weekends, the Dick Hale Sky Diving Show took place at the Boardwalk beach. In 1972, the daring parachutists jumped from a World War II Royal Canadian Air Force bomber, hitting the silk at eight thousand feet and attempting pinpoint beach landings in a roped-off area between the bandstand and the shoreline. There were two Coast Guard Auxiliary boats in the bay with Municipal Lifesaving Corps lifeguards onboard in case someone landed in the water and had to be picked up.

In 1976, emcee Skip Littlefield stood on the bandstand roof with a microphone to emcee the show. Carl Arnett, a Boardwalk employee for more than thirty years, recalls: "It took a long time for the skydivers to parachute to the beach, and sometimes Skip would run out of things to comment on, so he'd wave an arm and say dramatically, 'And *there* he is!' Pause. 'And *there* he is!' again and again until the landing. Occasionally one would land on the

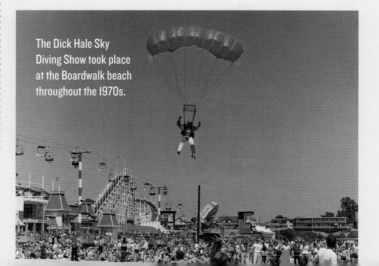

The Dick Hale Sky Diving Show took place at the Boardwalk beach throughout the 1970s.

The fifth annual Grand International Crawdad Crawl Championship was held on the Boardwalk beach bandstand, 1982.

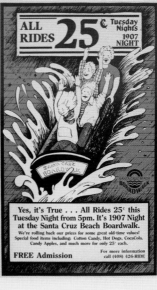

wharf, or in the water, or on top of a car. The skydivers liked to land in the water if they were working on a certificate for water jumps."

In 1982, the Santa Cruz Beach Boardwalk hosted its first (the fifth annual) Grand International Crawdad Crawl Championship, which featured crawdads racing underwater on a one-hundred-centimeter-long track. Although the event didn't compare to the races at Churchill Downs or Indianapolis, it did bring serious crawdad racers and fans back year after year, when crawdad jockeys brought their chargers to vie for the honor of being a crustacean sensation.

The event known as "1907 Nights" began in 1982, the year of the Boardwalk's seventy-fifth anniversary. In celebration of a bygone era, rides, hot dogs, soft drinks, candy apples, and cotton candy were a quarter. Locals loved it. Everyone loved it, and the concept is still going strong in 2007.

One of the Santa Cruz Boardwalk's corniest, clammiest, and most delicious promotions began in 1982: the Clam Chowder Cook-Off. Cooking teams have come dressed as scuba divers, the clam fairy, and in tuxedos and tutus. Humor and creativity run the gastronomic gamut as Boston and Manhattan chowder ingredients are chopped, cooked, and consumed. Chowder fans taste their way from one end of the Boardwalk to the other. The cook-off benefits the Santa Cruz City Parks and Recreation Department.

ABOVE: Beach Street Revival poster, 1989. Beach Street Revivals had street rod outings and car shows, surf music and hula hoop contests, fifties costume balls, and parades in which classic cars spent the evening cruising Beach Street.

ABOVE RIGHT: A 1983 poster promotes 1907 Nights as "rolling back prices for some old-time values. When was the last time you could visit an amusement park and ride a roller coaster, get a hot dog and a soft drink, play a game, buy a souvenir, and still receive change for your dollar?"

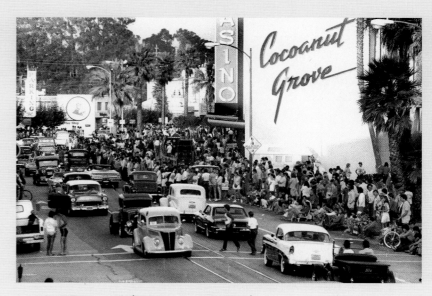

Beach Street Revival, 1983. (Photo courtesy of Dan Coyro)

137

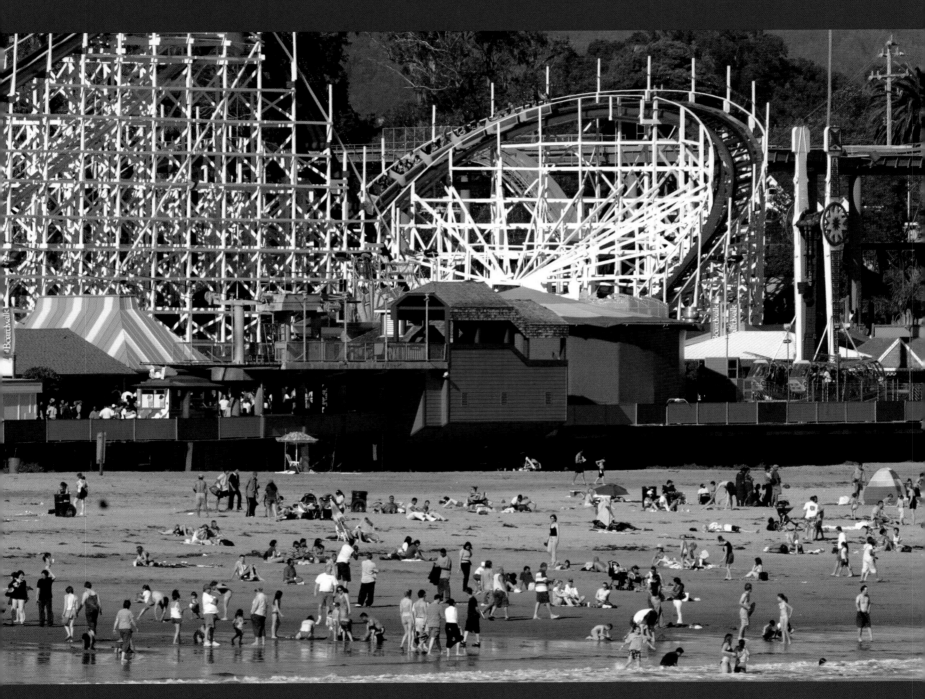

Santa Cruz Beach Boardwalk, circa 2000. (Photo courtesy of Shmuel Thaler)

Warm Sand, Cool Surf, Hot Rides

PAST AND FUTURE walk hand in hand on the Santa Cruz Beach Boardwalk. It's the last major oceanside park on the West Coast and the oldest continuously operating seaside amusement park in California.

When Charles Canfield became president upon his father's death in 1984, he was already an experienced industry leader. Charles had grown up on the Boardwalk, worked as a ride operator at sixteen, owned several game concessions, and served as the company's vice president. Under his leadership many new rides have been added, including the Double Shot, Ghost Blasters, Fireball, Hurricane, and Wipeout. His devotion to the company and its staff is evident: "I've run the rides, collected money, blown up balloons, cleaned up restrooms. I'm not opposed to doing any of that. You've got to do it to know what the Boardwalk is all about." Today Charles upholds his father's legacy and continues to invest several million dollars a year in maintaining and improving the park.

Although the Boardwalk strives to keep up with the times and to delight new generations, there is a reverence for history and a respect for the past that permeates the running of the company. This commitment to historical preservation has earned the park both state and national honors. In 1987, the Looff Carousel and the Giant Dipper were named National Historic Landmarks, and two years later, the state made the entire Santa Cruz Boardwalk and the Cocoanut Grove a California Historic Landmark.

The Santa Cruz Beach Boardwalk is also keenly aware of the environment, particularly because of its exquisite setting on Monterey Bay. The company has received many regional awards for its recyling, water reclamation, and energy conservation efforts, including the honor of the State of California Ecotourism Business of the Year.

The 3-D Fun House clown watches over the 2003 Santa Cruz Sentinel Triathalon. (Photo courtesy of Shmuel Thaler)

TO PUT THINGS IN PERSPECTIVE

Here's what was happening:

1985 Sony builds a radio the size of a credit card.

1986 The *Voyager* spacecraft sends back images of Uranus.

1989 The Berlin Wall falls.

1990 Michael Crichton's novel *Jurassic Park* is a huge success.

1992 Disneyland opens in Paris.

1994 In the United States, the most popular radio format is country music.

1995 *Toy Story* is the first completely digital feature-length film.

1997 Kodak offers the first point-and-shoot digital camera.

2000 The world does not end despite Y2K fears.

California State Landmark plaque, placed at the park on May 11, 1990.

President Charles Canfield and general manager Ed Hutton meet Tiny Tim in 1993.

WATCHING OVER THE SEASIDE PARK

Sunshine brings the tourists to Santa Cruz, but all weather —good and bad—can create serious challenges for a seaside amusement park. Being located at the beach is almost as much a burden as it is a blessing: The ocean breeze smells wonderful, but rides and buildings take a constant beating from the sun, the sand, and winter storms. Corrosion from the salt air is the biggest nemesis of rides and buildings, making a full-time expert maintenance crew a year-round necessity.

Mechanics, welders, and electricians continuously check all rides for safety at the park and keep them in good operating condition. Winter provides the opportunity to disassemble, recondition, and reassemble rides. The Boardwalk and buildings require upkeep from painters, carpenters, and plumbers. Janitors are needed to wash windows assaulted by seagulls and salt air and to clean floors powdered with gritty sand. In addition to cleaning up Boardwalk exteriors and parking lots, grounds crews mechanically sift and clean the sand in front of the Boardwalk to get it ready for sun lovers. The schedule is heavy for everyone, but the rewards are great.

A photograph from a February 1926 *Santa Cruz Sentinel* article shows the high tide and waves that destroyed two beach bandstands.

STORMS AND NATURAL DISASTERS AT THE BOARDWALK

Winter storms and other natural disasters have caused damage at the Boardwalk from its beginning. From the February 13 and 14, 1926, edition of the *Santa Cruz Sentinel*: "At high tide the beach was hit by a storm that destroyed the two beach bandstands, ripped off every board extending from the beach to the first floor of the Casino and tore away most of the steps in front of the Natatorium and Boardwalk. Old Scenic Railway cars placed alongside bobbed like boats in the breakers as waves rolled high under the buildings."

On October 17, 1989, during the Loma Prieta earthquake (magnitude 6.9), the earth rumbled for fifteen seconds, although it seemed so much longer—and the aftermath lasted for months. The temblor did a million

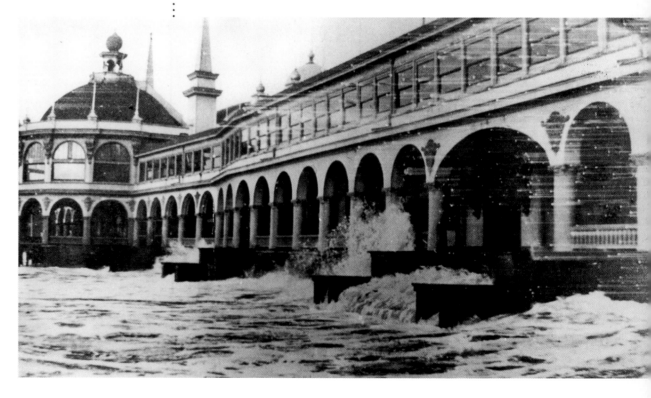

dollars in damage to the Santa Cruz Boardwalk. The Casa del Rey Retirement Hotel had to be demolished, as did the bandstand. Several towers on the Logger's Revenge ride were jolted askew, and the Cave Train tracks had to be leveled. The walls of the Cocoanut Grove and the Casino arcade required patching and repair, the seawall also had to be patched, and the cement flooring of a section of basement buckled from hydrostatic pressure.

BELOW: Displaced residents of the Casa del Rey wait out aftershocks from the 1989 Loma Prieta earthquake. (Photo courtesy of Dan Coyro)

BOTTOM: The beach requires yearly cleanup, as it fills with trees, branches, and logs washed down the San Lorenzo River during winter storms.

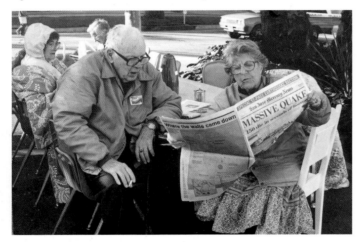

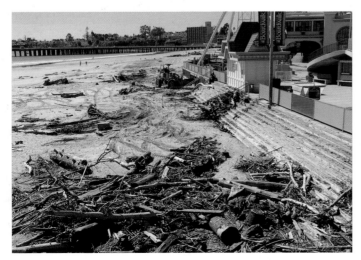

A BEVY OF BOARDWALK PROMOTIONS

In the 1970s, general manager Dana Morgan brought valuable industry experience to the Santa Cruz Boardwalk at a time when the threat of new competition from the Great America amusement parks loomed. Morgan helped raise maintenance standards and guide major improvement projects, including a complete remodel of the Cocoanut Grove and the addition of Logger's Revenge.

Once new and improved operational standards were in place, amusement industry pro Ed Hutton was hired in 1980 to build attendance and expand the season. Hutton soon became general manager, bringing in a professional marketing team that built on the tradition of Fred Swanton. The team reestablished the role of promotions in extending the Boardwalk's operating season, thereby securing its future. "We were trying just about every type of event, nothing was too crazy," remembers Marq Lipton, who was then the promotions manager and later the Santa Cruz Seaside Company's vice president of marketing. "Anything to draw attention to the park, attract media and get attendance. Once, when a Boardwalk concessionaire found a ten-pound potato in his food delivery, we put it on display as 'Santa Cruz's Largest Potato.'"

Many of the promotions established in the 1980s—including 1907 Nights, the Clam Chowder Festival, and the Friday Night Summer Band series—are still popular and highly successful today. In 1984, the Best Legs in the Bay Area strutted on the Boardwalk bandstand, in a contest sponsored by radio station KFRC and—you guessed it—Nair hair removal products. An unbelievable seventy-five hundred people showed up for that one, even though the entrants were behind a curtain with only their legs showing.

More than fifty teams entered the Budweiser Tug of War event on May 5, 1985, with the winner taking home a

$3,000 prize. In 1986, there was the Hard Body Contest, in which contestants first had to ring a bell on the high striker. That qualified them for a chance to win a new, fully loaded truck. The Boardwalk hosted hot rods and muscle cars, beach games, and arm-wrestling tournaments. There was hardly a moment when something wasn't going on: marching band contests, strongest-man-in-the-world contests, sand castle building, cheerleading competitions, and so on.

There was even ice skating at the beach. For the *Too Hot to Skate* event in 1995, an outdoor ice rink was built at the beach. The CBS network aired a two-hour television special on this world-class skating show, which featured Olympic silver medalist Nancy Kerrigan (1994) and Olympic gold medalists Oksana Baiul (1994), Viktor Petrenko (1992), and Scott Hamilton (1984). The conditions in Santa Cruz were also perfect for another sport: beach volleyball. The early 1920s had marked the beginning of beach volleyball and competitive players have flocked to the area ever since.

FUN FOOD FACTS

During 1984, the Boardwalk served:

- 5,300 pounds of popcorn
- 152,000 hot dogs
- 62,000 candy or caramel apples
- 70,000 pounds of saltwater taffy

ABOVE: Vintage, muscle, and custom cars take over part of a Santa Cruz Beach Boardwalk parking lot during the Hot Rods at the Beach event, 2005.

BELOW: In 1986, Popeye, Olive Oyl, and Brutus became official Santa Cruz Boardwalk characters.

BOTTOM RIGHT: The Boardwalk's arm-wrestling tournaments were exciting and had many serious, professional competitors in June 1991—even Popeye competed.

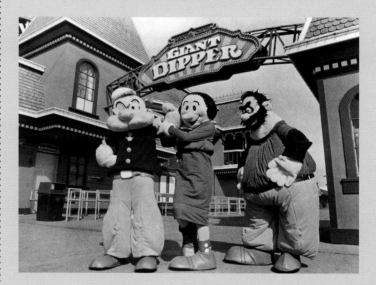

Olympic medalists ice-skated at the beach for the *Too Hot to Skate* TV special, 1995.

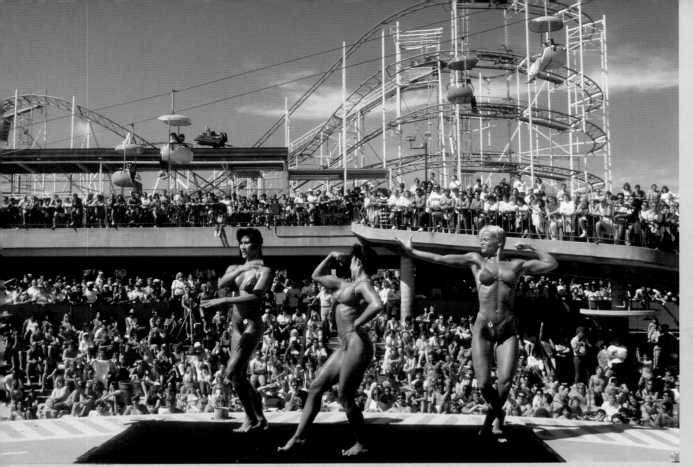

TOP LEFT: Bodybuilders flex and pose for the judges on the Boardwalk's bandstand, near the Jet Star, during the 1986 Muscle Beach Party. (Photo courtesy of Dan Coyro)

BELOW LEFT: Every February, teams dress up as giant shellfish, clam clowns, mermaids, and more to vie for cash prizes and awards at the Clam Chowder Cook-Off Festival.

BELOW: A pig riding a roller coaster was one of the sand sculptures created for the 1994 sand castle contest.

FAR LEFT: Bands from throughout California compete in music, showmanship, and marching at the annual Santa Cruz Youth Band review in October.

LEFT: Junior high and high school cheerleaders from throughout Northern California compete in this annual qualifier for the United Spirit Association Cheerleading Nationals.

BELOW: At the 1986 Jose Cuervo Gold Crown volleyball game, world-class players and teammates Sinjin Smith and Randy Stoklos drew thousands of spectators to the Boardwalk. Other top players included Mike Dodd and Olympic gold medalist Karch Kiraly. (Photo courtesy of Dan Coyro)

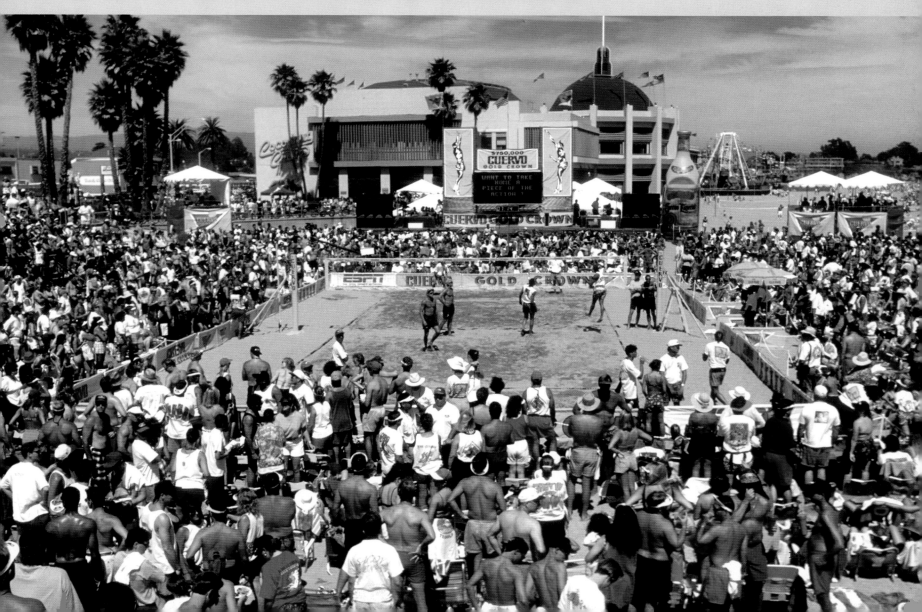

ABOVE LEFT: Clint Eastwood, on location at the Boardwalk, directed and starred in *Sudden Impact* in 1983.

ABOVE RIGHT: Wally Kurth (above center) is escorted through a crowd of fans who know him as Ned on *General Hospital* at the Soap Opera Festival, 1988. (Photo courtesy of Dan Coyro)

THE BOARDWALK GOES HOLLYWOOD

Everyone likes to come to the beach—and Hollywood actors, producers, camera operators, and technicians are no exception. The historic Santa Cruz Beach Boardwalk has become a popular site for location shoots over the years. The Boardwalk has starred in everything from industrial films, commercials, and music videos to made-for-TV movies and feature-length big-screen releases.

A few famous examples over the past fifty years include *Mr. Peabody and the Mermaid* (1948), *Harold and Maude* (1971), *The Entertainer* (1976), a Huey Lewis and the News music video (1982), *The Sting II* (1983), *Sudden Impact* (1983), *Fletch Lives* (1987), *The Lost Boys* (1987), and various episodes of *Candid Camera* (1991), *Good Morning America* (1991), and *You Bet Your Life* (1992). The following companies filmed commercials at the Boardwalk: AT&T, Chuck E. Cheese, Coca-Cola, Holiday Inn, Kodak, Levi's, Pacific Bell, Seiko, Sony, Toyota, United Airlines, and Yahoo.

TOP LEFT: Veteran film star Vincent Price rides the Giant Dipper in 1978 as part of *America Screams,* a television documentary about the country's love of thrill rides. (Photo courtesy of Bill Lovejoy)

TOP RIGHT: Actress Ann Blyth poses with newspaperman Tod Powell (right) during filming of the 1948 movie *Mr. Peabody and the Mermaid.*

CENTER LEFT: *The Entertainer,* starring Jack Lemmon, filmed extensively at the Boardwalk in 1975.

CENTER RIGHT: Actors Mac Davis and Karl Malden (seated, left to right) discuss a big deal while on the Giant Dipper during a scene in *The Sting II,* filmed in 1982. Scheduled to be shot during late summer, the film suffered unexpected delays, and production had to take place between downpours in January rainstorms.

BELOW: Loni Anderson, star of the 1987 ABC Movie of the Week *Necessity,* poses with the Cocoanut Grove in the background.

NEPTUNE'S KINGDOM AMUSEMENT CENTER

When it opened in 1907, the new Plunge building housed a huge indoor pool, which was replenished daily with fresh ocean water. In the 1960s, the Plunge closed due to aging equipment and ebbing popularity. An indoor miniature golf course served as an interim attraction while management decided the fate of the space. The "temporary" course amused patrons into the late 1980s, when the Santa Cruz Seaside Company undertook a full remodeling that was hastened by the Loma Prieta earthquake.

Today, in the same building, in honor of that nautical beginning, Neptune's Kingdom sports a jaunty, pirate-themed miniature golf course as the centerpiece of a modern entertainment complex. Neptune's Kingdom opened in 1991 in the space once known as the Plunge. Now the immense original arches curve above the two-story, eighteen-hole miniature golf course.

The miniature golf course—with talking pirates, booming cannons, exploding powder kegs, and a rumbling, fiber-optically active volcano—makes for an interesting exercise in concentration. Holes bear such names as Lafitte's Black Powder Works, West Indies Shipping Company, and Shipwreck Reef. Nearby, kids can listen to tall tales told by the animatronic twosome Captain Ned and Seaweed the Wonder Parrot. Upstairs, the Historium showcases Boardwalk history with a display of photographs that capture highlights of past eras. A game deck

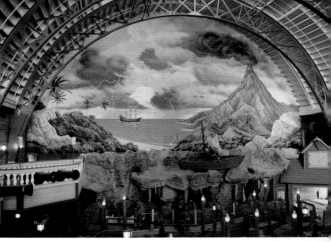

Trucks brought in two thousand yards of sand to fill the Plunge for construction of a miniature golf course in 1963.

The Neptune's Kingdom entertainment complex opened in 1991 in the space once known as the Plunge.

offers pool tables, air hockey, ping-pong, video games, and a snack bar. The Barbary Coast Restaurant and a video arcade also operate year-round in Neptune's Kingdom. Carl Henn, the director of maintenance and development for the Seaside Company, recalls the construction phase of Neptune's Kingdom: "It sure was fun building this thing. How many builders get to work with pirates, waterfalls, and volcanoes?"

FAR LEFT: The Water Carnivals ended, but swimmers continued to enjoy the Plunge. Under arched fluorescent lights, Dolores Cross sits on a diving board in 1957. Still hanging above her are rings trapeze performers used more than a decade before.

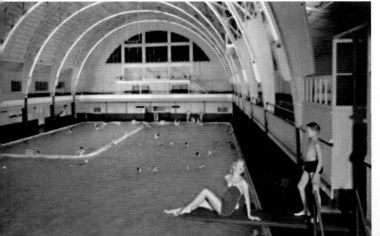

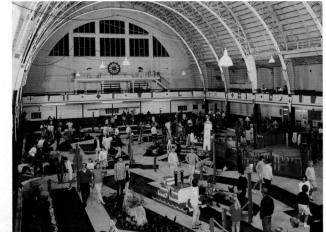

LEFT: In this 1968 photograph, golfers consider a putt through the door of the lighthouse, paying no attention to the platform on the balcony from which Water Carnival acts were once announced.

147

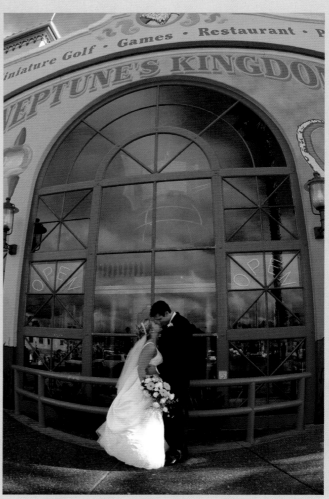

Folene Hiler, Carl Henn, an unknown girl, and Bob Stevens pose in 1962 at the antique photo concession in the Casino arcade. Hiler and Henn married three years later. Henn has worked at the Boardwalk since 1976; he is currently director of maintenance and development.

Lifelong friends in a family souvenir photo, circa 1957.

RIGHT: Married in the Cocoanut Grove, Karley and Corey Pope pose for a wedding photo in front of Neptune's Kingdom, 2002. Karley went on to become the Boardwalk promotions manager. (Photo courtesy Santees Photography)

LEFT: Souvenir photos are still an important part of a trip to the Boardwalk. The Collins family from San Carlos, California, creates a memento of their 2006 visit.

RIGHT: Dr. Kenneth Fergusson of Stockton, California, poses with his daughters, Jackie and Patsy, circa 1970.

SMILE AND SAY "BEACH": PHOTOGRAPHY AT THE BOARDWALK

Since the early days of the twentieth century, when photographers were taking shots of Victorian-clothed beachgoers in front of painted backdrops, the Santa Cruz Boardwalk has offered a variety of ways to take home photographic keepsakes. The methods of photography have evolved dramatically since those early days, but the Boardwalk photo experience has changed very little. Booths where one can pose several times for a strip of black-and-white photos are still a favorite.

Dick and Bill Ryder bought Michael and JoAnne Lucas's Vivid Visions photo concession, now called Antique Photos, in 1981. For the next five years, the Ryder brothers ran the concession. Then Dick's sons, Chuck and Bill, took over, operating it until 1991. Choosing gangster costumes or Wild West outfits, Boardwalk visitors posed with friends and family wearing dark overcoats and fedoras, ten-gallon hats, sheriff's badges, satin corsets, and net stockings.

Like generations before them, families have come to concessions like Antique Photos to pose in front of backdrops for a souvenir of their visit. Many families and couples return year after year to create a visual record of how they have changed through the years. One particularly memorable moment occurred when a young man arranged to have a photo taken with his girlfriend dressed in a costume of the Old South. Just before the camera clicked, the nervous fellow said, "Wait, we need a prop." Then he kneeled, took a ring out of his pocket, and asked his "Southern belle" to marry him. The photographer was able to capture the woman's expression perfectly. And they lived happily ever after . . . or so we like to think!

THE SOUNDS OF SUMMER

Name just about any surf band and they've probably played at the Santa Cruz Beach Boardwalk. How about the Beach Boys? Or Jan and Dean? Or the Surfaris? The music is a perfect fit for the Boardwalk, and the audiences of the summer concert series have loved it. These concerts started out featuring music from the 1950s and 1960s and have moved to music of the 1970s and 1980s, in what marketing vice president Marq Lipton describes as "keeping nostalgia current."

The Friday Night Summer Band Series began in 1988. Classic groups from the 1950s and 1960s played on an outdoor bandstand surrounded by sand and enthusiastic fans. The longest-running band at the concerts is Papa Doo Run Run, which first performed at the beach in 1990 and has returned every season for sixteen consecutive years. Formed in 1965 in San Jose, California, this group is a perennial favorite of Boardwalk concertgoers, most likely because of their legendary re-creations of classic Beach Boys and Jan and Dean beach party tunes. When Papa Doo Run Run plays the Boardwalk, they say it's like coming home—and having thousands of friends drop by to share the experience.

A perennial favorite, Papa Doo Run Run performs on the beach bandstand, 2004.

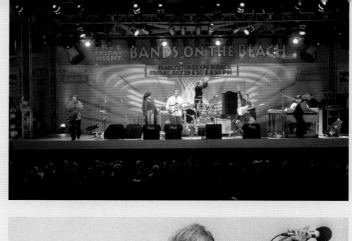

Singer Eddie Money is known for drawing the largest Friday Night Bands crowd ever, more than fifteen thousand people, with his renditions of "Baby Hold On" and "Two Tickets to Paradise." The Boardwalk has also played host to Rock and Roll Hall of Famers like the Coasters, the Lovin' Spoonful, the Shirelles, the Platters, the Yardbirds, and the Supremes. What could be better than sitting on a beach blanket with that special person, listening to the Drifters sing "Under the Boardwalk" and finish the night with "Save the Last Dance for Me"?

RIGHT: The 2003 Friday Night Band series boasted a stellar lineup.

TOP FAR RIGHT: In 2005, the FamilyStone Experience played at the Boardwalk.

CENTER FAR RIGHT: Nancy Sinatra, daughter of Frank Sinatra, kicks off the Friday Night Summer Band Series in 1995 with her best-known song, "These Boots Were Made for Walkin'."

BOTTOM FAR RIGHT: The Fabulous Drifters (shown here in 2001) never fail to elicit cheers, applause, and a few sentimental tears when they sing "Under the Boardwalk" to a crowd of nostalgic and appreciative listeners.

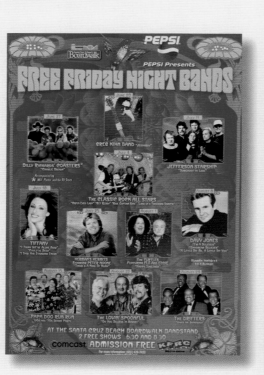

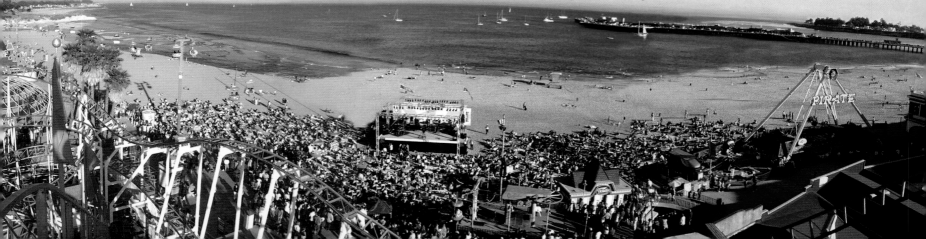

This panoramic view of a 2002 concert at the beach shows just how big the crowds can grow.

FAMILIAR FACES ON THE BOARDWALK

Take a walk on the Boardwalk and you'll see lots of friendly faces, but not all of them are people. Leo the Lion helped teach kids not to litter throughout the 1970s, 1980s, and 1990s. When he "swallowed" a bit of litter, Leo would say, "Hey kids! It's feeding time. I'm Leo, the paper-eating lion!" and kids would run around looking for pieces of paper to put in his mouth. Laffing Sal, the six-foot-tall, 1930s robotic woman from San Francisco's historic Playland-at-the-Beach, now lives and laughs at the Boardwalk.

A fixture since the 1930s, Grandma Fortune-Teller is still around to consider your fortune. Her head nods and moves left and right, and her chest moves as though she were breathing. Her hand passes over the cards, and a fortune pops out of the slot.

Harold "Peewee" Presswood performed in the Plunge Water Carnivals when he was ten, and he appeared on marketing materials during the 1990s.

Leo the Lion helped teach kids not to litter.

Grandma Fortune-Teller, 1932.

The Clown Toss continues to be a favorite game on the Boardwalk to this day.

RIGHT: This 1940s photograph of Harold "Peewee" Presswood was used in Boardwalk advertising during the 1990s.

In the Cave Train cavern, it's hard to get some cavemen to leave a card game.

ABOVE LEFT: This caveman has been sitting in his tree for more than forty years.

ABOVE RIGHT: Laffing Sal now entertains at the Boardwalk.

THE ENDURING BOARDWALK

"We're an old seaside park that is changing all the time, but we're keeping our history alive. . . . Parents and grandparents look forward to returning year after year to share their childhood experiences with their own children and grandchildren."

—Charles Canfield, president of the Santa Cruz Seaside Company

Over the years, other seaside amusement parks across the country have closed due to housing encroachments, natural disasters, or financial downturns. But the Santa Cruz Beach Boardwalk endures. Why? Because Californians and other visitors love to sun themselves, watch the pelicans and the surf, and then scream their heads off on a classic wooden roller coaster. Here you can find a combination of a major amusement park, classic and modern rides, sand, surf, sunshine, and safe, inviting surroundings.

Try to imagine how many married couples had their first dates at the Boardwalk. Or kissed on the Ferris Wheel. For some people, the Beach and Boardwalk remain part of their most romantic memories. For others, the Boardwalk has been a carefree respite from the rigors of war, or school, or life in general. "People in this crazy world need to be able to relax and shake off all that stress," says Charles Canfield. "You can get lost on these rides and eat things you don't normally eat. You can have time together as a family and be outdoors at the beach. It feels good to know we can offer that in a safe and fun place, and we're dedicated to providing that in the twenty-first century."

The Boardwalk, a one-of-a-kind playland, is a financial success and a social phenomenon. As Gary Kyriazi's book *The Great American Amusement Parks* puts it: The Santa Cruz Beach Boardwalk is "without a doubt . . . the best and most beautiful seaside amusement park in the nation." Today, the Boardwalk offers thirty-five rides, three arcades, thirty games of skill, forty food locations, an electronic shooting gallery, indoor miniature golf, and gift shops with everything from beachwear and sunglasses to wet suits and jewelry.

"I feel like I'm continuing an important legacy here at the Boardwalk," says Canfield. "And I'm proud to be a part of keeping it alive." The Santa Cruz Beach Boardwalk has been generating entertainment and entertaining generations for a hundred years. It's not about to stop now.

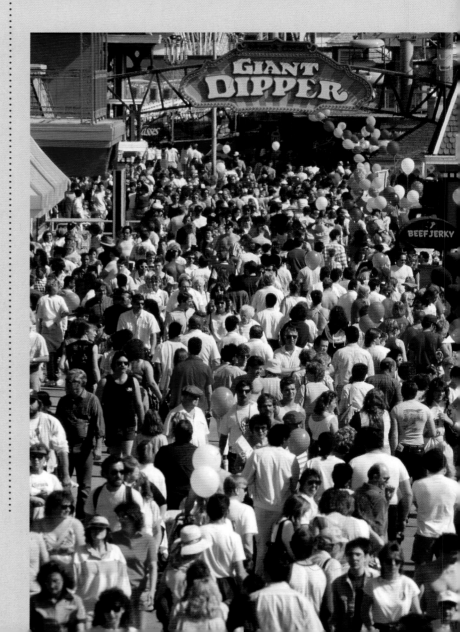

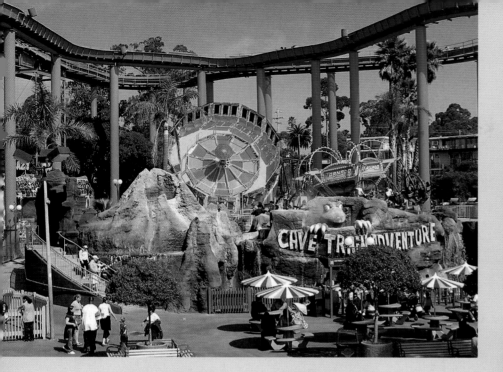

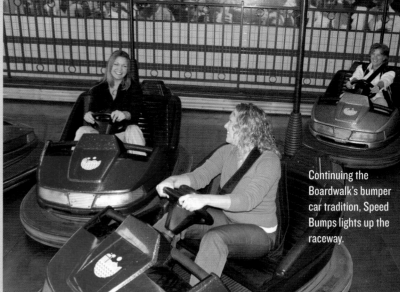

Continuing the Boardwalk's bumper car tradition, Speed Bumps lights up the raceway.

ABOVE: The plaza near the river in 2004, with the Cave Train and a bonanza of rides and food carts.

The Hurricane, a high-tech metal roller coaster, catapults guests around its pretzel-like body at four-and-a-half Gs and features banking angles up to eighty degrees.

The Double Shot launches riders skyward at more than three Gs, giving them a breathtaking view of the California coast. Then they experience the weightlessness of negative G forces as they are shot back down.

ABOVE: The original Surf Bowl bowling center opened in the 1950s. The Santa Cruz Seaside Company took over the operation in 1994, renamed it the Boardwalk Bowl, and pepped it up with a state-of-the-art scoring system, Atomic Bowling, a video arcade, and a patio.

OPPOSITE: The Boardwalk today, on a sunny, summer holiday afternoon.

Santa Cruz Beach Boardwalk employees, 2007.

SANTA CRUZ BEACH BOARDWALK EMPLOYEES

Board of Directors

Charles Canfield
Robert Millslagle, DDS
Albert Rice
Jeffrey Rice, MD
Jim Van Houten

Employees

Maria Alcalan, Wardrobe Assistant
 Supervisor
Jessica Alfaro, Operations Office/Guest
 Services Supervisor
Jennifer Allford, Security Officer
Erick Alvarado, Food Service Operator
Omid Aminifard, Director of Operations
Jose Aparicio Mendoza, Electrician
Carl Arnett, Director of Technical Services
Jennifer Atchley, Employment Assistant
Juan Ayala, Arcades Operator
Bob Bailey, Electrician
Jim Baker, Senior Support Equipment
 Mechanic
Rita Barrera, Carousel Motel Front Desk
 Supervisor
Rejeanne Bass, Cash Control Manager
Shanan Behm, Human Resources Assistant
Eric Bernhardt, Senior Coaster Mechanic
Vern Billington, Mechanic
Brandon Bishop, Merchandise Lead
Janet Blaser, Employee Relations
 Coordinator
Alexa Bolas, Merchandise Cashier
Chuck Bondi, Lead Electrician

Bert Bongiovanni, Carousel Motel
 Maintenance
Rezin Brannon, Security Supervisor
Jim Brezil, Arcade Technician
Nicole Bricmont, Merchandise Manager
Xiomara Brioso, Boardwalk Bowl Cafe Cook
Whitney Brooks, Fiberglass Technician
Keeya Bushnell, Food Service Lead
Meaghan Campbell, Whiting's Foods
Charles Canfield, President
Tom Canfield, Vice President of Operations
Rodolfo Cardona Nieves, Painter
Nicolas Carrillo, Grounds Crew
Ron Carskaddon, Boardwalk Bowl Senior
 Front Desk Clerk
Allen Casapis, Surf City Grill
Tiffanni Casillas, Marini's
Ramon Castellanos, Buildings Crew
Sylvia Castellanos, Games Operations
 Supervisor
Maria Castillo, Marini's
Ricardo Castillo, Arcade Operator
Lorena Castro, Marini's
Marcel Cathrein, Whiting's Foods
Jose Ceja Lopez, Sea and Sand Front
 Desk Clerk
Auriel Chairez, Surf City Grill
Maricela Chairez, Ride Operations
 Supervisor
Bobbie Chavez, Wardrobe Lead
Natalie Chavez, Marini's
Julia Chircalan, Sea and Sand Front
 Desk Clerk
Esperanza Cobos, Cash Control Lead
Tim Coe, Arcades Operator

Lizbeth Cordero, Sun Shops
Laura Corona, Food Service Operator
Miguel Corona, Arcades Supervisor
Raul Corona, Food Service Lead
Merry Crowen, Vice President of
 Hospitality/Lodging
Jorge Cruz, Marini's
Nohemi Cruz, Marini's
Rudy Cruz, Painter
Dick Damon, Security Chief
Dan Dangzalan, Security Manager
Art Darden, Security Supervisor
Elvira De La Torre Cuevas, Games Supervisor
Kathy Deagen, Director of Compensation/
 Benefits
Paul Della Santina, Purchasing Manager
Tish Denevan, Interviewer/Trainer
Randy Denham, Carpenter
Antonio Diaz, Cocoanut Grove Janitor
Lily Diego, Women's Restroom Attendant
Jo Anne Dlott, Vice President of Human
 Resources
Allen Dolph, Sun Shops
Joe Duggan, Twisselman Enterprises
Sabrina Dunleavy, Whiting's Foods
Brent Dunton, Corporate Sales Manager
Marlene Echeverria, Boardwalk Bowl
 Cafe Cook
Amanda Edsall, O'Neill
Taryn Elward, O'Neill
Ed Ernes, Senior Welder
Efrain Espinoza, Arcades Supervisor
Elizabeth Fabian Paramo, Cocoanut Grove
 Assistant Lead Cook (Hot)

Jaime Fabian Paramo, Cocoanut Grove Assistant Lead Cook (Cold)

Mbor Faye, Grounds Crew

Jan Fencl, Senior Technical Artist

Jeff Fichter, Mechanic

Joe Fiorenza, Mechanic

Martin Freeborn, Merchandise Supervisor

Brigid Fuller, Publicist

Paul Gabriel, Mechanic

Felipe Gamboa, Ride Operations Supervisor

Alexander Garcia, Security Officer

Angel Garcia, Food Service Operations Supervisor

Feliciano Garcia, Grounds Crew

Ron Garcia, Arcades Technician

Vicente Garcia Jimenez, Food Service Lead

Zoë Garcia, Human Resources Office Manager

Fabian Gauthier, Boardwalk Bowl Front Desk Attendant

Olga Gelacia, Surf City Grill

Frank Gemignani, Ticket Sales/Parking Manager

Anthony Gesek, Marini's

Kelly Glanton, Grounds Crew

Candice Gollwitzer, Marketing Office Manager

Sadie Gregory, Security Officer

Annalisa Griffis, Event Planning Assistant

Sergio Grimaldo, Marini's

Virginia Guhin, Marine Program Instructor

Brian Gustavson, Lead Arcade Technician

Claudia Gutierrez, Food Service Operations Manager

Valente Gutierrez, Food Service Operator

Howard Guy, Men's Restroom Attendant

Lucila Guzman, Marini's

Rogelio Guzman, Boardwalk Bowl Food and Beverage Manager

Samuel Guzman, Marini's

Christa Hamilton, O'Neill

Christina Handle, Cash Control Lead

Florence Harrell, Security Office Clerk

Lloyd Hartsell, Cash Control

Susan Hawkins, Cocoanut Grove Bar and Facilities Manager

Carl Henn, Director of Maintenance and Development

Omar Hernandez, Games Operator

Mark Hersey, Senior Technical Services Staff

Severin Herum, Games Stock Person

Jeff Hill, Lead Painter

Sequoia Hoffmeister, Food Service Administrative Assistant

Rob Holmberg, Whiting's Foods

Cindy Hood, Twisselman Enterprises

Susan Hottel, Games Administrative Supervisor

Larry Isonio, Senior Mechanic

Jill James, Art Director

David Jessen, Facility Development Superintendent

Laura Johnston, Marini's

Bambi Jones, Lead Nurse

Lorie Juhl, Boardwalk Bowl Youth Program Manager

Kathie Keeley, Sales Director

Aki Kelly, Technical Services

Dana Kerrick, Marini's

Sam King, Arcades Technician

Willie King, Director of Boardwalk Bowl

Dino Kypreos, Plumber Trainee

Sarah Latoza, Arcades Operator

Michael Le Blanc, Senior Mechanic

Dianna Ligon, Director of Property

Trent Lindgren, Whiting's Foods

Aaron Lipton, Sea and Sand Desk Clerk

Marq Lipton, Vice President of Marketing and Sales

David Long, Cocoanut Grove Office Manager

Michael Long, Painter

Aaron Lopez, Games Maintenance Lead

Abigail Lopez, Wardrobe Staff

Heidi Lopez, Merchandise Cashier Lead

Richard Lopez, Boardwalk Bowl Senior Front Desk Clerk

Jose Luna, Purchasing Assistant

Manuel Luna, Cocoanut Grove Lead Dish Machine Operator

Isidro Luna Herrera, Boardwalk Bowl Mechanic

Jason Mabe, South Pacific Apartments Manager

Dan Macdonald, Safety and Training Specialist

Marlene Machado, Property Maintenance

Jonathan Macias, Communications Lead

Andrew Madden, Buildings Lead

Carol Marini, Marini's

Joel Marini, Marini's

Joseph Marini Jr., Marini's

Joseph Marini III, Marini's

Kathy Marini, Marini's

Ellen Maruska, Ride Operations Manager

Consuelo Mata, Ride Operations Supervisor

Ignacio Mata, Security Supervisor

Monty Matteson, Senior Technical Services Staff

Bonne Maurer, Guest Services Lead

Joshua McGinnis, Arcades Operator

Annie McNeill, Cocoanut Grove Sales Manager

Richard Medina, Technical Services Assistant

Rene Mejia, Security Patrol Officer

David Mena, Cocoanut Grove Facility Service Lead

Moises Mena, Cocoanut Grove Facility Service Lead

Arturo Mendez, Food Service Lead

Eva Mendoza Z., Boardwalk Bowl Cafe Cook

Joe Meredith, O'Neill

Sofiya Milenkova, Surf City Grill

Ann Miller, Operations Office/Guest Services Manager

Dwight Miller, Mechanic

Kathy Miller, Sun Shops

Marshall Miller, Sun Shops

Steven Miller, Property Cleanup

Zack Millington, Technical Services Assistant

Robert Millslagle, Executive Vice President

Bonnie Minford, Archivist
Nati Miranda, Boardwalk Bowl Front Desk
 Supervisor
Dori Molcan, Cocoanut Grove Sous Chef
Armando Montes, Food Service Lead
Eduardo Montes, Games Operator
Andrea Montoya, Cocoanut Grove
 Assistant Baker
Allison Moorhead, Surf City Grill
Craig Moorhead, Surf City Grill
Daniel Morales, Food Service Operations
 Supervisor
Marcella Moran, Sun Shops
T. J. Moran, Sun Shops
Hugo Moreno, Security Officer
Jose Moreno, Buildings Crew
Lisa Morley King, Director of Sea and Sand/
 Carousel
Paul Mosso, Marini's
Crecia Munson, Facility Development
 Assistant
Max Murray, Marini's
Mike Murray, Cocoanut Grove Banquet and
 Bar Supervisor
Miles Musser, Programmer
Carol Nicholson, Surf City Grill
Billy Norman, Grounds Crew
Willie Norteye, Lead Grounds Crew
Joan Novelli, Surf City Grill
Randy Novelli, Surf City Grill
Elodia Oblea Padilla, Carousel Motel Room
 Attendant
Sergio Ochoa, Grounds Crew
Macario Orozco, Cocoanut Grove Facility
 Services
Victor Pacheco, Marini's
Jim Padgitt, Plumber
Cristina Palacios De Cabrera, Cash Control
Charles Parker, Boardwalk Bowl Parking Lot
Heather Parsons, Cocoanut Grove
 Executive Chef
Sonida Path, Food Service Operator
Jim Payne, Men's Restroom Attendant
Cesar Pedraza, Lead Mechanic
Amy Penfield, Operations Secretary

Idubina Perales, Surf City Grill
Bob Pereira, Security Officer
Ernie Pereira, Mechanical Maintenance
 Manager
Yolanda Perez, Arcades Operator
Barb Phillips, Games and Arcades Manager
Karley Pope, Promotions Manager
Celia Ramirez, Sea and Sand Front Desk
 Supervisor
Richard Ramirez, Carousel Motel Front
 Desk Clerk
Eva Ramos, Cocoanut Grove Baker
Donna Raphael, Director of Retail/Games/
 Arcades
Stephen Ratcliffe, Games Maintenance Lead
Jimmy Raun–Byberg, Artistic Painter
Anilu Reyes, Games Supervisor
Ariel Reyes, Arcades Operator
Kris Reyes, Director of Community Relations
Hermelindo Rocha, Boardwalk Bowl
 Mechanic
Vivian Romandia, Wardrobe Staff
Jerry Romero, Arcades Operator
Joe Rossi Jr., Vice President of Finance
Ingelise Rowe, Executive Assistant
Andy Rowland, Mechanic
Ed Ruda, Coaster Mechanic
Lisa Ruiz, Ticket Sales/Parking Assistant
 Supervisor
James Ruston Jr., Lead Plumber
Arnulfo Saldana, Buildings Crew
Kevin Samson, Corporate Sales Manager
Alejandro Sanchez, Arcades Operator
Melissa Sanchez, Marini's
Sandra Sanchez, Boardwalk Bowl Assistant
 Restaurant Manager
Victorino Sanchez, Cocoanut Grove Facility
 Services
Yolanda Sandoval, Surf City Grill
Susan Scherer, Surf City Grill
Paul Schockner, Cash Control
Sextus Selvaratnam, Cash Control Assistant
 Manager
Jeff Sergent, Technical Services

Sally Sessions, Cocoanut Grove Events
 Director
Cimaron Shanahan, Arcades Operator
Austin Sherwood, Advertising Director
John Shull, Mechanic
Carol Siegel, Employment Manager
Marty Siegel, Corporate Sales Manager
Juan Carlos Silva, Grounds Crew
Shelley Silva, Revenue Accounts Supervisor
Everard Simonpillai, Food Service Director
Stephen Sims, Security Officer
Makenzie Sisk, Whiting's Foods
Riley Sisk, Whiting's Foods
Paula Smith, Merchandise Cashier
Regina Smith, Accounts Receivable
Ryan Smith, Electrician
Nakia Soeharsono, Production Artist
Jorge Solano, Ride Operations Manager
Luis Somoza, Ride Operations Supervisor
Frank Spagnola, Mechanic
Karl Speight, Buildings and Grounds
 Manager
Donaven Staab, Webmaster/Sound
 Specialist
Desiree Steber, Twisselman Enterprises
Chris Steen, Grounds Crew
Rose Stephens, Sea and Sand Room
 Attendant
Sandi Jo Stoltenkamp, Work and Travel/
 Interviewer
John Takemoto, Senior Coaster Mechanic
Trenton Teigen, Residential Property
 Manager
Patrick Thinguri, Gardener
Jamie Thompson, Boardwalk Bowl
 Bartender
Christopher Tighe, Security Officer
Christophe Tomatis, O'Neill
Angie Tomlin, Boardwalk Bowl Cafe
 Food Server
Ross Toshitsune, Whiting's Foods
Joanne Toth, Whiting's Foods
Aide Trinidad, Carousel Motel Room
 Attendant
David Troetschler, Mechanic

Alisha Tuntland, Boardwalk Bowl
 Bookkeeper
Audrey Twisselman, Twisselman Enterprises
Matt Twisselman, Twisselman Enterprises
Rich Van Dine, Property Maintenance Staff
Helen Vance, Cash Control
Lauren Vargas, Marini's
Angela Vasquez, Sun Shops
Kalin Velev, Senior Accountant
Sir William Vignone, Mechanic
Joel Villanueva, Security Officer
Ryan Vyborney, Arcades Operator
Kelly Wallace, Mechanic
Gary Walliser, Games Operator
Jenifer Walrath, General Liability Specialist
Amy Walters, Maintenance Secretary
Brian Walters, Lead Coaster Mechanic
Ryan Walton, Boardwalk Bowl Cafe
 Food Server

Ken Wantland, Facility Maintenance/
 Development Manager
Joe Weakley, Food Service Assistant
Ray Weber, Carpenter
Allen Weitzel, Safety and Training Manager
Emiko Whelan, Marini's
Dave White, Lead Carpenter
Dan Whiting, Whiting's Foods
David Edward Whiting, Whiting's Games
Edward Ross Whiting, Whiting's Games
Jamie Whiting, Whiting's Foods
Jeanne M. Whiting, Whiting's Games
Jeff Whiting, Whiting's Foods
Jenny Whiting, Whiting's Foods
Ken Whiting, Whiting's Foods
Nik Whiting, Whiting's Foods
Ron Whiting, Whiting's Foods
Steffan Whiting, Whiting's Foods
Ted Whiting III, Vice President of General
 Services

Margie Whiting-Sisk, Whiting's Foods
Ted Whiting Jr., Whiting's Foods
Heidi Whiting–Sussman, Whiting's Games
Daniel Williams, Cocoanut Grove Cold
 Station Lead
Rob Winslow, Boardwalk Bowl Mechanic
 Supervisor
Derek Wolf, Controller
Sondra Woods, Advertising Specialist
Susan Woodward, Whiting's Foods
Sydney Wright, Whiting's Games
Chad Yamate, Twisselman Enterprises
Cindy Yeager, Accounts Payable Supervisor
Richard Yeager, Lead Gardener
Ramon Zaragoza, Ride Operations
 Supervisor
Manuel Zavala-Ramirez, Facility Services
Elvira Zepeda, Buildings Crew
Ramon Zermeno, Buildings Crew

SANTA CRUZ BEACH BOARDWALK CONCESSIONAIRES

1895–1906

Lyman Austin: Casino Grill
Mary Jane Hanly: Hanly Baths
William Lemos: Painter

1907–1914

J. J. Brashear: Candy Kitchen
A. Cohen: Cigar Stand
J. W. Dickerson: Curios
A. E. Hawes: Human Roulette Wheel
Hill and Douglass: Casino Barber Shop
E. J. Mann: Peanuts and Popcorn
W. J. Mitchell: Ice Cream Stand
Louis Sallee: Penny Arcade
William Scherer: Photos
L. A. Thompson: Scenic Railway
Ernest Wentzel: The Cow Food Stand

1915–1938

Nathan Aboudara: Boardwalk Lunch "BBQ
 Pit" Stand
Jerry and Marie Bacon: Pie Shop
Claude Barrington: The Beer Garden
C. H. Bender: Curio Shop
Winnie and Ed Blaisdell: Winnie's Turnover
 Pie Shop
Mr. Carlyle: Fun House
Herb and Helen Cunningham: The Derby,
 Piggy Race Games, Souvenir Photos
Olive Durand: Bathing Suit Store
Bob Edmeades: Bob's Place Food Shop
John Faraola: Spendthrift and Vagabond
 Speedboats
Charles Fitzsimmons: Games, Skeeroll,
 Pokerino, Casino Imports
Don Gillis: Casino Fountain Lunch

Adolf "Goldie" Goldstein: Goldstein's Soda
 Fountain, Mari-Gold Stand
Kate Gunnison: Casino Fountain Lunch
Julie Gunther: Casino Fountain Lunch
Sam Haberman: "The Ham Man" Roulette
 Wheel
Jennie Hagley "Mother Sperry": Hot Scotch
 Scones
Wade Hawkins: Goldstein's Soda Fountain,
 Mari-Gold Stand
Edna Jensen: Casino Fountain Lunch
William Johnson: Speedboat
Joe Lane: Frozen Custard Stands
Arthur Looff: Giant Dipper Roller Coaster
Charles I. D. Looff: Carousel
Joseph V. and Josephine Marini Sr.: Salt
 Water Taffy, Sweet Things, Food, Clothing
Victor A. Marini: Candy, Food, Soft Drinks,
 Mari-Gold Stand

Henry "Hot Dog" Miller: Hot Dogs, the Beer
 Garden
James O'Connor: Shooting Galleries
Ed "Doc" Reicher: Dante's Inferno, Laff
 Land, Milk Bottle Game, the Unborn
Elizabeth Rounan: "Snooky" the Humanzee
T. W. Ryan: Mirror Maze, Haunted Swing,
 Mysterious Hand
Ed Smith: Bootblack Concession
Cottardo Stagnaro II Family: Speedboat
Malio H. "Stago" Stagnaro: Speedboat

1939–1951

Elmer Anderson: Midget Speedway,
 Midget Boats
Larry Ashdown: Larry's Seaside Inn
Homer Barker: Games
Roy Fulmer: Curio Shop, Gifts and Souvenirs
Domenic "Jimmy" and Betty Giovinazzo:
 Walking Charley, Greyhound Race Games
Don Hayes: Midget Speedway
Harry Hill: Giant Dipper Hot Dog and
 Hamburger Emporium
Ruth and Glen Hunter: Ruth's Hamburgers
Violet Hunter: The Bright Spot
Dick Lane: Frozen Custard Stands
Harry Lohr: Midget Boats
Andy Miller: Casino Bowling Alley
Ethel Miller and W. N. Dirkes: Boardwalk
 Lunch "BBQ Pit" Stand
Mary Pedri: Sketch Artist
George Peters: Hamburger Stand
Fred Russell: The Bright Spot
Barney Segal: The Bright Spot
Don Sinkensen: Midget Boats
Raymond Smith: Games
Gifford, J. V. "Jot," and William Troyer: Casa
 del Rey Hotel, Cocoanut Grove Ballroom
Pete Warner: Boardwalk Lunch "BBQ Pit"
 Stand, Warner's MGR Soda Fountain
J. Ross Whiting: Shooting Galleries

1952–1983

Chuck and Esther Abbot: Belgian Waffles
Al and Ethyl Arnold: Arnold's MGR Soda
 Fountain
Dave Barham: Hot Dog on a Stick
Tony Berry: Sportland Arcade
Charlie and June Booth: Pie Shop
Charles L. Canfield: Games
Ray and Marge Carpenter: Ray's Hot Dogs
Thelma and C. E. "Buck" Dahlman: Pie Shop
Chuck and Lillian Eder: Eder's Restaurant
John Fulmer: Curio Shop, Gifts and
 Souvenirs
Steve and Merrie Ann Handley: All-
 American Hot Dogs
Ed Hutton: Corn on the Cob, Hot Dogs
Ted Kimple: Guess Your Weight
Bill Kincannon: Pie Shop
Fred "Pop" Knowles: The Bright Spot
Bill and Ginger Larzalere: The Seaside Inn
Michael and Jo Anne Lucas: Antique
 and Souvenir Photos, Your Name in
 Headlines
Charles Luce: River Parking Lot
Art Malquel: Art's Hot Dogs
Toni and Joe Mana: Monogram Hat Stand,
 Add-a-Dart Game
Joe and Carol Marini Jr.: Candy, Men's and
 Women's Clothing, Souvenir Hats and
 Shirts
Joel and Kathy Marini: Candy, Men's and
 Women's Clothing, Souvenir Hats and
 Shirts
Victor and Mary Marini Jr.: Ruth's
 Hamburgers, Fresh Cut Fries
Francis "Mac" and Sylvia McDaniel:
 Pretzel Carts
Earl and Dorothy Meyers: Tacos Aqui
Marshall and Kathy Miller: Sun Shops,
 Clothing, Retail, Souvenirs, Gifts
W. J. Mitchell: Refreshment Stand
John "Chachie" and Peggy Ottaviano:
 Chachie's Hot Dogs and Tacos

Jack and Sandy Spottswood: Jax Marionettes
Bill Stoner: BBQ Pit Restaurant
Dave Towle: Corn on the Cob, Hot Dogs
Audrey Twisselman: Hot Dog on a Stick,
 Chicken in a Basket, World Grill
Dennis and Karen Walker: Eder's Restaurant
Lillian Walker: Root and Walker's Coaster
 Lunch
Carrie Weaver: Dodge 'Em Soft Drink Stand
Howard "Hodgie" and Barbara Wetzel:
 Hodgie's at the Boardwalk
Jack Wheeler: Boardwalk Lunch "BBQ Pit"
 Stand
Ed and Jeanne Whiting: Shooting Galleries,
 Games
Ken Whiting: Whiting's Foods
Les and Marjorie Whiting: The Bright Spot,
 Frozen Custard Stands
Margie Whiting-Sisk: Whiting's Foods
Ron Whiting: Whiting's Foods
Ted and Esther Whiting Jr.: The Bright Spot,
 Frozen Custard Stands, Whiting's Foods
Ted Whiting III: Whiting's Foods
Pat and Fred Wooldridge: Games

1984–2007

Joe Ferrara: Atlantis Fantasyworld
Joe Marini III: Salt Water Taffy and Other
 Sweet Treats
Craig and Allison Moorhead: Surf City Grill
T. J. and Marcella Moran: Sun Shops,
 Clothing, Retail, Souvenirs, Gifts
O'Neill: Clothing, Beachwear, and Apparel
Dean and Joane Richter: Photos
Bill Ryder: Antique and Souvenir Photos
Chuck Ryder: Antique and Souvenir Photos
Dick and Dorothy Ryder: Antique and
 Souvenir Photos
Art and Katherine Shaw: Gyro Sandwiches
Matt Twisselman: Hot Dog on a Stick,
 Chicken in a Basket, World Grill,
 BoardWok
Nik Whiting: Whiting's Foods

INDEX